HOW TO
START AND
RUN A
Commercial
Art Gallery

Edward Winkleman

*Allworth
Press*

14 13 12 11 10 6 5 4 3 2

Published by Allworth Press
An imprint of Allworth Communications, Inc.
10 East 23rd Street, New York, NY 10010

Cover design by Mary Belibasakis
Interior design by Mary Belibasakis
Page composition/typography by Integra Software Services, Pvt., Ltd., Pondicherry, India
Cover photo by Mike Garten

ISBN-13: 978-1-58115-664-5
ISBN-10: 1-58115-664-2

Library of Congress Cataloging-in-Publication Data:
Winkleman, Edward.
How to start and run a commercial art gallery / Edward Winkleman.
 p. cm.
Includes bibliographical references.
ISBN 978-1-58115-664-5
1. Art galleries, Commercial–Management. 2. New business enterprises–Management. I. Title.
N8620.W56 2009
708.0068—dc22
 2009011839

Printed in the United States of America

TABLE OF CONTENTS

To Murat (Bambino) Orozobekov

INTRODUCTION

The Easy Part and the Hard Part

Shortly after moving to New York City, I met a producer of off-Broadway plays at a party. Listening to him describe his passion, I grew highly impressed with his resilience in finding backers for his productions. He said he wouldn't even begin to become discouraged until the thirteenth potential investor turned him down. In fact, he took anything other than a flat-out "No!" as encouragement, and he rarely accepted the first "No!" as a final answer, anyway. Nothing was going to dissuade him from following his dream.

I was busy soaking up these insights, so I was caught by surprise when he asked what I was doing in New York. What was my dream, he wanted to know.

"I'd like to open an art gallery," I answered.

"That's great," he replied. "How are you going about doing that?"

"Er . . . uh . . . well," I said. "I'm doing studio visits with lots of artists, and working freelance for a gallery, and attending art fairs, and . . ."

"That's the lamest thing I've ever heard," he interjected.

"Excuse me?" I asked, visibly offended.

"What is an art gallery?" he continued. "It's a space with art on the walls. If you want to open an art gallery, get a space and put art on the walls."

"Wait . . . er . . . it's not that simple," I protested.

"Yes, it is," he insisted. "It's exactly that simple. Get a space, put art on the walls, and you will have an art gallery."

He was right, of course. It *was* that simple. Six months after that conversation, I rented a space on the Lower East Side for a weekend, put art on the walls, and had my first (if highly temporary) art gallery. I even sold some work. What the producer-mentor didn't tell me back then, though, was that finding a space and putting art on the walls is the easy part. Staying in business is the real trick.

As with many small businesses, new art galleries have a fairly high attrition rate. There are several specific reasons for this in the commercial art business. First, it can take at least three years before a new gallery will become profitable, perhaps more if the artists in the program are emerging. Second, the paths most art dealers take to opening their own spaces do not include much in the way of classic business administration. Third, you won't go very far in the art business without a real passion for art; if you don't have one, you should probably reconsider opening a gallery. Finally, to be successful, you will need more than passion or even business experience; you'll need entrepreneurial instincts. With all that in mind, the focus in this book is on the business side of starting and running a commercial art gallery, with an emphasis on which standard practices are perhaps ripe for entrepreneurial innovation.

Indeed, because an art gallery is such an individual enterprise, standard practices are constantly evolving as new players with new agendas enter the field. From deciding on the percentage of sales that goes to artists in consignment agreements, to establishing resale rights for living artists and their estates, to figuring out how many artists a gallery can effectively represent, long-standing guidelines are continuously being rewritten by newcomers. Even the term that gallery owners use to refer to themselves keeps evolving. Early in the twentieth century, the phrase "picture seller" was quite common, and lingers on, especially in the secondary market, although it carries the connotation of antiquity for many younger dealers. Then slowly, "picture seller" gave way to "art dealer," which is more or less the most common term today. A little more than a decade ago, though, the term "gallerist," which was already widely used in Europe, became more and more common as the owners of American galleries increasingly saw that a part of their responsibility was to promote individual programs, visions, or statements about art. Both terms are used somewhat interchangeably in the United States today, but because we're discussing the nuts and bolts of running a business in this book, I'll stick with the phrase "art dealer."

Each chapter of this book focuses on some component of either getting started or running your gallery from as generic a point of view as I can offer, but I should note that as the owner of an emerging art gallery (meaning, I focus on the primary market), my personal experiences will undoubtedly color my opinions and advice. There are many other types of art galleries, though (we'll look at the range of them

in chapters 2, 3, and 4), and while the basic terminology and concepts apply to all of them, you should read each section with the understanding that the most successful galleries are the ones that reinvent the model to fit their unique goals and talents. In other words, take what you can from the information and advice in these pages, but keep in mind that there is no one-size-fits-all path to success.

The overriding assumption throughout this book is that the audience most interested or in need of this information includes primary-market art dealers just getting started and others (like artists) who want more insight into how their galleries operate. Although some of the following chapters include discussions on secondary-market practices or concerns, even those passages are geared heavily toward what it is about those situations a new primary-market dealer should know. There are very few "rules" in the art business, but I do assume most dealers seriously looking to open a secondary-market commercial gallery will not need much of the advice provided here.

ACKNOWLEDGMENTS

Had Tad Crawford and his world-class colleagues at Allworth Press not conceived of this book, I would not be writing an acknowledgments section at all. Therefore my first thanks must go out to the writer Daniel Grant for recommending me for this book, and then to Tad Crawford, Robert Porter, Nicole Miller, and Janet Robbins for their expert guidance and kind encouragement throughout the process.

A number of my fellow art dealers were selflessly liberal with their time and advice as I was writing this book. In particular I would like to thank Andrew Witkin of Barbara Krakow Gallery; Penny Pilkington and Wendy Olsoff of P·P·O·W Gallery; Michael Jenkins of Sikkema, Jenkins, & Co.; Pavel Zoubok of Pavel Zoubok Gallery; Jeff Bailey of Jeff Bailey Gallery; Margaret Thatcher of Margaret Thatcher Projects; Rachel Gugelberger of Sara Meltzer Gallery; Heather Marx and Steve Zavattero of Marx & Zavattero; Valerie McKenzie of McKenzie Fine Art; Dennis Christie and Ken Tyburski of DCKT; and last, but certainly not least, the two magnificent women I pester with questions on a daily basis: my darling neighbors, Lisa Schroeder and Sara Jo Romero of Schroeder Romero Gallery. I would also like to thank other colleagues who have been helpful with their advice to me over the years. Many of them may be surprised to see their names listed here, but I have learned so much of what I know about running a gallery from their examples and thoughtful recommendations that I would feel guilty for not noting it here. They include Joe Amrhein, Alun Williams, Becky Smith, Joel Beck, Christian Viveros Faune, Eric

Heist, Michael Waugh, Steven Sergiovanni, Monica Herman, Heather Darcy Bhandari, Zach Feuer, Janine Foeller, Jane Hait, Irena Popiashvili, Marisa Newman, Monique Meloche, Kavi Gupta, Andrea Rosen, Andrea Marinkovich, Royce Burton, Tatiana Okshteyn, Norberto Lobato, and Harry Nolan. There were also art world professionals who don't own galleries but were kind enough to help me explain how they interact with art dealers. Special thanks go to Franklin Boyd, Esq., and Jonathan Neil of the art consultancy Boyd Level; Elizabeth Estabrook of Amann + Estabrook Conservation Associates; independent curators Courtney J. Martin, Berit Fischer, and Omar Lopez-Chahoud; art historian and writer Jane Harris; art handling expert Tomasz Nazarko; and fine art photographers Etienne Frossard and Mark Woods. I also owe a debt of gratitude to New York collectors Michael Hoeh, John McGovern, Joel and Zoë Dictrow, Beth DeWoody, Tim and Terri Childs, and many, many more (including one, in particular, who wished to remain anonymous but knows who he is). It has been truly lovely to get to know you over the years, and your generous support of the gallery and this project is so very much appreciated.

Much of what you'll read in this book was first explored through the open forum of my blog (*http://edwardwinkleman.blogspot.com*), where generous art world professionals, passionate art lovers from around the globe, and artists have contributed to and helped me refine what I consider the best practices for dealing in art. I am very grateful to my readers for their comments, questions, and constant reality checks. Further, I would like to thank the curators, writers, collectors, and artists I have worked with over the years, many of whom have become very dear friends, for making every day in the gallery an experience I cherish. To the artists we work with in our gallery in particular (yes, I'm going to list them all): Ivin Ballen, Cathy Begien, Jimbo Blachly, Jennifer Dalton, Rory Donaldson, Muratbek Djumaliev, Yevgeniy Fiks, Joy Garnett, Christopher K. Ho, Shane Hope, Christopher Lowry Johnson, Gulnara Kasmalieva, Alois Kronschlaeger, David Kinast, Thomas Lendvai, Carlos Motta, Sarah Peters, Lytyle Shaw, Eve Sussman, and Andy Yoder—none of this would matter in the slightest without you and your inspiring artwork. Nothing in the business is as satisfying as learning something new from you each time we talk or I have the pleasure of seeing your work.

Running our gallery would simply not be feasible without the tireless efforts of our associate director, Max-Carlos Martinez. Perhaps the kindest wish I can offer any new dealer is that you be so fortunate in starting your own gallery as to find someone as charming, patient, and talented as Max. He's a prince among men anywhere, let alone the very aggressive place we call the art world.

And finally, anyone who regularly reads my blog or who happens by the gallery won't have missed the fact that I am basically lost without the man known far and wide as "Bambino." In real life, his name is Murat Orozobekov. He's vice president of our business, our gallery manager, and without a doubt the single most generous person I have ever met in my life. This book is dedicated to him.

1

Education: How to Learn What You Don't Know Before Opening a Commercial Art Gallery

Getting an education specifically designed to prepare you to run an art gallery can require a bit of assembly. Having a PhD in art history does not guarantee that you'll be any good at managing a small business, just as having an MBA does not guarantee that you'll develop an eye for the kind of art that collectors will want to purchase. Attempt to combine two such degrees, and you may end up owing more in student loans than an art gallery is likely to pay you for quite some time. Besides, many of the most successful art dealers of the past hundred years have had no advanced degrees in art or business. How much each of them knew about art, or about selling it, varied widely before they opened their galleries. Their reasons for starting their spaces ranged from being asked to do so by artists who trusted them, to discovering they had a knack for it through some other avenue, to simply believing they could do it better than anyone else out there. In other words, for the same range of personal reasons many small businesses are opened. So don't be at all daunted if your background is in nursing, computer programming, or communications (all real examples of previous careers for flourishing dealers I know).

Even though there is no predominantly held degree for the art gallery business, there are good sources of information for what you probably should know before opening your own space. Likewise, there are excellent examples of the more typical paths to becoming an art dealer, which are worth considering. In this chapter, we'll look briefly at the history of art dealing and then at how a few successful art

dealers got their start. We will also delve into the more formal options for gaining an education, including continuing education courses, "apprenticeships" (in quotes because it's often best to keep the fact that you're apprenticing at another gallery your little secret), a good mentor, and advanced studies courses tailored toward gallery management. Finally, we'll examine some of the common misconceptions about what a gallery is (or is not) to ensure that you're heading into this world with your eyes as wide open as possible.

A BRIEF HISTORY OF ART DEALING

It behooves any budding art dealer to gain at least a cursory knowledge of giants in the field, if only because other dealers you will do business with may use them as shorthand for certain types of business models or cautionary tales. It may be impossible to know exactly who the first person was to serve as the representative for an artist or to buy an artwork with the intention of turning around and reselling it for a profit, but by the time Western art took that giant leap forward in the form of the Italian Renaissance, there were already vendors acting as middlemen between collectors and artists. Giovanni Battista della Palla was among the first international art dealers to make it into the history books by name. Immortalized in Giorgio Vasari's marvelous series of biographies, *The Lives of the Artists,* for having sold work by the greatest artists of his day to the king of France, he undoubtedly falls into the "cautionary tale" category. Della Palla, having been imprisoned as a traitor, comes down to us as a somewhat inglorious character (historians have called him, among other things, a "two-bit merchant"). Accounts vary as to whether he was eventually beheaded at Pisa or took his own life in prison, but della Palla is arguably the basis for many of the negative stereotypes about art dealers that persist today. Things do get better for the profession's reputation, though—I promise.

Throughout much of the history of art dealing, trying to make a living selling artwork alone was not considered prudent. Lazaer Duvaux, the celebrated eighteenth-century French "luxury merchant" (*marchand-mercier*), offered a mix of exquisite furniture, jewelry, ceramics, and sculptures to his fashionable and very wealthy clients. (Duvaux's importance continues to the present day because sales ledgers he kept between 1748 and 1758 still provide contemporary scholars with a treasure trove of provenance information.) Well into the nineteenth century, art was often still viewed—even by many of its merchants—as parallel to a home furnishing, and was sold as a sideline in shops that offered mirrors, furniture, or even toys. Boston craftsman John Doggett, for example (one of the earliest recorded dealers in America), opened his shop in 1810 to sell both pictures and frames. His shop went on to become Williams and Everett, one of the most important art galleries in America, but selling art alone was not his original business plan. Many art galleries continue to mix art and

design objects in their inventory, the way Doggett started out doing. In fact, there's been an interesting resurgence of exhibiting high-end design in some of the most prestigious fine art galleries lately. Where that may lead the profession remains to be seen, but many dealers are keeping an eye on those enterprising souls who are daring enough to blur the lines after years spent separating the two genres.

At some point along the line, the relationship between artist and dealer evolved from one based solely on commerce to one that includes sincere advocacy. Even in the face of commercial failure, this new kind of art dealer champions certain artists because he truly believes in them. For many people, including many artists, the image of the art dealer as an enthusiastic patron (scouring drafty studios, finding that misunderstood genius who's been toiling in obscurity and breaking all the rules, and then working tirelessly to promote this newly discovered modern-day master in the face of even the most scathing of critiques) remains a romantic ideal. A closer look reveals that among famous dealers, even some of the greatest have been known to "let go" of artists whose work they couldn't sell, but like many legends, this one is at least partially grounded in truth.

The contemporary version of the legend seems to have begun in earnest with the arrival of the French dealer Paul Durand-Ruel. Born in 1831 to a family of picture dealers, Durand-Ruel is considered the first modern art dealer to support his artists with monthly stipends and solo exhibitions. Championing first the painters of the Barbizon School, he eventually brought widespead attention to the brazen young artists known today as the Impressionists. This was no small act of faith on his part. The Impressionists were widely ignored or derided for decades, and it took Durand-Ruel years to earn back the money he spent buying up their output. Through his galleries in Paris, London, and New York, as well as a steadfast faith in the importance of this bold new art, Paul Durand-Ruel eventually won over the public and helped change art history. The fact that he ultimately more than made his money back should not be overlooked.

From this point forward in our brief historical recap, it is possible to divide art dealers into two camps: those who enjoy working to promote relatively unknown artists and those who prefer to sell work from established names. There exists considerable overlap in business models, but for a certain breed of art dealer, the thrill of discovering and nurturing new talent seemingly holds little to no interest. They wish to work only with reliably bankable artists. This type of art dealer found its archetype in the form of Joseph Duveen. Born in 1869 in Hull, England, but expanding his family's business to include galleries in the toniest districts of London, New York, and Paris, Duveen was a natural salesman. Excessively charming and exuberant, he would notoriously work his clients into a near frenzy of desire for the works in his gallery by dramatically insisting he simply couldn't part with the Old Master painting he had

recently wrestled away from some duke or count somewhere in Europe. His wife's reported deep attachment to a piece was frequently the source of the dealer's dilemma. After several rounds of such theatrics (each seeing the price of the work in question rise), Duveen would reluctantly relent and note that he would just have to figure out how to break the bad news to Mrs. Duveen later. Among Duveen's clients were some of America's richest men at the time, including Henry Clay Frick, William Randolph Hearst, J.P. Morgan, Henry E. Huntington, Samuel H. Kress, Andrew Mellon, John D. Rockefeller, and Joseph E. Widener. Much of Duveen's success is ascribed to his realization that the one thing eluding these titans, who otherwise had everything money could buy, was the sense of immortality that only art can bestow.

While Duveen was becoming extremely wealthy selling the work of long-dead artists, two of his contemporaries were working overtime to shift the serious attention—and money—over to the works of the more recent and still living European artists who would usher in the era of Modernism. Following in the footsteps of Durand-Ruel, Ambroise Vollard (1866-1939) and Daniel-Henry Kahnweiler (1884-1979) sold between them some of the greatest works of art created by such revolutionaries as Georges Braque, Paul Cézanne, André Derain, Juan Gris, Fernand Léger, and Pablo Picasso. Vollard's practice of buying up a large chunk of an artist's inventory and then reselling the work for a remarkable profit earned him a few detractors, but in addition to making money and publishing biographies of Cézanne, Edgar Degas, and Pierre-Auguste Renoir, he had unquestionably one of the best eyes of any dealer ever. The younger Kahnweiler, in awe of Vollard, was overall a better art dealer, and by that I mean he was revered by artists, critics, and collectors alike. In addition, Kahnweiler was a respected art historian. As one of the first people to recognize the importance of Picasso's seminal painting *Les Demoiselles D'Avignon* (he reportedly asked to buy it on the spot), he was recognized as deserving of the highest compliments to which an art dealer can aspire, in my opinion: he was widely heralded than a "connoisseur."

Throughout the twentieth century, the number of notable art galleries increased so dramatically worldwide that a discussion of each would make this brief history anything but. Limiting the following list to those in the United States that you might hear used as examples of how to (or how not to) run your business is a matter of necessity and not an indication that art dealers in other parts of the world were any less innovative, successful, or unfortunate than these dealers.

Two of the oldest galleries that continue to dominate their field in the U.S. today began as New York branches of Parisian businesses. When Michael Knoedler, who came to America as the director of the French engravers Goupil & Company, opened his own space in 1846, he raised more than a few eyebrows among his competition by forgoing the entry fee (about twenty-five cents then) that most other galleries charged. This visitor-friendly policy, the wise choice to mix contemporary European artworks

with those by Americans, and a focus on solo exhibitions (pleasing both his artists and the press) eventually led to Knoedler being the first art dealer to be invited to become a member of the Century Association, a distinguished club of artists, writers, and "amateurs of letters and the fine arts." The gallery he and his family built, Knoedler & Company, remains one of the most respected and flourishing of American art galleries.

Knoedler's longtime competitor, Wildenstein & Company, has an arguably more colorful history. Also a family business (now in its fifth generation), the gallery was founded in Paris, and the Wildensteins opened a New York branch in 1903. Famously secretive about the inner workings of their business, the Wildensteins have nonetheless seen a fair bit of sensationalist press. From a controversial period in which Georges Wildenstein was reportedly forced by the Nazis to sell art confiscated from Jewish dealers in Paris, to a 1956 suit filed by Knoedler against the Wildenstein company for allegedly hiring a private investigator to wiretap Knoedler's phones, the history of the gallery is almost as interesting as the sales of acknowledged masterpieces they have placed among the world's top museums.

The twentieth century also saw the rise of galleries opened by dealers as well-known by the art world now (if not more so) than many of the artists they exhibited. Alfred Stieglitz opened Little Galleries of the Photo-Secession in 1905. Eventually, it became known simply by its street address, 291. It was among the first spaces to eschew the plush red velvet of most important galleries in favor of a crisp, modern look. Julien Levy's Gallery of Modern Art was founded in 1931 and is noted for introducing the Surrealists to America and for hosting the first cocktail-party opening. What Stieglitz and Levy personified as well was that passion for contemporary art had grown so much in New York that it became possible to be an influential art dealer without being a very successful businessperson. Steiglitz was notoriously ambivalent about sales, having once asked a collector who had sought the gallery out to buy a watercolor what made him think he deserved to own the piece. Levy worked hard but had both the Great Depression and the slowness with which Americans warmed up to Surrealism to contend with. After closing his gallery briefly to enter the Army in 1942, Levy eventually closed for good in 1949. A lack of funds forced Stieglitz to close 291 in 1917, but he continued to organize exhibitions and eventually opened another gallery, An American Place, in 1929. It lasted until 1946, the year Stieglitz died.

Two illustrious galleries were also opened by women better known for their passion and visions than for their abilities to make money selling art. After her first failed attempt in London with Guggenheim Jeune Gallery, Peggy Guggenheim opened her second gallery in New York in 1942 to incredible acclaim. Named Art of This Century, her Fifty-Seventh Street space was considered a work of art itself, with its highly innovative installations and lighting systems designed by the architect Frederick Kiesler. Art of This Century heralded the dawn of New York's rise to

art-capital status when it hosted the first solo exhibitions of Jackson Pollock, Mark Rothko, Hans Hofmann, and Clifford Still, to name a few. Despite her considerable personal wealth, however, Guggenheim insisted that visitors pay an entrance fee and was reportedly upset when she learned that her secretary had let students and artists in for free when she wasn't there. By the time she left New York for her new Venetian palazzo when WWII ended, most of her artists had already left her gallery for newer spaces, hoping for more sales of their work.

One of those newer spaces was owned by Betty Parsons, who is the first art dealer interviewed in a book I can't recommend highly enough: *The Art Dealers: The Powers Behind the Scene Tell How the Art World Really Works*, written by Laura de Coppet and Alan Jones (Cooper Square Press, 1984) and revised by de Coppet in 2002. I have given this book to new dealers as a gift many times. Although it is now somewhat difficult to find in bookstores, you can get it from online booksellers with ease. It would be indulgent of me to continue with this history of art dealing up to the present day when nothing I can tell you will be anywhere near as valuable as what you will learn from reading these concise, supremely helpful interviews with the people who are that history.

LEARNING FROM OTHER DEALERS' EXPERIENCES

Because most successful approaches to running a gallery are as individual as they are innovative, there is much about art dealing that you could learn from reading just about any dealer's biography. Even before you dive into the eye-opening stories found in de Coppet's and Jones's interviews, I recommend the wonderful overview found in Malcolm Goldstein's remarkably well-researched book *Landscape with Figures: A History of Art Dealing in the United States* (Oxford University Press, 2000). In addition to more information about many of the dealers I noted in the section above, Goldstein's history includes a detailed inventory of innovations and changes in business practices.

When you're ready for even more details, a few must-read full biographies include the following.

- **Joseph Duveen.** Either *Duveen: A Life in Art* by Meryle Secrest (University of Chicago Press, 2005) or, for a more sensationalist account, *Duveen: The Story of the Most Spectacular Art Dealer of All Time* by S.N. Behrman (Little Bookroom, 2003).

- **Edith Halpert.** *The Girl with the Gallery: Edith Gregor Halpert and the Making of the Modern Art Market*, by Lindsay Pollock (PublicAffairs, 2006).

- **Julien Levy.** *Julien Levy: Portrait of an Art Gallery,* eds. Ingrid Schaffner and Lisa Jacobs (The MIT Press, 1998).

- **Peggy Guggenheim.** A bit more scandal than business, perhaps, but this combination of Guggenheim's biographies offers insights into the mindset of the "dealer as patron": *Out of This Century: Confessions of an Art Addict*, by Peggy Guggenheim (Universe Books, 1979).

LEO AND JEN: TWO AUSPICIOUS BEGINNINGS

Each of the biographies above is chock-full of lessons for the established art dealer and beginner alike, but the focus of this chapter is what (or whom) you need to know before getting started in the business. With that in mind, I will recount the beginnings of two dealers representing opposite ends of the spectrum regarding what kinds of connections or involvement with the art world they had before opening their spaces. First is the subject of my favorite interview in *The Art Dealers,* one of the most beloved and truly influential art dealers of the twentieth century: Leo Castelli. Charming, energetic, and extremely graceful, Castelli eventually represented some of the giants of American contemporary art, including Rauschenberg, Johns, Warhol, Lichtenstein, Stella, and Rosenquist.

Castelli was born in Trieste, Italy, but lived and worked all over Europe (making him eventually fluent in Italian, French, English, and German). He began his first gallery when artists he knew in Paris convinced him to do so. Among the artists he knew there were superstars like Max Ernst and Salvador Dalí, so he was already moving in rather impressive circles when he started. But history interceded, making his first exhibition there in 1939 one of only two that he presented before war consumed Europe.

Castelli moved to the United States shortly after WWII. Here, he was again encouraged to start a space by artists he met and others who had also emigrated, but he resisted, explaining in an interview conducted by The Smithsonian Institution that "everything was going very, very badly. No money, nothing. No market, zero."[1] But Castelli had art dealing in his blood, and through the contacts he had made in Europe, plus a bit of being in the right place at the right time, he ended up with a huge opportunity when German-born gallerist Karl Nierendorf passed away unexpectedly in 1947.

Nierendorf's inventory in his New York gallery (he also had a gallery in Berlin) included a large collection of work on consignment from one Nina Kandinsky (widow of Modernist painter Wassily Kandinsky), who lived in Paris. Those administering Nierendorf's estate in New York wrote to Mrs. Kandinsky asking what they should do with the work. A telegram came back right away saying, "Give everything to Castelli." With this windfall of valuable paintings, many of which ended up in the collection of the Guggenheim Museum, Castelli was back in the art business. Of course, Castelli's story is not likely to be your story. Unless you are already friends with some of the world's most important artists or just happen to be the only person a legendary artist's family knows in a foreign city when asked what to do

with their world-class collection on consignment there, you might have to blaze a slightly different trail to the opening of your own space.

A less star-studded but just as remarkable beginning is illustrated by the story of New York contemporary photography dealer Jen Bekman, who opened her small, eponymous gallery on Spring Street in 2003. By cashing in her 401(k) and maxing out her credit cards to raise the start-up capital (and even sleeping on an air mattress in her mother's apartment so she could rent out her own apartment for the extra money), Bekman demonstrated the sort of faith in her dream that launching any small business demands. In the space of five short years, she had such an impact on the market for contemporary photography that she earned the title "Innovator of the Year" from *American Photo* magazine.

What's all the more impressive about Bekman's story is the fact that although her background included a wide array of jobs (from switchboard operator in a New York hotel to Silicon Valley dot-com mover and shaker), none of them were directly related to the art industry. In a recent interview in the *New York Times,* Bekman acknowledged that when she opened her gallery, she "had no experience to speak of—she had never even bought a photograph or a painting—but she did have two clear goals: to help emerging artists become more appreciated, and to encourage a broader swath of people to feel comfortable buying art."[2]

Bekman, not having powerful art world connections or a windfall of high-priced art to get her started, accomplished both her goals through ingenious innovations, two of which harnessed the power of the Internet to connect people with art. Hey, Hot Shot! (*www.heyhotshot.com*) is an online competition for emerging photographers that attracts legions of artists and collectors. The winner of the competition is rewarded with representation by the gallery. Another Bekman Web site, 20×200 (*www.20×200.com*), has been such a raging success (within months of its launch, it was selling thousands of prints) that it enabled Bekman to hire staff and, for the first time since she opened, to begin to pay herself a regular salary. Each week, 20×200 offers two new multiples: a photograph and a work on paper. Each piece is available in three sizes. The smallest size is offered in the largest edition (200 copies are made) for a remarkably low price of $20. The larger size of each work is offered in smaller editions (the medium-sized version is an edition of twenty for $200, and the larger version generally is an edition of two for $2,000). As Bekman notes on the Web site, "There are a lot of people out there who want to sell their art and a lot of people who'd like to buy it. They just have a hard time finding each other. The Internet is the perfect place to bring those people together."

EDUCATIONAL OPPORTUNITIES

Whether it's a knack for connecting your clients' needs with technology or a gift for communicating with both artists and collectors, the most useful traits among successful dealers are a passion for art and good business sense. I have designed this

book to give you as much information about the business side of running a gallery as I can. Unfortunately, however, I can't be there in person to answer all the questions you might have that I have not anticipated, which is why you might consider some of the more interpersonal education and work experience opportunities available (though, admittedly, obtaining them may require a bit of searching or a willingness to work for little money).

Continuing Education Courses

Although they seem to come and go a fair bit, some universities occasionally offer continuing education courses designed to teach the basics of running an art gallery. Depending on where you live, though, such courses may be scarce. As of this writing, New York University has just launched a new one-year certificate in art business (see *www.scps.nyu.edu*). The course, which caters to professionals who wish to work in "art galleries and auction houses, or as wealth managers, financial planners or advisors to high-net-worth individuals," has a scope broader than commercial art galleries alone, making it typical among most continuing education offerings. Tuition for the NYU course is approximately $2,500, and among its required classes are "Today's American and International Art Market," "Law and Ethics in the Art Market," and "The Art Auction." Elective classes include "Starting a Successful Art Business," "Wealth Management in the Arts Market," "Fine Art as a Financial Asset," "The Art Dealer in the 21st Century," and "Essentials of Appraising." Again, as this course is brand new, there is no feedback available on it yet.

Apprenticeships

Perhaps the most painless path to opening one's own gallery—because it permits you to learn what it takes before you invest your own money—is working for (apprenticing in) an existing gallery. There are various entry-level positions at larger commercial galleries, many of which require no background in art history, per se. Any of these can provide the sort of on-the-job training and advancement that will give you the insight and confidence to break out on your own one day. Many of the most popular galleries in Manhattan's contemporary art center, Chelsea, are owned by former directors of other Chelsea galleries. As in any field, though, it is probably best not to tell your employer that your goal is to be their competition one day, so I wouldn't recommend highlighting during your job interview that you see this position as an "apprenticeship" or, after you have been hired, leaving your future gallery's architectural drawings lying about.

In considering which position in a gallery to take as your apprenticeship, it should be noted that a directorship will be the most educational and beneficial, as a director often has many of the same responsibilities as the owner of a gallery. In smaller galleries, just about any position can conceivably lead to a directorship.

In a larger gallery (those with staff a of twelve or more) this can be less likely. Getting your foot in the door is only part of your mission, though; if you want to learn as much as possible, keep your eyes on a directorship. We'll look more closely at the typical positions in a commercial gallery and their responsibilities in chapter 10.

Once you get an apprenticeship, your goal will be to learn everything you can about the day-to-day operations of running a gallery so that when your name is on the door one day, you will be well prepared. I'll be honest here and admit that I highlight the educational value of such positions because most entry-level gallery positions do not pay much. It should also be noted that because every dealer's most valuable resource is information, most of it specific to the artists represented or artwork sold there, much of what you're doing while working for someone else may not apply directly to owning your own gallery. Unless you steal their artists (which happens but isn't recommended for karmic reasons), you're going to have to become the expert in the work of other artists, anyway. So, what should you focus on learning during your apprenticeship to ensure that it serves your own goals well?

In a nutshell, you want to climb to a position where you can practice and hopefully master selling art. Because art is the quintessential luxury product (that is, people don't need it), selling it requires a certain skill set beyond what is needed to sell other, more useful things. Learning how to talk about art to those who may know it much better than you do is not easy for most of us (save a few seemingly natural-born art dealers). Practicing on someone else's dime, so to speak, can ease the impact of the incipient mistakes most people will make in a world as murky and peculiar as the art market.

There are other things you should learn from an apprenticeship as well, but those will become clear to you once you're ensconced in this terribly insider-based world. If I told you in detail what those things were here, I would likely elicit the wrath of my fellow art dealers and possibly undermine my own business, because essentially, what these things boil down to is what makes up that gallery's competitive advantage. In other words, what you want to learn is how that gallery operates to give it an edge over its rivals, much of which will be highly specific information provided through hard-earned relationships. You want to learn this not so much to copy it (as the examples of Castelli and Bekman were designed to convey, most successful galleries are born out of unique circumstances or innovations), but so you can recognize how such information is used in fashioning your own improved approach.

Mentors

The ultimate prize of any apprenticeship in an established gallery isn't cracking the code to its competitive advantage, convincing its best-selling artists to follow you to your new space, or even securing the contact information of its A-list collectors. If

you're looking to make a lifelong affair of your gallery, then the single best thing you can take away with you is the respect and support of your former boss. Having a generous mentor to whom you can continue to reach out is positively priceless in this business. Regardless of how fast-paced a gallery you may be leaving, it's highly probable that you won't have truly "seen it all" before you set out. Knowing you have someone you can call when the unexpected happens—and it will—can be the ultimate secret weapon in your arsenal.

Even for new dealers who have not had apprenticeships, finding a mentor remains perhaps the single most valuable step they can take early on. A book like this cannot possibly prepare you for the wide range of delicate dilemmas that will crop up in dealing with artists, collectors, curators, and critics. Moreover, having a source for reliable recommendations for experts (like conservators, arts lawyers, and art handlers) can save years of costly trial and error. Befriending someone with experience under his belt can also provide the peace of mind that will help new dealers find the courage it takes to go out on their own.

Advanced Studies and Graduate Degrees

It may seem counterintuitive to discuss advanced studies opportunities last in this chapter, but the truth of the matter is that as much as advanced studies can provide advantages in the gallery business, they are not the typical path for most successful dealers. Then again, that may be because many of the best courses are relatively new. Of the gallery management degrees offered throughout the United States, most are focused on the museum gallery model, but a few are dedicated to the more commercial side of the business.

As with continuing education courses, what is available near you may not even approach what is offered in New York or the other major arts centers, most of which do not seem to be geared toward distance learning. So, if you're interested in advanced studies, you may likely need to relocate. A graduate studies course, "Art Market: Principles and Practices," offered by New York's Fashion Institute of Technology (*www.fitnyc.edu*) provides a good example of what you should expect in terms of basic admissions requirements, curriculum, course descriptions, and faculty from an advanced study course, so we'll use it as our model.

The Fashion Institute of Technology (FIT) requires applicants to have a bachelor's degree in what they consider an appropriate major from an accredited college or university and a cumulative GPA of 3.0 or higher. If English is not the primary language of the institution at which the applicant's Bachelor's degree was earned, applicants are required to provide evidence of sufficient Test of English as a Foreign Language (TOEFL) scores. Graduate Record Examination (GRE) scores are also required, and preference is given to applicants with degrees in art history.

(If you complete a minimum of four college-level courses in art history, you can still be accepted.) Finally, FIT prefers that applicants have a minimum of two years of college foreign language courses under their belts.

The curriculum for the "Art Market: Principles and Practices" course includes the following:

> **First term:** "Principles of Gallery Management I: Gallery Design & Operations," "History of Modern Art: 1870 to 1945," "Marketing Art for Profit and Non-Profit Organizations," and "Writing about Art."

> **Second term:** "Principles of Gallery Management II: The Business of Art," "History of Contemporary Art: 1945 to Present," "Computer Technology for the Art World," and "Starting an Art Business."

> **Third term:** "Principles of Gallery Management III: Valuation & Appraisal," "Seminar: The New York Art World," "Seminar: Art, Law, & Professional Ethics," and "Exhibition & Interpretation: Theory, Planning, & Design."

> **Fourth term:** "Public, Corporate, & Service," "Exhibition & Interpretation: Practicum," an internship, and a qualifying paper and maintenance of matriculation per term.

A sampling of the FIT course descriptions shows an emphasis on commercial galleries and entrepreneurship. This is missing from most similar offerings at other universities, where, again, courses tend to focus on museum models. FIT's courses also seem to offer what I consider to be a perceptive look forward into how technology will continue to impact the business. Furthermore, its seminars benefit from having the New York art world at its doorsteps, making what it calls explorations of current practices highly credible. Finally, the faculty at FIT seems a bit more heavily weighted with academics than with professors who have actual commercial gallery experience, but the fact that it does include a few puts it a step above many other programs. It's also encouraging, as the art market goes increasingly more global, to see a few faculty members who are educated in countries other than the U.S., but even more diversity there would also be something to consider.

The following is a very short list of other advanced study courses. I present these because of their geographical diversity and because their descriptions indicate that they would give any budding art dealer a solid grounding in the overall concerns of arts management, if not necessarily specific insights into the commercial side of the industry. I recommend that you contact each institution directly to research further whether its program is a good match for your personal business goals.

District of Columbia

- American University master's degree in arts management
 www.american.edu/academic.depts/cas/perarts/academics/artsmgt.htm

Illinois

- Columbia College Chicago master of arts management
 *www.colum.edu/Academics/Graduate_Study/Arts_Ent_and_Media_
 Mgmt/index.php*

New York

- The art business program offered by Sotheby's Institute of Art New York
 www.sothebysinstitute.com/newyork/art-business.html

Ohio

- The Ohio State University master of arts in arts policy and administration
 http://arted.osu.edu/programs/mapa.php

Pennsylvania

- Carnegie Mellon Heinz College master of arts management (MAM)
 *www.heinz.cmu.edu/school-of-public-policy-management/arts-
 management-mam/index.aspx*

Wisconsin

- University of Wisconsin-Madison Bolz Center for Arts Administration
 MBA in arts administration
 www.artsadministration.org/node/214

MYTHS AND TRUTHS ABOUT OPENING
AN ART GALLERY

If you've read this far and you still think it's easy to open and run a successful gallery, that might be my fault. I so love this industry that I tend to romanticize the good parts and downplay the parts that will try the patience of even the most stoic person. (I've had other dealers blame me for encouraging them to risk something they didn't want to because of my exuberance and optimism.) So, before we go on, let me dispel a few popular myths about owning a gallery and reveal a few of the less pleasant truths. I do this not to discourage you from opening your own space, but to help you compare your expectations with the realities of the business.

When it first started to dawn on me that I wanted to open an art gallery, I enthusiastically shared my epiphany with a mentor of mine (a secondary-market dealer on the East Coast). He frankly warned me that I was never likely to become rich by doing so. He had no doubts about my ambition or commitment; he was merely sharing the hard-earned wisdom of his years in the business. Each gallery is different, of

course, but the conventional wisdom is that it takes about three to five years before even the best-run primary-market commercial galleries (without significant connections already supporting them) will begin to see a profit. Many fledgling dealers give up and close before then. Even if a gallery does turn profitable, the art market, like any market that relies on people feeling flush enough to purchase luxury items, is impacted greatly by the psychological mood swings brought on by concerns about the economy.

Further complicating this picture is that when the art market is strong, new galleries pop up like mushrooms to compete for the attention of potential collectors and critics you might have been counting on or courting. Obviously, there is also relentless competition from other already established galleries. Finally, this is a business in which very little is stable. Artists will leave for a bigger gallery once there is finally a market for their work; rent in your neighborhood will skyrocket suddenly, forcing you to find a new location (and consuming all the money that moving requires); and critics will inexplicably hate your latest exhibition, not to mention a whole range of other things you cannot control, which will all impact your bottom line. As I noted earlier, art is something no one *needs*. Selling lots of it, therefore, requires commitment, knowledge, and connections.

And it never really gets easy. A SoHo dealer I know, who still runs a gallery that is in all the history books of twentieth century art in America, recently confided in me that the roller coaster that is a gallery's cash flow situation never ends. Some months you're flush; others, you're scrambling. The bigger your operation becomes, the more expenses will appear to separate you from your income.

It must be noted that a commercial gallery is a small business, not a hobby. In opening one, you will be taking on legal responsibilities and liabilities, and a good chunk of your time as owner will be spent overseeing the rather unglamorous details involved with the business, including insurance, taxes, shipping, utility bills, and payroll. Your artists, employees, and collectors will rightfully expect a great deal from you. There will be days when you wonder what else could possibly go wrong and nights when you wake at 4:00 a.m. in a cold sweat remembering something that absolutely *had* to get done—but didn't. Mistakes will happen. Art may get damaged in transit. Inventory may get misplaced. People who promise to pay you by Tuesday won't. However, if you're not discouraged by any of that, then chances are you may just love every minute of it.

NOTES

1. *Leo Castelli, interview by Paul Cummings,* Smithsonian Archives of American Art, *May 14, 1969.*

2. *Julie Scelfo, "Easing the Pain of Collecting,"* New York Times, *February 28, 2008.*

2

Identity: Defining Your Program
and Other Branding Issues

Because commercial art dealers are assumed to be experts in the types of art they sell, it stands to reason that a dealer would limit the range of art she represents. Knowledgeable collectors might be somewhat skeptical about a gallery that sells sexy video installations by emerging American artists, ancient sculptures from Central Asia, and Old Master paintings from Europe. Perhaps it is not impossible for a program to represent all three effectively, but in addition to sending mixed messages to those seeking specialists to work with or buy from, staying abreast of the latest developments in each field would likely prove more time-consuming than productive. Most art galleries, therefore, have specific programs in order to maximize the advantage of filling a niche in the market that often reflect the unique experiences, connections, and interests of the gallery owner.

Defining your program, however, is only one part of building your gallery's identity. What type of gallery you open and how well suited you are to run it are important distinctions to make early on because they should influence every decision you make in your initial steps, from where to locate your space to how you market your art. In making each of these decisions, you will always want to play to your personal strengths and work to keep your message and strategy consistent. For example, say you are opening a hip, energetic gallery exhibiting "bleeding-edge" art. You probably won't seek out a space on the most quiet, conservative street in the city, nor will you likely have your customers greeted by a stern, matronly

receptionist. (I mean, you *could* . . . that might be über-cool if done the right way, but you might just end up looking like you're trying a bit too hard.) Because matching every aspect of the gallery to your identity is important to your success, it's imperative to think it through before you invest in some of the more expensive parts of getting it up and running.

Ensuring that you've considered the impact of every detail, from how you host your receptions to how you answer the telephone, and how each enhances your identity is time extremely well spent. A clearly communicated identity will not go unnoticed by the collectors, museums, critics, or artists you want to attract. If this is done consistently, each element of your physical space, online presence, and other marketing efforts will work in lucrative harmony. In this chapter, we'll look at the steps you can take early on to nail down your gallery's identity, from writing a mission statement to making coherent branding decisions. We'll also consider the various approaches to re-branding your gallery if the need arises.

CHOOSING A PROGRAM

The term "program" is used somewhat loosely in the gallery world. Generally, it refers to the manner in which you present the artwork you sell to the public. For example, do you put on group exhibitions of art historical importance, do you present an ongoing series of solo exhibitions by the contemporary artists you represent, or do you not present organized exhibitions at all, but rather hang whatever inventory you have on hand? Another use of "program," however, can refer to the specific time period or genre of art that you sell. Are you specializing in Modernist works on paper or pre-twentieth-century American folk art? Do you work only with South American artists? Do you limit your inventory to work that deals with a specific subject matter? The gallery programs that stand to return the most profit often represent the most risky investments, so choosing a program based on what art is currently most profitable may not work out as well as choosing what you personally know best. Matched with the right dealer, any program can be rewarding— intellectually, spiritually, and financially.

But what if you don't know what type of art you are best suited to sell, or you don't like the idea of limiting yourself to a particular genre or time period? What if your only guideline is choosing art that speaks to you, or your only rule is to sell quality art, regardless of time or place of origin? Does it really matter? Not necessarily. Nearly every conceivable rule there has been for running a gallery has been broken by innovative newcomers, often with tremendous success. This is the art business, after all. However, the trend toward specialization seen in nearly every other industry in the world can also be seen increasingly in the art market, and for

the same reasons: expertise is efficient, productive, and profitable. So, it might make sense for you to consider focusing on a particular niche. Once you've made that decision (and again, you're probably always better off playing to your strengths), you can move forward with defining your identity.

As I mentioned in chapter 1, looking at how successful galleries have gone about something can be a helpful part of your education, even in your decision of how to define or discuss your program. To that end, I asked two galleries, the owners of which are members of the Art Dealers Association of America (ADAA), to tell me about their programs. Wendy Olsoff explains the program of New York's P·P·O·W Gallery (founded in New York's East Village in 1983 by Olsoff and Penny Pilkington) as follows.

> *Right before we opened, we received a phone call from arts writer Kim Levin of the* Village Voice. *I was shocked and nervous to be speaking to the press. She asked me to define our 'agenda'. At the time, I was completely taken aback, and twenty-five years later, I still am left speechless by this very question. We recently received an award from Artists in Residence (AIR) for working with women in the arts. In our acceptance speech, I confessed that we never consciously made an effort to show women artists, but sought the best work, which happened to be made by women artists. Over the last quarter century we have been known for showing not only women artists, but also figurative artists, political artists, photographers, and artists of color. The point I am trying to make is that our program evolves as we evolve, and mirrors what is out there and in our heads at the same time. Our artists influence us the most—and that list does change. This might not be the most carefully planned 'agenda' or 'program,' but it has worked for us.*

Andrew Witkin, director of Boston's Barbara Krakow Gallery, defined its program in the following way:

> *Barbara Krakow Gallery is located in Boston, Massachusetts, and exhibits internationally renowned artists and artists from the local community. The work is mainly minimal or conceptually based. The gallery is interested in educating people to trust in what they respond to, helping to be the bridge between the artist and viewer, and attempting to be a shelter for the art of today by giving it a home. While [employees are] committed to the work they present, they make no judgments that what they show is better than any other work out there, but are zealous in at least explaining why they care about this art. They believe respect, honesty, integrity and equality are still relevant to contemporary times.*

Important in both galleries' programs is how they incorporate their values. Also note that the ways they've expressed their ideas about their programs are consistent with their identities: Barbara Krakow Gallery's program is more formal in many ways than P·P·O·W's, and that is reflected in how the directors talk about their respective programs. We will return to these ideas of values and identity consistency as we examine the tools and considerations involved in defining your program.

WRITING A MISSION STATEMENT

The single best step you can take toward defining your identity (or beginning a business at all, actually) is to write a mission statement. What is a mission statement? In a nutshell, it is a succinct set of declarations about your business's intentions and goals. Usually, it is no longer than two or three sentences. A mission statement should clarify what you hope to accomplish by being in business and how you intend to accomplish it. Writing a mission statement will give you a solid yardstick against which to measure how well you're doing at any point in time, as well as what you could do better, what you're doing that perhaps you don't need to, and what else you should be doing. In other words, it provides solid guidance through the myriad decisions that you will face every day.

The generic mission of any business (because it's the path to your own success) is to meet your clients' needs. In a commercial art gallery, however, clients can be interpreted as collectors and as artists (if you're working directly with artists). As a result, you must meet the needs of both in order to achieve your greatest success. Your gallery's mission statement should, therefore, include how you intend to meet the needs of both.

There are plenty of models for the best way to go about writing a business's mission statement, but the most straightforward ones I've seen have four steps:

1. **Identify your clients and products.** Which collectors or artists will you serve? Will you seek them out regionally or internationally? Will you cater to the well-educated collector and established artists or work to educate beginning collectors and what we call "emerging" artists?

2. **Identify the needs that you intend to meet.** With artists, this may include greater exposure in new parts of the world, more connections and resources to keep making their artwork, or simply sales; with collectors, this may include a range of services, from education to collection management, to in-depth curating or, again, simply sales.

3. **Identify your values.** Is community awareness one of your goals? Reviving the interest in arts in your city? Championing a particular point

of view? Building a reputation for integrity or having a "good eye"? Or simply making as much money as you can?

4. **Bring these all together into one succinct statement.** Here, you essentially decide which artists and collectors you are serving, what needs of theirs you are meeting, and how you wish to be seen by both those you are serving and by the community at large.

The following gallery mission statement is fictional. It is provided merely to illustrate how these four components could be consolidated.

Representing regional artists working in a Neo-Mannerist representational style (and including painting, sculpture, and photography), we seek to promote the rich variety of local talent found in [Any State, USA]. Through innovative online marketing, American and European art fairs, and scholarly catalogues and group exhibitions, we seek to place our artists' work in a wide range of international private and museum collections. We also seek to promote the visual arts in our community by contributing to local educational efforts and supporting regional art institutions.

Giving you a dozen examples won't change the fact that writing your gallery's mission statement can be a frustrating task. How can you encapsulate a vision that took you years to develop, or that you expect to expand as you learn, into one short statement? It took me months before I was even remotely satisfied with mine. It took multiple drafts, a wide range of feedback, and some tough soul searching. Once it was done, though, I found it a remarkably effective guide to making virtually every decision about the gallery. In talking with collectors, potential artists, journalists, or even new employees, a well-defined mission statement will enable you to communicate clearly what your goals are, even in the most delicate of situations.

For example, you may meet a new collector who really loves your program and has begun to purchase significant works from your gallery. Things are moving along very well in the dealer-collector relationship until the day she mentions that her nephew, who is in a band, also makes paintings in his spare time. Your collector admits that she is not really sure whether these paintings are any good, but she passionately lobbies you to look at them and should consider giving her nephew an exhibition, anyway. Believe me, it happens.

The details of such scenarios vary, but generally the issues involved are the same. If you don't at least look at the work, you'll potentially offend this new client. If you look at the work but don't want to exhibit it, you'll have to explain why. Clearly, telling this passionate collector that her nephew's work is not very good won't win you any points, but explaining that it doesn't fit your particular mission

will be an argument you can more rationally communicate without hurting anyone's feelings:

> *Thank you for sharing your nephew's work with me, Mrs. Jones.*
> *I enjoyed seeing his paintings. Because my focus is in contemporary repre-*
> *sentational work, though, and his work is abstract, it's not right for our*
> *program. He should be working with a gallery that specializes in abstract*
> *paintings, like 'Gallery X' or 'Y Fine Arts.'*

You may need to get even more specific about why her nephew's work isn't right for you, but if you have carefully defined your mission and have communicated it consistently, Mrs. Jones will recognize the truth of your assessment and will not take your rejection personally.

A well-defined mission statement serves to guide more important business decisions as well. Which museum curators should you get to know? Which art fairs should you participate in or attend? How do you communicate in a way that will encourage journalists to print accurately what your gallery is all about? If you have taken the time to write a solid mission statement, these decisions and statements will come much more easily.

BRANDING DECISIONS

Branding is the art of communicating quickly and succinctly exactly who you are, what your mission is, and the degree of quality the public can expect each time it buys from you. The most common branding tools are logos, symbols, or slogans (the "golden arches," for example, and the "swoosh" symbol immediately convey very precise identities and a perceived level of quality to anyone who sees McDonalds' or Nike's branding), but companies who use branding to its fullest potential leave very little to chance in any of their communications or interactions with the public. Each and every detail of the customer's experience is carefully considered. A consistent branding effort reassures clients that they will receive the same quality of product or service each time they encounter that business. An inconsistent branding effort sends mixed signals, looks sloppy, and undermines your efforts to build confidence and separate yourself from the competition in the minds of potential clients.

Opinions vary about how important—or even desirable—having a well-defined brand is for a commercial art gallery. On the one hand, there are dealers who work only with the artists they feel are important, regardless of whether there are any connecting themes or styles among them, so they may feel it is nonsensical to promote their program as if it were cohesive. There is even a sense among some dealers that notions of branding are too corporate, or antithetical to the independent spirit they

love about the art world. On the other hand, there are dealers for whom a carefully cultivated brand is a natural extension of how they run their business. Even if their programs are diverse, they wish to capitalize on the effectiveness of branding in communicating to clients a constant message. The following discussion assumes that whichever opinion you hold, your decisions about branding will be better informed if you consider its workings in detail. Therefore, the following recommendations come from the point of view that branding is something you should do well if you're going to do it at all.

Because the product an art gallery is selling (i.e., artwork) generally has it own unique identity, most galleries go for a minimal or understated architectural branding within their space, the "white cube" or stately salon being the most common approaches. However, there is a wide range of branding opportunities in any gallery's advertising, logo, letterhead, and Web site, to name just a few. Indeed, from the style of your installations (in your gallery or at art fairs) to the refreshments you serve at your opening receptions, there is no shortage of ways to reinforce your "brand" to the world.

The only "rule" in this part of setting up your gallery is to ensure that your branding is unambiguous in order to maximize its impact and avoid confusing the public. It should be communicated in every aspect of your interactions with clients and the public. Here is a short list of day-to-day ways you can reemphasize your brand. Some of these may seem obvious to anyone who's worked in a company of any size before, but in your gallery, you will also want to see that each of these components reinforces your identity (and, of course, that your identity advances your mission).

How you operate your private viewing room or office. From what you install on the walls to the furniture you have, and from how you welcome your clients to how you answer the telephone, everything you do in your office speaks to your clients about who you are. The more consistent those things are with your identity, the more your clients will trust what you're telling (and selling) them. If you specialize in bleeding-edge artwork, it may be fine to have an energetic (i.e., frantic or messy) office, but if your mission is selling Minimalist art, a busy, salon-style installation in your viewing room probably won't help you much.

Print and visual materials. Maintain consistency in the look and feel of your letterhead, business cards, catalogs, wall text, advertisements, etc. After you choose your logo, make sure that the font you use in letters, catalogs, wall text, labels, etc. is a good complement and always the same. Recognizability is helpful. For example, consider making your mailed invitations so distinctive that your clients know that they are yours just by their shape or texture, even before seeing your logo. A similar look and feel to your catalogues might encourage collectors or institutions you

send them to to group them on their bookshelves, where the catalogs will remind them each time they glance at the spines that your mission is well defined.

Web site. In addition, obviously, to carrying over your logo and chosen font to your Web site, take time to consider how your identity can be strengthened or underlined by it. For example, a big part of my gallery's identity is its dedication to an open dialog about contemporary art. This is reflected on the Web site via a list of "Dialog" links to blogs and artists' Web sites.

Your staff's personal appearance. Although you may want to stop short of issuing uniforms (or maybe not; that's your call), if you're investing heavily in branding the elegance of the high-end traditional art you offer, having clients see torn jeans and running shoes on your receptionist will probably not reinforce your mission. Dress guidelines are commonplace in most work environments and are something you should consider for your gallery, as well.

Installation design. Although the artwork in each exhibition in your gallery will determine the details of the particular installation designed for it (e.g., painting the walls a different color, using wall labels, and setting up special lighting), your decisions here are among the most important parts of how you define your identity to the public. For example, providing a bench for viewers might be an easy way to demonstrate that you encourage them to spend more time contemplating the artwork and to confirm that education is a key part of your mission. Another example of how you can send the right (or wrong) message with your installation design is how warm or cool the tone you choose for your gallery walls is (the industry standard is white). We originally tried a cool, bluish white for our new location in Chelsea, but we found that people were taking the art that we exhibited with humor more seriously than we had intended. When we reverted to the warmer, more yellow white we had used in Brooklyn, we felt the mood lighten significantly with the very first exhibition. And the same goal of underlining your identity consistently should guide how you present your booth at art fairs. For example, some trendy galleries have taken to scribbling artists' names in pencil next to their work at art fairs, which provides a visual cue that conveys their youthful spirit or edgy programming.

Networking and Volunteering. A big part of running a successful art gallery is networking. Where and how you professionally socialize, therefore, can also be one way to underscore your brand identity. If an essential component of your program is education, for example, then participating in panel discussions at area schools or arts councils will not only be putting your time (if not money) where your mouth is, but is very likely to give you opportunities to meet other professionals with similar interests. If getting your artists into regional museums' collections is one of your goals, then joining the museums and mingling with its trustees and curators at private events can signal that supporting the museum is one of your priorities.

Promotions. The promotional efforts commercial art galleries make tend to stop short of trinkets emblazoned with logos or price-slashing holiday sales because art galleries are generally seen as more serious than that. There is an expected decorum that leads dealers to find classier ways to get their names out there. If the identity you're cultivating is one of scholarly expertise, then a keychain flashlight with your Web site URL on it might undercut that message. (Then again, as I have mentioned before, the rules are constantly being effectively broken.) More traditional promotional efforts include participating in a program designed to bring attention to a certain facet of the art world, such as the Asian Contemporary Art Week held annually in New York (*www.acaw.net*). Collaborating in events with other galleries, such as the Paris-Brooklyn Exchange held in 2002—in which ten galleries from the Williamsburg district in Brooklyn exhibited the work of artists from ten galleries in the Marais district of Paris, and vice versa—can grab the attention not only of your collectors but of government officials you may want to befriend, as well.

CHANGING YOUR IDENTITY AND RE-BRANDING

Because art history marches on, partnerships dissolve, interests change, artists leave one gallery to join another, and initial efforts sometime simply fail, you may find yourself (after having spent years promoting a consistent identity) needing to re-brand. It may seem like jumping the gun to discuss that process here, but some of the lessons dealers have learned in re-branding may help you consider how to go about it more thoroughly the first time around.

One of the most common re-branding efforts among dealers is to change a gallery's name that had seemed to capture the essence of why the gallery opened back in the day, but didn't age well or continue to reflect its values as it matured. The name most galleries seem to end up with after such soul-searching is generally the surname of the primary owners or the full name of the sole owner. The following anecdote might help explain why.

I was riding the subway one day and bumped into the director of a well-established gallery from whom I had bought some work before opening my own space. He knew I had since started a gallery in Brooklyn and he apologized for not having made it out to visit yet. He apologized as well for not recalling the name of our gallery. When I told him it was Plus Ultra, he looked surprised. "Plus Ultra?" he said. "I know Plus Ultra. I just didn't know that was you." I spent the rest of the ride wondering how many other people in the art world with whom I had worked hard to network also had never connected the dots and thinking what a waste of marketing potential that represented. Indeed, since I switched to an eponymous gallery name, I have seen a noticeable jump in instant recognition when I introduce myself outside the gallery context.

How to go about a re-branding as drastic as a name change is a matter of some debate. Some dealers I've spoken with recommend following the advice your parents always gave you for taking off an old Band-Aid: do it in one fell swoop. Others will combine the old name with the new name for some transitional period and then gradually fade the old one out. Even though we used this gradual method, it was still about a year after we finally dropped the old name altogether before most of our contacts stopped using it. Whether that reflects human nature or the success of our first branding efforts, I may never know. But if it ever becomes necessary to do it again, I will definitely switch them all at once.

SUMMARY

Nothing will serve you as well in making the right choices to reinforce and make the most of a strong identity than writing a good mission statement. Regardless of how cohesive a brand or identity you want your gallery to have, knowing exactly who your clients are, what their needs are, and how you're best suited to meet them will save you time and money. Making expensive choices without a clear goal is usually akin to throwing money away. Beyond that, having your business meet your vision in terms of making you money, advancing important art, and giving back to the community is much easier to do when that vision is clear and supported by all the decisions you make.

3

Business Models and Customary Practices: The Primary Market

In a document that is downloadable from its Web site, the Art Dealers Association of America (ADAA) outlines the four main categories their members fall into, including 1) primary-market dealers, 2) secondary-market dealers, 3) public and private dealers, and 4) art consultants.[1] Broadly speaking, each category represents a specific aspect of or business model for selling art, although many interpretations of each model exist and there is overlap throughout the industry. Dealers who own public galleries (galleries that are open to the public, as opposed to appointment-only private dealers' spaces) tend to specialize in either the primary or secondary market, but many work in both to some degree.

In addition to such categories, a gallery's business model can be thought of in terms of more detailed decisions and practices, such as how to split sales with living artists (e.g., who gets what percentage), what hours it is open to the public, whether it buys artwork to resell or takes work only on consignment, and business partners (if any) and what role each plays in running the gallery. In this book, I focus on the concerns and practices of public dealers working in the primary market. In this chapter, I'll discuss the standard practices of both primary-market and secondary-market models and what differences exist between them, then I will spend the remainder of this chapter on the primary market. (I'll explain what a new art dealer should know about the secondary market in chapter 4.) Again, significant overlap exists within any given gallery, but what works well in one market may be

irrelevant in the other. Also in this chapter, I'll look briefly at the various legal structures your business can have, discuss what you should consider when talking with your attorney or accountant about choosing one, and highlight what every commercial art dealer should know about the Uniform Commercial Code.

CAVEAT

Although the discussions in this and the following chapters address art as a commodity, it must be noted that there are much easier ways to earn a living than by selling art. It is assumed, therefore (at least by anyone who knows how hard it is to make money as a dealer), that enthusiasm and an understanding of the importance art holds for mankind play a major role in influencing anyone to open an art gallery. Indeed, it is somewhat artificial to discuss business models for selling art as one would models for selling cars or vacuum cleaners. Without a passion for art that your clients can sense, you most likely won't be very successful in getting them to buy from you. Still, with the goal of offering advice as matter-of-factly as possible, the following descriptions are presented from a businessman's point of view. Just bear in mind that profit is only one part of what dealers find important and rewarding about selling art.

PRIMARY VS. SECONDARY MARKETS: AN OVERVIEW

There are two main differences in the typical business models of primary-market versus secondary-market art dealers: a) working directly with the artists whose work you sell and b) buying outright the work you sell. Primary-market dealers today tend to do "a" but not "b." Secondary-market dealers tend to do "b" but not "a." Both represent specific business challenges and opportunities, and which model is best might depend on which of these choices is possible for you or best suited to your personal talents and situation.

The chief business challenge presented by working directly with artists is having two groups of "clients" (artists and collectors) that you're trying to please. This can become complicated when the needs or goals of these clients conflict and leave you stuck between the two. Your artists, in addition to *your* collectors, whom you have every incentive to keep happy, may have other collectors through their other galleries or through their own efforts whom they wish to keep happy. There is only so much artwork available sometimes. Mastering the arts of diplomacy, compromise, and persuasion then becomes an essential part of being a successful middleman (which includes meeting your own needs and goals).

The main business challenge in buying rather than consigning the work you intend to sell, of course, is finding the required capital. For example, an artwork you think you have a client for comes up at auction. You decide to buy it and then

approach the client about its availability, knowing that the opposite order of events might lead to their getting it via other means. However, this requires having the money to outbid everyone else who may want that artwork. Unlike primary-market dealers, secondary-market dealers face such scenarios, which can lead to nerve-wracking situations in which their very livelihood teeters on whether that one major deal goes through.

There are, of course, opportunities and rewards for both models, and I'll discuss those in this and the following chapter. To illustrate how both types of dealers manage the challenges and opportunities of their respective models and to show how some dealers successfully blend the two, I'll compare the shared tools and practices of each.

Shared Business Practices

Despite the differences between the two markets, there are some practices that most public galleries share. Though not every art gallery follows these practices, they are fairly standard across the country. New dealers often bring their own special twists to these practices in efforts to increase sales for and attention to their artists.

Business Hours

Most public commercial art galleries are open Tuesday through Saturday. Whether they open at 10 a.m., 11 a.m., or even noon, most close at 6 p.m. Some younger galleries—especially those in what are sometimes called "alternative" locations—operate on a weekend schedule instead as a strategy for attracting clients when the more mainstream galleries are closed. Friday to Sunday or Friday to Monday is typical. For all galleries, summer hours are highly individual and hard to predict, as many galleries change their schedules from year to year. Some switch to a Monday to Friday schedule, some to a Tuesday to Friday schedule, and others close for months at a time during the warmer weather. Frequent visitors know to check for summer hours on galleries' Web sites or to check their voice mail recordings before venturing out. Galleries also clarify their summer hours on exhibition announcements, press releases, and any publications in which they are listed.

Exhibitions

For the most part, galleries host exhibitions to draw traffic. Some installation-based work may only make sense as a public event, but much of the work in exhibitions could move from an artist's studio or from its previous owner's collection into a new owner's collection without the public ever knowing about it. The reason to put the work on display, given that many (if not most) of the people who stop in to see it will not be potential buyers for it, is to facilitate a dialog about the artwork among

the art-viewing public and to (hopefully) receive critical acclaim. Most living artists highly value the response to their work from exhibitions, and galleries can attract the important new clientele from the press that good exhibitions garner.

The average length of an exhibition tends to be between four and six weeks, with a total of seven to ten exhibitions per year for most galleries. Once it is presented as part of an exhibition, the artwork is generally expected to be on display for the duration of the show, regardless of whether it sells or not. This is especially relevant if the exhibition will be written about in the press during its run (you don't want an important art critic to hear that the piece she described so painstakingly wasn't there when an important museum director who was moved by her review stopped in to see it).

Some exhibitions are designed not so much to sell the work as they are to build the artist's or the gallery's reputation. These "statement" exhibitions fail or succeed based on the buzz they generate (which hopefully, in turn, pays off in other ways), but they still cost as much, if not more, than exhibitions in which the goal is that the work will sell out. As a strategy for building a business, statement exhibitions must be carefully balanced with paying the bills. Many newer dealers have surprised the public, who read nothing but rave reviews of their statement exhibitions, by being forced to close.

Opening Receptions

Regardless of whether they focus on the primary or secondary market, most art galleries will mark the opening of a new exhibition with a reception party. Typically, gallery exhibition announcements include the hours of the reception and whether an RSVP is required. If the exhibition is for a living artist, the reception is typically seen as an opportunity for the gallery's clients to meet her, as well as for her friends and family to celebrate the artist's achievement. Receptions are also designed to put visitors in a festive mood, which helps to facilitate sales of the work.

With creating a festive mood in mind, beverages (and, less commonly, food) are traditionally served at many galleries' openings. How elaborate that service is often ebbs and flows with how strong the art market is, how popular the artist on exhibition is, and whether the reception is private or open to the public. Galleries that host private and then public receptions may not offer any refreshments at all for the latter. Also, if the artwork on display is of a delicate nature, it may not make sense to offer visitors food or drink that might lead to accidents. Occasionally, an art dealer will be ticketed or at least warned by the local police for serving alcoholic drinks without a license or permit to do so. While this is not a frequent problem, it might warrant checking with your local authorities to see what they say about the issue.

Exhibition Information Customs

Frequent visitors to commercial art galleries have come to expect certain types of information to be available for any exhibition, including a checklist with full details of the works in the show; a copy of the exhibition press release (usually one that they can take with them); access to the artist's biography, press clippings, and images of previous work; extra (take away) copies of the announcement card; and someone to answer any additional questions they might have. Art writers may request a press kit for the exhibition, which generally includes copies of the materials noted above and information on how to obtain images for publication should they decide to request them. Other possible sources of information may include brochures or catalogs on the artist, which are often made available for sale, if not given away. Finally, most galleries have available a blank "sign-in" book in which visitors can record their names, impressions, contact information (for the gallery's mailing or e-mail lists), or a message for the artist.

Selling Work Out of an Exhibition

Public commercial art galleries sell work in several contexts (directly out of artist's studios, from their back rooms, at art fairs, via commissions, etc.), but when the work in an exhibition is for sale, there are certain customs and legal requirements for indicating to the public what is available and how much it costs. An exhibition checklist may or may not also serve as a price list in some galleries, which makes it difficult for the casual visitor to know if a work they see is one they can buy. It should be noted that there are plenty of reasons a gallery would exhibit work that is genuinely not for sale (a status often designated on an exhibition price list with the acronym "NFS"). For example, the work is sometimes borrowed from someone who ultimately wants it back, but for historical or conceptual reasons it's essential to the exhibition as a whole. In such cases, it is customary (and may be required by the loan agreement) to indicate on the checklist that the work is being shown courtesy of that owner.

Not distributing prices or indicating which works are available on the public checklist is controversial. Most galleries that do this will produce a checklist with prices upon request, and in some locales it is against the law to not have the prices posted conspicuously (although how often such laws are enforced varies). Two concerns among dealers lead many to make their prices difficult to learn. The first is that the artwork they have is so expensive that listing prices might encourage theft, and that since they can't afford guards, they would need to open by appointment only. The second gets to the heart of why the practice is contentious. Some critics of the practice assert that it enables unscrupulous dealers to charge whatever they think the

prospective buyer will pay, but the real objective is actually controversial enough: most dealers simply wish to control where the work they're selling is placed. If a museum or other influential collection has expressed interest in the work in the past, for example, a dealer may want to put off any other potential buyers until the institution has the opportunity to see the work and make a decision. Gallery visitors complain that by not making the art's availability or prices readily accessible, dealers get the chance to "size up" anyone who makes an inquiry (the implication is that they will lie about the work's availability if they don't feel the work should be sold to this person). I must admit that I understand why dealers would do this, but it's a good idea to check with your local department of consumer affairs to ensure that your gallery complies with the law on all these issues.

Another price list custom, one that seems to have become passé in certain galleries lately, is to indicate which works in the exhibition have been sold already with a largish red dot. Half a red dot (or, in some spaces, a dot of a different color) indicates that the work is on reserve. Depending on whom you ask, the custom is considered either charming or tacky. Lately the word "SOLD" has replaced the red dot in many spaces. This at least has the advantage of being clear to everyone.

Maintaining Mailing Lists
Other than intuition and interpersonal relationships (and, of course, access to art), the single most important asset an art dealer has is probably her mailing list. As regular mail increasingly gives way to e-mail, what someone means by "Please put me on your mailing list" may need to be clarified, but because e-mailed messages still can't make the same impact that a strong piece with a good visual in a client's hands can, most galleries still invest quite a bit of time and effort in maintaining both lists. Most e-mail programs include powerful tools for adding, grouping, and editing e-mail addresses and other information about your contacts. However, there are database systems designed specifically for art galleries that help you do that and more with all the information you may want to store, retrieve, and categorize about your contacts and the art they have bought from you or are potentially interested in buying.

One of the most popular of such programs is GalleryPro by Artsystems (www.artsystems.com). GalleryPro is a top of the line management system whose function is to integrate contacts' information with the gallery's transaction records, shipping records, statistics, etc. As such, it has a top-of-the-line price, which is why some galleries develop their own management systems in database programs like FileMaker Pro or Microsoft Access. Usually, these homegrown systems don't have the sophisticated integration and one-stop management capabilities of a system like GalleryPro and require some supplemental manual work in order to deliver the same kind of results, but then again, many galleries may never use all of the

functions that the high-end software offers. Still other galleries manage to get by with a combination of simple spreadsheet software (like Microsoft Excel) and a good, old-fashioned filing system of printed documents, but such manual management is not scalable and may end up limiting how quickly a gallery can grow.

Managing Inventory

One of the first full-time staff positions a gallery generally fills as the business grows (or as the job becomes impossible for the owner to try to keep doing himself) is that of registrar. This staff member is in charge of recording all of the artwork that comes in and goes out of the gallery. In medium to large galleries, that will not include the actual shipping of, or even the coordination of the shipping of, the artwork—only the actual recording of the fact that new objects arrived or left the gallery, including their condition and any special instructions for their installation or care. (I'll discuss this job position and its other possible responsibilities in more detail in chapter 10.) As with maintaining mailing lists, the Artsystems GalleryPro software is designed to make maintaining your inventory more manageable. Keeping accurate records of each work's provenance, condition, and insurance or retail appraised values, as well as expenses associated with framing or shipping, etc., makes providing essential information and services to both artists and collectors easier. This in turn makes for much happier clients of both kinds. In addition, when it comes time for an artist's *catalogue raisonné* to be compiled, such records will prove invaluable.

OVERVIEW OF THE PRIMARY MARKET

Primary-market dealers sell artwork for the first time, as opposed to reselling it, which is what secondary-market dealers do. Generally, this means that primary-market dealers sell the work of living artists and often work directly with those artists to develop a market for their work and help promote their careers. The thrill of being "in the trenches" as art history is being made can be both highly gratifying and frequently frustrating, as any primary-market dealer or artist can tell you. As in any relationship, trust is essential to ensuring that both parties can achieve their respective goals. (I'll discuss how to find the artists you'll work with as well as how to manage the artist-dealer relationship in more detail in chapter 14.) For the purpose of understanding the primary-market business model, though, it's important to keep in mind that working with living artists who are putting themselves out there in a very courageous way by exhibiting their art requires more personal involvement on the part of the dealer than would merely selling a product.

Many in the art world would argue that the single most important key to being a successful primary-market dealer is to have a "good eye." This means being good at recognizing significant artwork when you see it. Successful primary-market

dealers are also good at predicting which direction the market will head in. Combined, these talents equal being ahead of the competition in terms of finding and working with living artists whose work will be seen as importance or highly sought after.

Other vital characteristics for a primary-market dealer are being a good listener and being a good teacher. Unlike secondary-market dealers (in the secondary market, the target audience often already knows the historical importance of the artists you represent), primary-market dealers frequently start from scratch in understanding what the artist is doing (something that is done via studio visits and discussions with the artist) and then communicate that information to the rest of the world. With work that pushes the envelope in some fashion, this can also require creating a context in which important collectors, critics, and curators trust that you know what you're doing.

The same is true of artists you want to work with. Having a reputation as a dealer artists can trust (because of your ethics as well as the context you've created) plays a huge role in getting them to work with you as opposed to your competition. Trust is often easier, though, when the details of a relationship are carefully considered, fair, and clearly set out beforehand. That trust also comes from successfully promoting your artist's work. To that end, below I briefly outline the tools and practices primary-market dealers use to help manage their relationships with artists and to build their artists' careers, including consignment agreements, representation contracts, standard promotional strategies, sharing artists with other galleries, pricing artists' work, and protecting their artists' market. I should note here that I am offering most of the following observations with the assumption that as a primary-market dealer you will represent a set roster (or stable) of artists, but on occasion work with artists to whom you don't offer representation. Neither of those assumptions is a very safe one, however, as no particular model is necessarily better than any other. What works best for you and your artists is always the right path to choose.

Consignment Agreements

Although there are exceptions, most primary-market dealers today do not buy the work that they intend to sell from artists. Instead, they have consignment agreements with their artists, which means they have contracts (sometimes verbally stated, but preferably written [and, in many jurisdictions, legally binding regardless]) that state that payment for the artwork is only made once it has been sold. If the work is not sold within the agreed-upon duration of the consignment, the artwork may be returned to the artist or the agreement may be extended.

This was not always common practice, though. The legendary Parisian art dealer Daniel-Henry Kahnweiler would first buy out all the paintings from the

studios of Picasso, Braque, and other notable Modernists and then proceed to sell them. Kahnweiler's older and arguably more ambitious rival, Ambroise Vollard, was considered by some a "shrewd" businessman for buying in bulk at a low price and then selling high for considerable profit. Whether this benefited Vollard more than it did the artists depended on how successful he was in building a market for their work.

As they have evolved and are used today, consignment agreements have advantages for both artists and dealers, which is probably why they are the current standard. Artists who are struggling to get by and would be happy to have their studio inventory bought outright may not agree with this statement, but artists with established careers can benefit greatly from the flexibility and control that consignment agreements provide. One of the stories that Malcolm Goldstein tells in his history of American art dealers, *Landscape with Figures*, illustrates clearly how artists' careers can be damaged when a dealer owns too much of an artist's work.

The art dealer Samuel M. Kootz worked with important American Abstract Expressionists and European Modernists. He was successful overall, but he could not sell the works of two artists from whom he had bought over 100 works combined. The two were accomplished artists, but in 1951, Kootz stopped working with them and then tried to unload his inventory of their work in a sale at his gallery. When that failed, he offered his stock to Gimbel's department store, which marketed and sold the pictures as little more than common household goods. As Goldstein noted, "The bargain prices at which they were offered drastically undercut the value of all work by the artists, wherever it might be found, and threatened their market in perpetuity."[2]

Both of his former artists were hit hard by this—one suffered a heart attack shortly thereafter. Neither artist's market recovered until after their respective deaths. Kootz may have suffered a few whispered grumbles in response to his highly unethical behavior, but the law would have been on his side had the artists sought damages. The property was his to do with as he saw fit.

Today, primary-market art dealers rarely buy that much of an artist's work. Should one of your artists ask why you don't, it's fair enough to explain that you can't afford to, but the Kootz story can go a long way toward helping them understand that it wouldn't necessarily be in their best interests and that a consignment agreement is designed to serve them as well as you. Below, we'll discuss options for supporting your artists other than buying up all their work.

It is recommended that you have your lawyer draft a generic consignment agreement that you can use for each artist, if not one with specific terms for each situation, in order to ensure that you are complying with the law and that your own interests are safeguarded. You should encourage your artists to consider having their

lawyers go over the agreement as well before they sign. Many struggling artists do not have lawyers or the funds to hire them, but you can steer them toward Lawyers for the Arts (also known in some states as the Volunteer Lawyers for the Arts [VLA]), where they can receive pro bono assistance in reviewing the terms. Each state's VLA generally has its own individual Web site; the New York chapter's Web site is *www.vlany.org.*

A more detailed discussion about consignment agreements and the laws that govern them appears in chapter 14, but in short, most primary-market dealers split the money from sales 50/50 with artists. There are few notable exceptions to this custom, and when the percentages vary (ranging from 60 percent to 70 percent going to the artist), it usually reveals either a significantly lower overhead for that gallery (more typical outside major cities) or a philosophical stand. It may also reveal that an individual artist's market is so incredibly strong that she can command whatever percentage she wants.

Admittedly, 50 percent may seem like a high percentage for dealers to take (it certainly does to many younger artists) until you consider how much it costs to build and promote a market for an unknown artist. Some dealers will renegotiate the split after an artist begins to consistently bring in more money than the promotion of his work is costing the gallery (and personally, I feel that is fair and good business), but other dealers would rather offer artists at that stage of their careers help with production costs or other expenses and keep the split at 50/50 as a symbol that they are equals in the partnership.

Representation Contracts

Many primary-market dealers today delineate between "consignment agreements" and "representation contracts" in their discussions with artists. While the law considers any dealer who takes work on consignment to be that artist's agent so that the entire relationship between dealers and artists can be defined with consignment agreements, the term "representation" has evolved to imply an agreement to commit to one another indefinitely or for a period that transcends the typical consignment duration. Generally, until an artist and a dealer agree to go forward with representation, each consignment agreement may be the artist's last. With representation, the understanding is that the relationship will continue far into the future, independent of what work is on consignment or not at any given time. Representation, then, is a commitment to work with and nurture the artist's career independent of where their studio practice takes them or how their work develops. In other words, consignment agreements dictate the terms of selling individual works of art, whereas representation is about a commitment to the artist-dealer relationship. With this long-term commitment on the part of the

gallery to the artist's career comes the expectation that the artist will agree and live up to certain terms for access to future work and sales, such as not selling future work out of his studio to collectors who learned about his work through the gallery.

Representation contracts make such commitments legally binding for a set period of time (generally five-year intervals). Their terms generally outline in great detail what the gallery is offering (exhibitions, catalogs, advertising, clerical support, archiving, etc.) in exchange for exclusive access to or at least significant control of an artist's sales during that time. This degree of control is the contracts' most controversial component and the reason why, despite how much money can now be involved in the selling of contemporary artists' work, many primary-market dealers and artists still shy away from the idea of signing representation contracts. Such reasons may not sound very practical to people in other businesses, but the avoidance of them is widespread enough throughout the industry to reflect a strong and enduring preference to continue in the more casual style of working together. I'll admit that I don't use representation contracts, or even like the idea of them. That's mostly because I don't like the idea of either of us (me or the artist) being locked into an arrangement.

Not only do representation contracts add an additional expense (lawyer fees) and introduce an anxiety-provoking element into the start of any new relationship, but among younger artists I know who have signed them, contracts often become scapegoats for otherwise perfectly normal points of disagreement with their galleries. The contract takes on a significance greater than that of a legal agreement for many (imagined or not, artists report a feeling that the gallery is taking advantage of them by locking them into the contract terms). Resentment, rather than trust, seems to build as many relationships based on representation contracts progress.

Having said all that, however, the times, they are a-changing. When hundreds of thousands of dollars are at stake for an established artist's work, when it can take a dealer five or more years or to build a stable market for an emerging artist's work, or when the notion of loyalty seems to make less and less sense for both artists and dealers in the increasingly globalized market, representation contracts may begin to see a surge in popularity. While there are many standardized versions of other contracts an artist may need in her career (one great source is *Business and Legal Forms for Fine Artists* by Tad Crawford [Allworth Press, 2005]), sample representation contracts are hard to find. Perhaps that is due to their complexity, which makes any template too conditional to work through easily. Even more than consignment agreements, representation contracts should be written, or at least reviewed, by an attorney to ensure that they are in compliance with the law and that your own interests are safeguarded.

Regardless of whether you and your artists opt for a contract, the same topics should be discussed in detail before you both agree to representation. The New York Foundation for the Arts (NYFA) offers a thorough list on its Web site (*www.nyfa.org*) of which topics are important for artists to cover in representation contracts. Among the more common areas for negotiation are the duration of the contract, which may be contingent on sales; who pays for shipping, framing, storage, and insurance of the artwork; how much artistic control the gallery has over installations; whether the artist has any say in who purchases the work; what type of financial assistance the gallery may provide the artist; and how often the artist's work will be exhibited in the gallery.

Standard Promotional Strategies

Chapter 12 is devoted to promoting your gallery as a whole, but here, I'll outline some strategies that primary-market dealers use to promote individual artists. All of the ways that dealers work to promote the artists they represent are ripe for innovation. With hundreds of galleries currently following most of these same strategies, dealers who invent something new will be the ones who get all the attention for their artists. Still, the artists you wish to work with will likely expect certain traditional practices as part of their representation.

High on most artists' priority lists among the traditional practices are regularly scheduled solo exhibitions. How frequently you offer each artist one will vary based on the size of your stable, how many exhibitions you squeeze in each year, and how often you feel it makes sense for an artist to have one, but on average, primary-market galleries offer solo exhibitions every 1.5 to 3 years for each artist they represent.

Keeping the interested parties content about the pacing of solo exhibitions can be quite the juggling act. If an artist has multiple galleries pressuring him to generate more work, he may be more than content to have fewer solo exhibitions. On the other hand, an artist may view what he perceives as an inordinately long gap between solo exhibitions as a sign of dwindling faith or interest on the part of his dealer. Collectors will also wish to see regularly scheduled exhibitions of the artists whose work they have purchased from you. Further complicating the decision-making process is your responsibility to ensure that your exhibition schedule has an attractive (and financially sound) rhythm to it.

Another promotional strategy that primary-market dealers utilize is the private studio visit. Taking clients for exclusive calls in an artist's workspace not only assists with sales, but also helps to build a bond between you and your collectors and artists. Even though many clients will enjoy the authenticity of a behind-the-scenes peek at how your artist really works, you must ensure their

comfort and safety by discussing it with your artist beforehand. Deciding how best to conduct your studio visits with clients will take a bit of trial and error, no doubt, and will reflect your personal style, but many dealers choose to let the artist discuss the work and then later, privately, discuss prices and availability in some other context.

Art fairs are increasingly becoming an important promotional strategy for primary-market dealers. I'll discuss the ins and outs of art fairs extensively in chapter 13, but here it makes sense to note that solo installations at fairs have proliferated so much of late that artists may soon begin expecting their galleries to offer that form of high-profile exposure as part of representation. Few dealers will present a solo booth at each fair in which they participate (they present a significant risk, given how expensive fairs are), but the popularity of them at fairs is due in part to their ability to offer a stronger context for an artist's work than the more conventional group installation.

Primary-market dealers disagree as to whether publishing catalogues for individual artists is a good use of gallery resources. Because collectors and curators often request catalogues of artists in whom they are interested, a gallery's inability to offer one can suggest that this artist is not well established or renowned. On the other hand, catalogues produced in conjunction with an exhibition at a respected institution are prestigious, and it may be wiser for a gallery to focus its resources on sponsoring such efforts and ensuring that the institution can produce as high quality a catalogue as possible. Distributors of catalogues tend to favor institutionally sponsored publications over gallery-produced ones, as well. Still, when an artist reaches a point in his career at which not having a catalogue would limit important opportunities, it is wise to invest in producing one.

Perhaps the ultimate promotional activity you can work toward for your artist is an exhibition hosted by a museum or other institution. Openly describing any work you do toward securing one as a promotional strategy, however, can put you in an awkward position with the institution's curators and directors, who are loath to have their scholarly work tinged by commercial concerns. Still, the truth of the matter is that art dealers work hard to promote their artists to and network with those in decision-making positions at such institutions precisely because such exhibitions lend credibility and prestige to their artists' careers, which can help sales. (OK, so that assertion is perhaps a touch jaded; dealers are also incredibly proud of their artists who receive institutional attention.) Institutions are used to dealing with all degrees of overprotective or meddlesome dealers, but it still warrants noting here that a dealer's role in any artist's exhibition at such a venue is to support her artist professionally and provide the institution with whatever tools they need to produce the best exhibition and supplemental materials possible. In other words, let them ask

you for what they need. Injecting your own objectives into the process, as tempting as that may seem, is inappropriate and can reflect poorly on your artists.

Pricing Your Artists' Work

If you buy the work outright from your artists, you can price it for resale at whatever you feel is appropriate. When consigning work, however, the decision on pricing (unless otherwise specified in a contract) ultimately falls to the person who owns it, and that is the artist. But that doesn't mean you have no input. Just because an artist feels that a piece should cost $100,000 doesn't mean that you could ever get that much for it or that your own reputation wouldn't suffer considerably for offering it at such a price. A big part of the diplomacy of working with a living artist is getting her opinion on what you feel is the right price for her work. Fortunately, many artists are only too happy to listen to their dealer's advice about pricing.

In setting the price for a work, therefore, you must take into account the artist's estimation but should also be guided by previous prices (that is, whether there is already an established market for the work) and industry norms for artists of similar stature. In addition, issues of size, quality, and materials must be considered. Another factor that can determine price, of course, is the law of supply and demand. If an artist has a waiting list for her work, a dealer can rightfully increase her prices. Taking a very long-term view on such decisions is critical, as I'll discuss in the section below on protecting your artists' markets. "Killing the goose that lays the golden egg" analogies aside, you have obligations in making pricing decisions beneficial to both your artists and your collectors.

Although there are no hard-and-fast rules in the industry, and although other dealers will mostly defer to your judgment when consigning or buying work from you or sending their clients to you for work you deal in, your overall reputation will be influenced by whether you are seen as knowing what you're doing when it comes to pricing. Therefore, it makes sense to be familiar with and to always consider industry norms when setting your prices. Some norms are based simply on common sense (such as, all else being equal, an editioned piece being priced lower as the edition size goes higher, and vice versa), whereas other norms are based on age-old prejudices about medium (such as a drawing by an unknown artist being, generally speaking, at least half the price of one of his paintings of the same size). A good, quick way to come up to speed on pricing norms in the primary market is to walk around an art fair and make inquiries. So long as your questions are good-natured and honest, you'll generally receive the information you're looking for.

As in any industry, offering your clients competitive prices for similar products can work as a strategy for gaining market share. Until there is a demand for your artists' work, it generally makes sense to keep their prices as low as you reasonably

can. Whether it's possible to harm an artist's market by pricing work too low is a question you'll hear more from artists than from collectors, of course, and there may be some truth in the notion that true value is tied to perception of value, but personally, I feel it's better to let actual demand drive prices up. Experienced collectors have a very good sense for when prices are artificially inflated.

Sharing Artists with Other Galleries

One of the most challenging aspects that primary-market dealers face in working with living artists seems to be sharing them with other galleries. I happen to subscribe to the philosophy that it is better to collaborate to increase the overall size of an artist's market than it is to expend energy and time trying to protect your small slice of it. There are significant considerations involved, of course, not the least of which is balancing what's best for your artist's career with what's best for your business, but by seeming to overprotect or dissuade an artist from working with other dealers, you stand to undermine your relationship, anyway. As in all such matters, being a good listener (to hear what your artist's goals are) and a good negotiator (to ensure that you attain the best arrangement you can with other dealers) go hand in hand with being straightforward and aboveboard with all parties involved. It can be tricky enough to satisfy everyone without having questions about integrity enter the equation.

Among the many details to figure out when other galleries work with your artists, two stand out as the most problematic: 1) who gets access to which work and 2) which, if either, gallery serves as the artist's primary gallery. Typically, an artist's first gallery—the gallery that "discovered" him—tends to feel entitled to wield more influence in these matters, but it doesn't always work out that way. The devil lurks in every imaginable detail involved here.

The issue of access to an artist's work is complicated by location and context. Although shipping costs can legitimately influence which gallery it makes the most sense to have sell the larger (read: more expensive) works, balancing the highest quality and highest priced work among an artists' galleries can eliminate unproductive resentments. Context, on the other hand, is perhaps a more polite way of referring to which gallery is more prestigious, gets more traffic, and participates in the better art fairs. An artist may wish for his best work to be seen in the best context. While this is understandable, a constant supply of clearly minor works may lead the other galleries to reevaluate how committed they are to the artist. Supporting your artist's need to supply all his galleries with first-rate work is simply one part of building as large a market for him as possible.

The term "primary gallery" here does not refer to the primary (versus the secondary) art market but to the gallery primarily responsible for an artist's career—that

is, the number one gallery in a declared hierarchy. Galleries in higher-rent locations tend to feel entitled to serve as artists' primary galleries, even when they are not the first gallery with which the artist works. The bad blood between galleries that this negotiation can cause is legendary. The reasons it can be so treacherous are that it is often seen as a matter of respect, and, of course, it involves money. For the additional exposure primary galleries supposedly offer as well as the additional services they provide (such as maintaining the artist's master archive), an artist's primary gallery often requires his other galleries to pay it a commission (usually 10 percent of the retail value) on all sales, which gets to the heart of the pervasiveness of primary gallery designation power struggles. Again, balancing the artist's best interest with your gallery's interest in such situations is much easier if you keep your eye on the ultimate prize: building your artist's market.

Protecting Your Artists' Markets

Another tricky part of being a primary-market dealer is protecting the markets you've so carefully built for your artists. That does not mean price-fixing or anything illegal, just practical business decisions designed to ensure that you conscientiously build a market based on solid, credible pricing and never lose sight of the fact that all markets fluctuate. The art world has more than a few artists whose prices were permitted to rise too quickly, who now find themselves unable to lower their current prices without upsetting collectors already in possession of their work and no one else willing to pay what are now considered inflated prices for their latest work. There is no way around it, and usually, the artists' dealers are to blame for this. An artist may insist on inflated prices, even to the point of threatening to leave the gallery, but a dealer, charged with the task of looking out for her collectors and her artist, should never sell a work at a price that she knows doesn't offer solid value, since this may end up undermining the artist's market.

Most of the public drama surrounding over inflated prices plays itself out at the only truly public forum for observing the workings of the art market: auctions. Because what can happen at auctions is highly unpredictable, and because most primary-market dealers generally prefer to buy work back that clients wish to sell and then carefully place it again, dealers can become very anxious when clients take their artists' work to auction.

The anxiety stems mostly from how the public may interpret the auction results: often without taking into account the quality, condition, and provenance of the piece. If a piece sells at auction for a great deal above its high estimate, for example, it can create the false impression that all of the artist's work will fetch that much and initiate a sense among other collectors who were wondering whether to sell that now is the right time. If a piece fails to sell at auction, potential buyers may take it

as a signal that the artist's work is overpriced across the board. Communicating how to interpret the auction results to all of her collectors can present a huge challenge for the artist's dealer.

One way that some primary-market dealers have attempted to avoid this challenge is by encouraging their collectors to bring back any art they wish to sell to the gallery first. Some dealers have gone so far as to make "right of first refusal" for resale one of the conditions of their initial sale to a client. Although this is a controversial practice, most dealers I know who use it truly are looking out for their artists' best interests.

Two other ways that primary-market dealers try to protect their artists' markets are being conscious about the context their work is seen in and avoiding overexposure. Context, as noted above, is code for the perceived quality of where the work might be seen, whether it is in another gallery, an institution, an art fair, or what might be considered a "nonserious" venue (i.e., an exhibition in a restaurant or as a backdrop for some form of entertainment), and it is a legitimate concern. There is no easy way to advise your artists about such matters, other than to earn their trust and be honest about your reservations when you have them. Younger artists especially may be so happy to be exhibiting somewhere that they don't see how certain contexts impact the perceived value of their work. Likewise, some dealers' concerns about "overexposure" are merely code for "I wish you had given me that piece to sell." Then again, in a market where rarity is one of the criteria for determining pricing, it doesn't necessarily benefit an artist for collectors to feel they have plenty of time to make a buying decision because there is plenty of work available.

LEGAL CONSIDERATIONS: OWNERSHIP STRUCTURE AND THE UNIFORM COMMERCIAL CODE

The Small Business Administration (SBA) recommends that you think through the following factors in determining which legal structure is right for your business.

- Your vision regarding the size and nature of your business

- The level of control you wish to have

- The level of structure you are willing to deal with

- The business's vulnerability to lawsuits

- Tax implications of the different ownership structures

- Expected profit (or loss) of the business

- Whether or not you need to reinvest earnings into the business

- Your need for access to cash out of the business for yourself [3]

It's impossible for anyone to recommend one structure over another for you without knowing how you would respond to the issues above as well as having knowledge about the laws and standards in your location. The three main choices for business structure, each of which I have seen used for a commercial art gallery, are as follows.

- **Sole Proprietorship:** This is the most common form of business ownership, especially among small businesses (because it is easy to set up and easy to dissolve, and the owner retains all profits), but not for commercial art galleries. This is perhaps because of the unlimited financial liability and the more limited ability to secure financing from outside sources.

- **Partnership:** This includes the limited liability partnership, which seems to be a common choice for commercial art galleries. Like sole proprietorships, partnerships can be easy to set up but are much more difficult to dissolve. In addition, partnerships are vulnerable to interpersonal conflicts.

- **Corporations:** This structure, while more complicated and potentially more expensive (earnings can be taxed twice: once as corporate profit and again as personal dividend), has the benefit of separating assets and liabilities of the business from those of the owner. Corporations include limited liability companies (LLC) and, more recently, subchapter S corporations (or S corporations). This last form of business ownership, the S corporation, has become a popular choice for art galleries because it lets them pay taxes like a partnership but keep the limited liability of a corporation. To qualify for this structure, however, certain requirements must be met, so check with your accountant or attorney before making your decision.

You can find detailed descriptions of each form of legal ownership for small businesses, as well as a discussion of their advantages and disadvantages, on the SBA Web site at *www.sba.gov/smallbusinessplanner/start/chooseastructure/START_ FORMS_OWNERSHIP.html.*

Even though you could do much of the work in setting up the form of business ownership for your gallery, having your accountant or attorney do it is highly recommended. Whether it's best to work with both or just with your accountant may come down to whether you have any partners and, therefore, should consider signing operating agreements before you start. If you choose to make your business a sole proprietorship or corporation, your accountant can possibly do it all for you, and probably for less money than it would cost to hire both an accountant and an

attorney. On the other hand, making sure that any operations agreement you're using carefully addresses all the legal and tax ramifications of not only getting set up but also of later dissolving the company is not something you should do without your lawyer's expert assistance.

State laws governing sales, warranties, and payment via paper-negotiable instruments (such as a check) may vary in certain details, but throughout the U.S., an overarching "model law" known as the Uniform Commercial Code (UCC) forms the basis of most business law. The goal of creating the UCC was to have some uniformity among the states that adopt its provisions. What's important to know about the UCC when running a commercial art gallery (that is, what's important to understand about the laws governing your business transactions) is that in general, most states require a written agreement for any sale over $500. Furthermore, just because you don't specify certain terms in your agreement doesn't mean that a court, using the state laws based on the UCC, won't decide that you are bound by certain customs and standards, anyway. If you're seeking a cursory introduction, I'll note that the Cornell University Law School has an online version of the UCC (*www.law.cornell.edu/ucc/ucc.table.html*), but for answers to questions about the subtleties of business law in your state, consulting your attorney is well worth the expense. For more information, see *The Artist-Gallery Partnership*,[4] which is a highly accessible book devoted to the UCC as it applies to galleries, and *The Law (in Plain English®) for Galleries*. [5]

SUMMARY

As noted in the brief history of art dealing in chapter 1, some art dealers have no interest in working with living artists. Not only is working in the trenches of art history a risky venture, but keeping two sets of clients happy is obviously more difficult than satisfying only one. But the same passion for art that compels many people to work in the industry makes them natural allies for the men and women who create that art. Despite all the caricatures of greedy dealers taking advantage of a powerless artists, most primary-market dealers I know got into the business out of a sincere love for working with and supporting artists. Such relationships carry with them legal and ethical responsibilities, however, and should not be entered into casually.

NOTES

1. *Art Dealers Association of America*, "ADAA: Collectors' Guide," *http://www.artdealers.org/ collectorsguide.html (accessed March 2008)*.

2. *Malcolm Goldstein*, Landscape with Figures: A History of Art Dealing in the United States *(Oxford, England: Oxford University Press, 2000), 244–245*.

3. *Small Business Administration, "Small Business Administration - Choose a Structure," http://www.sba.gov/smallbusinessplanner/start/chooseastructure/START_FORMS_OWNERSHIP.html (accessed July 2008).*

4. *Tad Crawford and Susan Mellon,* The Artist-Gallery Partnership: A Practical Guide to Consigning Art, *3rd ed. (New York: Allworth Press, 2008).*

5. *Leonard DuBoff,* The Law (in Plain English®) for Galleries *(New York: Allworth Press, 1999).*

4

The Secondary Market

Selling artwork in the secondary market is easier than selling it in the primary market in one significant way: generally, the work you're selling is understood to be important (otherwise, why would it have sold in the first place?). Other than that, however, the secondary market is one that demands the kind of expertise that only comes with years of experience. In this chapter, I'll discuss the secondary market in terms of what a beginning primary-market dealer should know about it. To highlight the ways in which it differs from the primary market, I'll follow the same general topics I did in the previous chapter, including finding inventory, using consignment agreements, pricing the art, using promotional strategies, and protecting your markets. Throughout this chapter, I will rely heavily on interviews with two dealers I know who have much more experience in the secondary market than I have.

OVERVIEW

Secondary-market dealers resell artwork that has already been part of a collection. For the most part, this means they resell the work of artists who have either passed away or who have careers that are well established enough that dealers other than the ones who represent them might have clients for their work. It also means secondary-market dealers often buy and sell artwork of great historical importance, often for considerable sums, and often to buyers who expect expertise and exceptional service for their money. What secondary-market dealers miss by not being "in

the trenches" with contemporary artists, they more than make up for in the thrill of working often with extremely rare, important work in a highly competitive market.

Other than not usually working directly with artists, the major difference between the business models of primary- and secondary-market galleries is that operating a secondary-market gallery generally requires a great deal more capital. As noted in chapter 3, this is because the secondary-market model tends to involve buying rather than consigning inventory. Although consignment agreements are not uncommon in the secondary market, it can sometimes take years to place a piece, and many consignors may not be that patient. Also, much of the work you may wish to resell as a secondary-market dealer will have to be purchased outright or lost to a competitor.

Again, because my personal background is predominantly in the primary market, and because the goal of this discussion is to offer a meaningful comparison and contrast of the two models for the new primary-market dealer, much of the following discussion is based on interviews I have conducted with two art dealers who have extensive experience in both the primary and secondary art markets. Jeff Bailey is owner and director of New York's Jeff Bailey Gallery (*www.baileygallery.com*). Before opening his own contemporary, primary-market gallery in 2003, Bailey worked for one of New York's premier secondary-market dealers, who sells everything from Old Master to Modern works. As Bailey explains, "In the owner's office at any given time, there could be a Baroque picture, a Courbet, a Cornell box, a Tanguy, a Rothko. . . . It just depended on the time, what he found to buy and hopefully resell, or what was consigned to him."

The other dealer I interviewed is Pavel Zoubok, who began his business in New York in 1997. Focused on the field of collage, assemblage, and mixed media installation, Pavel Zoubok Gallery (*www.pavelzoubok.com*) is one of the world's few galleries that have seamlessly integrated both primary- and secondary-market practices into a single business model that simultaneously promotes both contemporary and historically important artwork. This hybrid of the two models evolved somewhat organically, as Zoubok explains: "Almost within the first year and a half of making shows, where I was really representing artists or showing works from estates, I was also starting to get consignments from people. For example, one of the first expensive things that I sold was a unique drawing by Duchamp. So I got a taste for it very early on, but it was always connected in one way or another to what I was doing in the primary market."

The essence of the secondary art market is perhaps best described by an observation attributed to legendary art dealer Joseph Duveen that some people have art and others have money. Connecting the dots between the two types, of course, is where the hard work comes in. Unlike primary-market dealers who are tasked with making the argument that their artists' work is important and often building their markets from

scratch, secondary-market dealers work for clients who often know exactly what they are looking for. Whether it's a specific piece needed to fill a gap in a collection or the very best examples of certain types of work as it comes back on the market, the art-work customers want can be very specific. Being the dealer who can secure that work for them is a big part of being successful in this market. Another part, however, is anticipating what they might want but don't yet realize or seeing an opportunity to create desire where not much currently exists. For this reason, some secondary-market dealers will work to buy up all the available work by an artist who they feel is under-valued or due for a resurgence in popularity. The fact that you are attempting to corner the market will get around, though, which can be a plus (other dealers with such work in their inventory make it known that they'll sell it to you) or a minus (other dealers with such work in their inventory know you'll eventually want to control the price of what they have and therefore that you will be willing to pay well for it).

Because expertise is one of the most valuable services that secondary-market dealers offer their clients, specialization is common in the field, but staking out a political or art historical point of view is not as common as in the primary market, where working with living artists can make championing one movement versus another that undermines it an important and strategic part of the gallery's program and identity. Asked whether specialization was more or less important in the secondary versus primary market, though, our experts both say that it depends. Specializing in the secondary market may not make sense, at least not right away, if cornering the market in your chosen field is too expensive or difficult. As Bailey notes, "It gets back to that: one always wants to have the best. Everybody does. What looks the best and what might be considered the most salable." Zoubok echoes that, saying, "I think a lot of people in the secondary market are generalists [because] there's less pressure to have a point of view."

Secondary-market dealers generally don't need to concern themselves with rep-resentation contracts or whether they have to pay a commission to an artist's pri-mary gallery. Most of the other concerns do have a parallel in the secondary market, though. The following sections will cover consignment agreements, promotional strategies, pricing work, and protecting the markets you've built. Much of that dis-cussion, however, requires a working knowledge of how secondary-market dealers acquire the work that they resell, so I'll begin by discussing what secondary-market dealers are conscious of in purchasing inventory.

Acquiring Inventory

When many people in the art world think of auction houses that specialize in art, they tend to think of the big players, like Christie's, Sotheby's, and Phillips de Pury. Secondary-market dealers know, however, that truly excellent work can often end up at the smaller regional auction houses throughout the country. People sell things

when they have to, and sleeper auctions can prove well worth the time it takes to keep up with what's being offered. If the work you wish to specialize in is by non-American artists, you will also want to keep an eye on what comes up at the international auction houses. An exhaustive list of regional and international auction houses is offered by Artnet.com (*www.artnet.com/AuctionHouseDirectory/ index.aspx*), which also recently launched its own online auctions. Also, although it may be a bit like finding the proverbial needle in a haystack, valuable work occasionally comes up on online auction services like eBay, as well.

Traditional print catalogues of pending auctions are still available through most auction houses, though increasingly some are offering catalogues as PDF files that you can download and print out yourself. Further, interactive catalogues offered online are becoming more and more customary, as are subscription services that will alert you when the artists you're interested in are coming up at auction. Among the e-mail services that Sotheby's offers, for example, are notices alerting you when a sale date has been posted or when a new catalogue is online, reminders for upcoming exhibitions, and results from the auctions in which you expressed interest. This is, of course, good marketing for the auction houses, and it ensures that they have a direct line to potential bidders.

Even though auction houses employ experts to research the authenticity of what clients bring them to sell, the onus still falls to secondary-market dealers to do due diligence on behalf of their clients. Zoubok puts it this way: "You should always assume that every piece of information that you get about a piece of art has to be substantiated. The most important thing is to ask a lot of questions. To always physically examine something as carefully as possible. Take it out of the frame. Ask questions about restorations." Indeed, auction houses are prepared to assist you in inspecting any work on which you're seriously considering bidding before it goes on sale. It's perfectly normal to ask auction house staff to let you see the work out of its frame or to arrange for further inspection if warranted.

A few final things to keep in mind when purchasing work from an auction house are that the hammer price is not the final price you'll pay, and that depending on where the auction is held or who is selling the work, a resale royalty may be due to the artist. As an art dealer with a Federal Tax ID (EIN), you won't have to pay state sales tax within the United States, but you will still need to pay the auction house's "buyer's premium." What their buyer's premium is depends on location as well as the price of the final bid. In New York, for example, Sotheby's charges an additional 25 percent on work with a hammer price of up to $50,000, 20 percent on amounts between $50,000 and $1,000,000, and 12 percent on any amount above $1,000,000. For a piece costing $1.5 million, for example, the buyer's premium will total $262,500—on top of the hammer price. Artist resale rights, or *droit de suite,* laws dictate what happens when a

living artist is entitled to a percentage of the proceeds or profits from the resale of his work. (I'll discuss such laws in more detail in chapter 14.) Auction houses will collect the resale royalty due an artist from the buyer.

Secondary-market dealers also frequently buy work from other dealers, quite often at art fairs. Having work in your inventory that you realize after a while won't be easy to place or receiving an offer that's too good to pass up can make another dealer a very attractive buyer. Selling to other dealers does have its downside, though. Each time a work exchanges hands between dealers, commission fees are added to the price the final buyer pays, so conscientious dealers try to keep such exchanges to a minimum. Moreover, knowing which collections have the work you specialize in is a big part of the job, so selling to other dealers who won't readily pass back information on where they place a piece that you sell them can create an information gap for you, as well.

Still, complex arrangements between dealers are not uncommon in the secondary market. Bailey recounts the following scenario: "At Art Basel one year, two dealers jointly purchased a Joseph Stella painting. They bought it together from a European dealer. But another dealer, a New York dealer, had seen that painting there and really liked it, too. She then went to these two dealers and said, 'I really like that picture. What are you willing to sell it to me for?' They took their markup because she clearly had a client for it. That took maybe a week to ten days to turn around. But they bought it because they saw an opportunity with it. The art dealing pipeline for a particular work of art can be very long."

In addition to being explicit about your expectations before entering into such arrangements with another dealer, the golden rule for collaborating on purchases is "get it in writing." The more care you take in spelling out the money part ahead of time, the more smoothly you'll be able to traverse any bumps in the road to placing the work. Indeed, as Zoubok cautions, "I think it's important to understand that in the art world, you deal with a lot of very strong personalities, a lot of idiosyncratic personalities, and the only way to protect yourself from somebody who maybe can be mercurial or litigious is to make sure that things are well defined in writing." In our interviews, both Bailey and Zoubok note that it is extremely important to always be fair when conducting business with other dealers. The art world is a small place, and your reputation is your most important asset in it.

Art is frequently sold by the heir of its original collector upon her death. Many well-known secondary-market dealers have launched their illustrious careers by securing important estates for their inventories. Just like auctions, the spectrum of estate sales can be quite broad, from those for internationally renowned collectors (who are likely to have made arrangements with a gallery or group of galleries), to those more humble estates that are liquidated by locally hired firms but perhaps still include that one

mythical, overlooked masterpiece that has sat in the deceased's attic and is sold off among a lifetime collection of relative junk. A fair bit of additional research will be required to find the sales that include art in which you may be interested, but the Web site *www.estatesales.net* lists liquidation companies and sales throughout the country.

Consignment Agreements

One final source for acquiring inventory is directly from clients who wish to sell from their collections. A secondary-market dealer may buy a client's work outright if that makes sense, but taking work on consignment is also common. Just as in consigning work from an artist, it is highly recommended that you not only get a consignment agreement in writing but that you have your attorney review the terms outlined within it, even if only for a template that you can then use for multiple clients. The more complex the terms become (including the money and the work on your part that is involved), however, the better it is to have your lawyer ensure that your concerns are safeguarded each time. The details can make all the difference.

Telling a client who would like to sell you a piece that you're not in a position to buy or are not interested in buying, but that you would be happy to take it on consignment, is often just the beginning of an extensive conversation. Most of the agreement's terms, not the least of which is the money, are entirely negotiable each time. Try as you might, you may not be able to secure the amount of money a client wants from selling a piece, but you still need to earn something for your time, expertise, and effort in selling it. To facilitate an explanation of the models you should use to determine what you will make from selling consigned work, we should first look briefly at the basics that should be covered in a resale consignment agreement. Again, your attorney should review your final terms, but broadly speaking, they will include the following.

- **Definition of the parties.** Who is the consignor (the client who currently owns the art) and who is the consignee (the dealer agreeing to sell it)?

- **Duration of the consignment agreement.** Define the start and end dates of the period the agreement is valid. If you are ultimately unable to resell the work, you or the consignor may wish to end the agreement or to extend the duration. Either way, this should always be in writing.

- **Details of each work being consigned.** Include the artist's name, the title of the work, the date, the medium, and the dimensions.

- **Sale terms.** State either a net price or the commission the consignee will receive from the sale price. (I discuss this in more detail below.)

- **Terms of possession and payment.** If you bring the work into your gallery to try to resell it, you will have important responsibilities that must be outlined in the agreement. You should also clarify the terms of

payment. At the very least, this should look something like: "Gallery XYZ assumes full responsibility for the above listed artwork for the period of the consignment. In the event of a sale, payment in full will be made to _____ upon receipt of payment from the purchaser."

- **Promotional authority.** In trying to resell the consigned work, exhibiting the work in your gallery, at an art fair, as part of a museum exhibition, or through another gallery may help. What you are authorized to do in this regard (as the consignee), and how the consignor should be recognized, if at all, should be detailed here, as well.

- **Artist resale rights.** If the artist of the consigned work is entitled to resale royalties, exactly what percentage is applicable and where that money comes from (e.g., before or after a commission?) should be specified, as well.

- **Signatures and date signed.** For both consignor and consignee.

Many of these terms can be perfectly straightforward. The consignor will either agree or not to let the work be exhibited, agree or not to have her name appear with the work if it is, agree or not to the duration you recommend for the consignment, etc. The money part, as usual, is where things can get complicated. The sale terms in the agreement should state the lowest amount your client is willing to accept for the piece (although it is always in both your interests to sell it for more), and should also explain how your commission is determined from the final price. There are three general models for determining the commission.

1. **The percentage model.** Here, you preestablish the exact commission percentage that you will receive of whatever the final price is. The customary commissions range from 10 to 25 percent, with 20 percent being the most typical. In this case, should the work sell for $10,000, your client will receive $8,000 and you will receive $2,000. This model has the benefit of ensuring that both parties profit as the final price goes up.

2. **The net-price model.** Here, you establish the net price that the consignor will receive for a sale, which leaves whatever is paid above that price as yours to keep. This model offers great incentive for you to get a high final price, but doesn't put the consignor at any risk if you cannot.

3. **The split-profit model.** Here, the value that the consignor will receive for the sale of the work is determined, and then the consignor and consignee split the amount above that value that the work sells for. Typically, the split is fifty-fifty, but like all of the money decisions, this too is negotiable.

Of course, before a secondary-market dealer agrees to one of the models or to a percentage, it's important to know what the real market should be for the piece. Therefore, pre-agreement research is essential not only to protect yourself, but to safeguard your client (and, as a result of that, your reputation). As Zoubok notes, "I would feel very awkward selling something for a price [at which] my profit seems to be out of scale with what the owner is getting."

Among the resources available for market research, the two most easily accessible are colleagues who sell the same artist's work and recent auction results. Being able to pick up the phone and ask another dealer what he thinks a piece is worth is priceless and a big part of why it's important to have a good reputation among your colleagues. Recent auction results can also tell you a great deal about how much the work may be likely to sell for. Online subscription services—such as those offered by Artnet.com and Artprice.com—make researching auction results incredibly easy. So easy, in fact, that consignors often use them to determine the net sales price they're looking for before they approach you to consign a piece, which can present its own challenges. What may seem like a similar piece online may have critical differences in terms of provenance, rarity, condition, and quality. Each of these will be important to the consigned piece's potential buyers, so the secondary-market dealer should ensure that his research includes such criteria before advising a consignor.

Pricing Work

As a secondary-market dealer selling work often of art historical importance and to a proven market, pricing your offerings will take knowledge and guts. As noted above, much of what you'll use to determine prices (provenance, condition, scarcity, and recent sales) will come via careful research, but the criteria will also include sub-jective measures, such as the quality of and your own personal feelings about a piece. If you own it outright, it's fully within your rights to refuse to part with it for any-thing less than an amount that will console you to see it go. Furthermore, you will build your reputation sale by sale, and how you handle what any secondary-market dealer will tell you are inevitable miscalculations will contribute to your standing among clients and colleagues. Zoubok says, "Generally speaking, when I buy for the gallery, I try not to buy with less than a 50 percent profit margin, if possible."

Promotional Strategies

Most of the promotional strategies that work in the primary market make sense in the secondary market, as well. Exhibitions, art fairs, catalogues, and institutional recognition can all help build awareness of the importance of the artwork that you are selling and the fact that you specialize in it. In place of private studio visits for artists who are deceased, you might invite clients to join you for a visit to museums

in which the artist you're promoting has work on exhibit. For the most part, parallels exist in both markets, although the secondary market has history on its side and therefore can take advantage of what seems like a more leisurely pace to those of us in the frequently frantic primary market. This seeming slowness, however, has its rationales.

Quality exhibitions in the secondary market, for example, may require that you borrow a significant number of artworks that are not for sale in order to highlight the importance of the one piece you are selling. In the primary market, this approach is rare because the price points of contemporary work make it unsustainable. For high-end, secondary-market works, though, that single sale can make the cost of such an exhibition a minor consideration. Furthermore, secondary-market galleries can use exhibitions with little to no salable work in the same way primary-market galleries use statement exhibitions: to gain the kind of attention that will bring in new consignments and new clients.

The rhythm of secondary-market gallery exhibitions may not be determined by which artist on the roster is overdue for a solo show, but there are still rationales that help to set the order and schedule. In explaining the reasoning behind which exhibitions were presented at the uptown secondary-market he worked for, Bailey notes, "It depended upon inventory, what felt right, what was really good, what was really special. Sometimes it was not unlike what any gallery does (in the context of mounting a group or thematic exhibition), and that is looking at what you have in inventory and trying to present it in the best way that you can."

Many of the truly high-end art fairs, such as TEFAF Maastricht and the two Art Basel fairs (see chapter 13 for a discussion of the hierarchy of the world's art fairs), include secondary-market dealers within their mix of galleries, and some exclude contemporary (and, as such, primary-market) galleries altogether. More and more single-artist installations can be found among secondary-market dealers at art fairs as well these days. Galleries that work in both markets sometimes get two booths at a fair if possible or divide up their booths between the two. Others use art fairs to highlight the art historical connections between the work of their contemporary artists and their more established ones by juxtaposing the work in scholarly installations.

Producing catalogues for secondary-market artwork has been used as a great marketing effort by some dealers, including Larry Gagosian. Considered the world's foremost primary-market dealer of contemporary art, Gagosian is also legendary for presenting art historical exhibitions by deceased artists which range broadly from Jackson Pollock to Peter Paul Rubens. Although much of the work is rarely on view for sale, Gagosian always produces a catalogue for the show, forcing him into competition with the world's great museums for the sources of great images of and text about these important artists.

Protecting Markets

Especially when a secondary-market dealer I know is holding a large inventory of an artist's work, the dealer's happiness with or ability to influence the pricing for that work becomes a critical part of the business. A secondary-market dealer, I know once saw a work in the booth of another gallery at a fair that was dramatically lower in price than a similar work in her booth. In talking with the other dealer, she realized that he was not going to reconsider his price, so she bought the piece from him in order to ensure that her clients didn't see it at the lower price point. How long it will be before that piece is seen in public again is anybody's guess, but with so much at stake, it was a good business decision on her part to buy it.

In protecting your markets, it is important to remember not to get greedy. Selling a work for so far above its true value that the buyer eventually learns about it can create a very unhappy client in addition to generating suspicion about all the other work you offer. As Zoubok notes, there's an ethical component to this, as well. "I would be very uncomfortable if one of my clients got into trouble and then they needed to sell something they bought from me only to find out that there's no room for them to get out. Or [if] they overpaid just because they could. I think that there's a responsibility [on the part of the dealer] to sell good quality and good value." When focusing on the work of a particular artist, having word get out that someone overpaid (and learned that they did the hard way) can quickly undo the trust you've built up through years of otherwise irreproachable work. In such situations, the ethical and sound way to resolve it is to buy the piece back yourself, let the client know how sorry you are about the miscalculation, and ensure him that it won't happen again.

SUMMARY

Although a primary-market art dealer may eventually find that more and more of his or her business is in the secondary market (especially as his artists' careers progress and their work comes up for sale again), most new art dealers tend to cut their teeth in the primary market. The difference in start-up capital it takes to launch a secondary-market versus primary-market gallery, plus the level of expertise it takes to succeed in the high-stakes secondary business, account for this, but so do the rewards of working with living artists and building their markets from scratch. In the following chapter, I'll delve more deeply into what you should consider in calculating the start-up capital you'll need to start your gallery. If you have access to enough money to build a significant inventory of secondary-market work, you might find that that's the right place for you. My focus on the primary market is not designed to dissuade you from choosing to focus on the secondary market as much as to simply acknowledge that most new dealers choose the primary market, instead.

5

Start-up Capital: How Much You Need and How to Get It

If all you have to go by are images set forth by Hollywood, you're forgiven for thinking that an art gallery has to be a cavernous, ground-floor space where champagne flows at the opening receptions and limousines drop off collectors dripping in haute couture who waltz in to snap up artworks by the dozen. In real life, though, influential galleries can be found in third-floor walk-up apartments, converted garage spaces, or tucked-away rooms in a warren of office buildings. Likewise, sometimes making just one sale a month is something you're thankful for. Therefore, in discussing how much start-up capital you'll need to open an art gallery—as opposed to a coffee shop franchise or some other out-of-the-box type of business—it must be stated that much will depend on some of the fundamental choices you make and on the state of the art market.

With this in mind, I will discuss the impact of those fundamental choices using an admittedly subjective system of gallery types, with a scale ranging from bare-bones to polished serving as one axis and a scale ranging from pure primary-market to pure secondary-market models serving as the other. As noted in chapter 3, my main focus is the primary market, but the basic business models often overlap. Further, when I refer to real dollars and cents here, my calculations are based on New York City prices, which means that some of your costs could be significantly lower depending on your gallery's location.

With all those caveats, in this chapter I will briefly explain what's meant by start-up capital and why it is important not to underestimate how much of it you will

need. Within the framework of our system of gallery types, we'll examine six factors you should consider in calculating how much start-up capital you will need—general business setup expenses, locations costs, build-out costs, initial inventory, office equipment, and initial promotions—and discuss how to estimate your monthly expenditures, including your salary for the first year. Finally, we will look at where you might find start-up capital, including what to consider when using your own money, the pitfalls of borrowing from friends and family, and the pros and cons of working with an outside investor.

OVERVIEW

In general business terms, "start-up capital" is the amount of money you need to see any new venture through its developmental stage and its launch stage. Start-up capital is typically calculated by adding your estimated preoperational expenses to your estimated monthly operational expenses for the initial months, during which you can't realistically count on income to cover those for you. For a commercial art gallery in particular, start-up capital might be more precisely talked about as "working capital." That's because it's not only the money it takes to get set up as a legal business, get your gallery space built out, buy any office equipment or furniture you'll need, get the artwork you intend to sell into the space, and announce to the world that you're open (all preoperational expenses) that we're calculating here, but also the money you need to get to work, including paying yourself and having the funds available to simply stay in business until enough income starts rolling in to cover your estimated monthly operational expenses. For some retail businesses, it is advised that your start-up capital cover at least the first three months of your estimated monthly expenses, but that would be overly optimistic for the average commercial art gallery starting from scratch. The more you will be dealing in the primary market, the more I would recommend starting with enough capital to cover at least your entire first year's monthly operating expenses, even when the art market is strong.

Regardless of what business you're in, it is recommended that you calculate how much start-up capital you will need only after writing a detailed business plan—see chapter 6 for thorough instructions on writing one for a commercial art gallery—and determining exactly where your start-up capital will go. Without taking these steps first and then carefully calculating a realistic amount, you may wind up underestimating the total and thereby finding yourself short of the funds you actually need, which is the number one reason new businesses fail. On the other hand, if you overestimate the amount you need, you risk alarming potential sources of capital who won't understand why you think you need that much. Time spent calculating credible numbers to have available to answer potential backers' questions will be time well spent.

Before we delve into the specifics of what you should expect in terms of pre-operational and estimated monthly operating expenses, let me disclose my personal point of view as it pertains to the axis system we'll use throughout. The "bare-bones primary-market model" (also known as the "bootstrap method" for starting a business) is the one I'm most familiar with, as it's how we launched our gallery. The art market was fairly strong in 2001, when I cofounded Plus Ultra Gallery with artist Joshua Stern in a converted garage space in what was considered an out-of-the-way location even within the Williamsburg area of Brooklyn. Our start-up capital at the time was so minimal that I'm embarrassed to share it. The corners we cut to get up and running (no alarm system, no support staff, no savings or line of credit) meant that we were surviving month to month from the very beginning. Fortunately, our first exhibition got a rave review in the *New York Times*, and the art market was booming then, so sales for that first month were very healthy. However, knowing what I know now about how lean times can be, I can't recommend trying to duplicate this approach unless the art market is very strong and you are prepared to personally perform much of the build-out construction and other work required to get started.

PREOPERATIONAL EXPENSES

Having offered so many discouraging disclaimers, I should note that many of my favorite art galleries were launched as a result of someone shelling out a remarkably small amount for preoperational expenses. By cashing in all kinds of favors, being prepared to forgo any real salary for quite some time, and being innovative with promotions, it can be done. Regardless of how creative you are, though, there are certain things that you will have to pay for to start a gallery that operates within the law and that the art world—especially artists— takes seriously. The more polished you wish your gallery to be or the more complex your business model, the more money you should count on needing for most of the following preoperational expenses. The first one is the only exception.

General Business Setup Expenses

These expenses will more or less be the same, regardless of how polished or unpolished a space you intend to open: incorporating, getting an Employee Identification Number (EIN), opening a business bank account, contracts with employees or business partners, etc. Although you could do some of the general setup steps yourself, I strongly recommend that you hire a lawyer (especially if you'll use contracts), or at least an accountant. The more complex your legal business arrangement is, the more this could cost you, especially if you need partnership agreements. Often, you can get a lawyer or accountant to set you up for a flat fee rather than an hourly rate, so definitely ask about that. Generally speaking, the

costs for getting legally set up in New York City using an attorney or accountant can range from $1,000 to $1,500.

Before amassing your start-up capital, you will need to set up your business bank account so you have some place to deposit it. Before you can open a business bank account, you will need a Federal Tax ID, or EIN (see this IRS Web site for more information: *www.irs.gov/businesses/small/article/0,,id=98350,00.html*). Among the things to consider in choosing your bank that might determine how much start-up capital you shoot for is whether it offers to waive its monthly fees as long as your account maintains a certain minimum balance. Another big consideration is how well suited it is to assist small businesses with services such as a line of credit, credit cards, and other tools that can help you better manage your cash flow.

Location Costs

In many of the tighter commercial real estate districts (that is, the ones you'll possibly want your gallery to be in), it is often best to work with an experienced broker. The fee for a broker's service is generally a percentage of the value of the transaction—either rent or sale price—for your space. Landlords renting commercial spaces (at least in New York) will ask for a security deposit ranging from three to six months' rent. They may give one or two months of it back to you over time if you've demonstrated that you pay your rent on time, though. This is one of the negotiation points your lawyer can hopefully help you with, but in calculating your start-up capital needs, it is an important thing to know.

Obviously, more polished spaces will rent or sell for more, but more bare-bones spaces may require more investment to build them out. I advise that you get an estimate from an architect and/or contractor for build-out costs before you agree to a space. Also, don't forget to add in your lawyer's fees for negotiating your lease or contract. Finally, getting your utilities all squared away to ensure that you have lights at your grand opening and a phone that gets a dialtone can require fees or deposits in some places.

Build-Out Costs

This is where you can realize big savings on start-up capital needs if your dream gallery doesn't need to be designed by a world-class architect or involve a total gut renovation. I've had some of the most important contemporary art collectors in the world assure me that they don't care about how luxurious our office space is or how fashionable our neighborhood is. They come for the art.

Regardless of how polished a space you feel is appropriate for your gallery, however, you will almost assuredly need to spend some money to ready any space that wasn't an art gallery before you took over. The two basic requirements for professionally exhibiting most art—walls and lights—are rarely acceptable in

spaces designed for other purposes. In addition to ensuring that the walls are ready to hang art on (see chapter 7 for what's typical and recommended), you will need a flexible lighting system. Installing one will likely involve electrical work that will be inspected by your local authorities, and this will require you to hire a certified electrician. After walls and lights, and even if you're going for the no-frills look, there may be any number of other build-out costs needed to make the space workable, to bring it up to code, or to comply with your lease, such as a heating, ventilation, and air conditioning (HVAC) system, plumbing for a restroom or kitchen, an alarm system, inventory racks, and on and on.

But let's say you get lucky, and all you need in the space you're renting are a few sheetrock walls that don't require an architect, a few track lights, and some straightforward electrical work. Recent bare-bones renovations of galleries I know in New York City have still cost about $20,000. Build-out costs between $50,000 and $250,000 are more typical for galleries that I would place on the middle to lower end of the bare-bones-to-polished spectrum. The sky is the limit after that; the larger the space you get and the further up the architectural food chain you go, the more money you will need.

One final thing to keep in mind here is that costs and schedules have a way of increasing during build-outs if they are not constantly managed. Ensure that you have the time to be available for your contractors, both to answer the questions they'll have and to ensure that things keep moving along at the pace and with the quality of work that will make you happy. If you're not sure you can stay on top of the build-out construction, you might consider adding some padding here for your start-up capital calculations.

Initial Inventory

If all of the work you're selling is on consignment, you won't have much to shell out in terms of building your initial inventory. You may have some shipping and installation costs, as well as, perhaps, off-site storage fees, but your totals here should not be considerable. Starting from scratch today, for an entirely primary-market model that will sell work only on consignment, I would budget about $2,000 to $5,000 for these initial costs. The further along the spectrum you move toward the purely secondary-market model, the more likely it becomes that you'll spend quite a bit on inventory before you will have what it takes to make an impressive debut. Here, again, the sky is the limit.

Office Equipment

Even if you are the gallery's only employee, you will most likely still want at least two business computers. You can possibly get away with only a laptop (which I'd recommend for art fairs and other travel situations), but they are not usually as good as large desktop monitors for showing clients images. If going the bare-bones route, you may

want to wait to buy software programs until you're certain that you need them, but generally, in a gallery, you'll find the Microsoft Office Suite (Word, Excel, PowerPoint, etc.), the Adobe Design Suite (Photoshop, Illustrator, and InDesign), iPhoto (or some comparable image manager), QuickBooks, and some gallery management system (either ArtSystems' GalleryPro or some other, homegrown database created from FileMaker Pro or Microsoft Access) helpful.

You will also need a printer, copier, scanner, and fax machine, all of which are now widely available as one multifunction unit, or some combination of machines that will perform those functions. You will also need a phone and at least two phone lines (unless you can swap out the line every time you need to send or receive a fax, which I don't recommend, having done it for a few years). More and more, anything you might want to fax could instead be scanned and e-mailed, but there remain a few business situations in which not having the ability to send or receive a fax will cause you headaches, so I'd recommend maintaining that capability for a few more years, at least.

As for furniture, you'll need at least one desk for yourself and possibly one for a receptionist. What qualifies as a desk is a personal decision, of course. For the first year in our space, we used a painted sheet of plywood held up by two filing cabinets. It wasn't elegant (and I don't miss it), but it got the job done. You should also consider having two additional chairs beyond the number of employees in the gallery, shelving, a filing cabinet or two, and a flat file solution (either a cabinet or, as we have used, a slotted crate turned on its side). I recommend adding a small refrigerator, as well. Much of this can be bought secondhand, of course—we inherited a few pieces of furniture and initially built our own shelving in some places to save money—but as I mentioned in chapter 2, furniture choices can play an important part in creating the image you want to project.

Although this will eventually fall into your monthly expenses, initially, you still need to buy an awful lot of office supplies and a range of hardware products to get up and running. Stationery, binders, folders, envelopes, staplers, paper clips, sticky notes, hammers, a drill gun (very important), spackle or joint compound, extra paint, brushes, rollers, bubble wrap, glassine, packing tape by the mile . . . the list goes on.

Initial Promotions

There is no shortage of places you can and probably should advertise the fact that you're opening for business, but your goal in this should be to reach the right audience and make the right impact. Personally, I believe that it is important to make a good first impression, but a successful initial promotional campaign must be carefully crafted as part of a consistent, long-term strategy. In other words, don't spend a dime at the beginning until you know that your original efforts will underscore and support the promotions you'll be paying for on your gallery's first anniversary. I'll discuss ongoing

promotional efforts, as well as those things you can do to promote your gallery that don't cost money, in more detail in chapter 11. Here, however, the focus is on what you should think about in calculating start-up costs for your inaugural announcements.

Having watched too many galleries make a huge initial splash and then go out of business within the first year, my views on this are admittedly hardened. For example, I've seen galleries announce their grand openings in every conceivable outlet, which ended up costing more than they expected, even optimistically, to take in until well past their first six months of business. If such an elaborate initial promotion is followed up by impeccable programming and a sustained advertising campaign, it might pay off. However, having such an extravagant expenditure without the ability to keep it going results in a one-month blitz that any number of possibly important clients might miss. It does you no good to have expensive one-page ads in periodicals that are collecting dust on their readers' shelves. The tortoise, not the hare, wins this race, in my opinion.

Again, connecting with the right audience should be the focus of your initial promotion. So, your first steps here, regardless of how much money you have to spend, are to define your message, define your target audience, and figure out the most cost-effective way of bringing that message to that audience. Who is most likely to visit your space before your reputation precedes you? Don't waste your start-up money advertising to collectors who only buy famous or established artists if you're launching an emerging art gallery, for example. Who will likely buy the art you're selling within your first year? How do you reach the collectors who pride themselves on supporting under-recognized talent and new spaces? How do you reach the art consultants or curators of the collections whose owners prefer to have a buffer between themselves and art dealers? Who is likely to write about your new gallery, and how do you most compellingly tell them a story that they'll want to share with their readers? Answering these questions will help you calculate where you need to spend money and where you need to spend time in developing your initial promotions.

Regardless of where you advertise, I recommend getting your Web site up and running, ready to underscore the message you're selling, before the first ad, e-mail, or print piece goes out. There's no point in spending all that money to drive someone to a page that says "under construction." There are as many variations in style, complexity, and expense for Web sites as there are Web designers and hosting services. I'll further discuss the range of options in chapter 11, but in calculating your start-up costs, you should know that there are domain name charges, hosting costs, and e-mail systems costs (you do want your e-mail address to be your gallery's Web site domain name, believe me) to consider here.

Direct-mail print pieces may be controversial in this era of environmentally aware business practices, but it's likely that you won't have the e-mail address for some

member of the target audience you wish to reach. There are ways to be more "green" in sending out print announcements (such as working with printers that offer post-consumer paper options or including a message that encourages recipients to visit your Web site to sign up for e-mail announcements), but a quality image printed on an invitation announcement remains one of the most surefire ways to sell artwork and to drive in traffic. How much you'll spend for printing and mailing any initial promotion pieces will depend on their size, quality of paper, design costs, location of their recipients (i.e., overseas mail costs more to send), and, of course, quantity. Most new art galleries shoot to build a mailing list of at least 3,000 recipients before they feel comfortable. Doing the math on that, I see (as of this writing): $0.43 cents for a domestic stamp + $0.35 for a reasonable quality 5" × 7" postcard × 3,000 recipients = $2,340 for a single, entirely domestic mailing. E-mail announcements are much less expensive per piece, obviously, but professional e-mail services cost about $30 per month on average. Further, you run the risk of being perceived as annoying, or worse, as abusive, if you overuse e-mail in communicating with clients if they have not specifically requested that you use e-mail to send them messages. Using an e-mail messaging service that permits recipients to unsubscribe from a list is becoming a standard "best practice" for businesses.

Print ads run the gamut in terms of cost ($6,000 for a full-page color ad in a monthly magazine is about average, as of this writing). The four main determinants of cost are size, color, frequency, and the publication's distribution or market niche. Most monthly arts publications offer full-page, half-page, and quarter-page advertisements. Some will offer smaller sizes and text-only listings, as well. Black-and-white ads tend to be about half the price of four-color ads. Most publications offer special rates if you buy a block of ads, but you can generally negotiate the price for any ad at any time. The stronger the art market (meaning, the more ad space they're selling), the less likely you'll get much of a discount, but it's always worth asking. Finally, the reputation and distribution of the publication will determine its rates, again making it crucial that you do your homework with regard to finding out which publications your target audience are most likely to read.

MONTHLY EXPENDITURES FOR THE FIRST YEAR

As noted above, some retail businesses can get by with as little as three months' worth of operational expenses in their start-up capital because of how quickly they can correctly assume that income will be sufficient to cover monthly expenses. This strategy is not the best option for a commercial art gallery, however. Even one sale can take months to close in this business, and the trials of the first year can be a real test of your commitment to this dream. Make it to five years in business, and then maybe you can relax a bit. Therefore, your start-up capital calculations should include at least one

year of working capital. What you'll be spending that money on, though, may be something in which potential investors will be very interested. I'll discuss your monthly expenses in more detail in chapter 8 (on managing your cash flow), but in helping you determine your working capital needs here, I'll outline briefly how to estimate your monthly expenses (both fixed and variable expenses), as well as how to calculate a monthly expense so important it deserves its own section: your salary.

Fixed Monthly Expenses

Your business's fixed monthly expenses should be fairly straightforward to calculate. Add your rent or mortgage, any loan repayment (and interest), utilities (including electric, water, garbage, phone, alarm system, Internet, etc.), and insurance to the salaries of or fees for staff and professional service providers, such as bookkeepers, lawyers, and assistants. These calculations will be part of any sound business plan you write.

Variable Monthly Expenses

These expenses are not so straightforward and thus will require a bit of guess work. To make an educated guess, it's good for you to do some preliminary calculations on exhibitions, promotions, and any art fairs you are planning for the year. How many exhibitions will you present? How complex are their installations (will you need to hire contractors to build temporary walls, buy video equipment, have pedestals built, etc.)? What should you calculate in shipping costs for your exhibition schedule and inventory maintenance? What's your advertising budget for this year? Does it make sense to go all out for one or two exhibitions in particular, publish a catalogue, or host an event? What about travel plans? Will you need to visit artists, clients, or other dealers in other locations? And don't forget to anticipate the unexpected. From repairing accidental damage to artwork to being offered a larger booth at an art fair than you had requested, both rainy days and unforeseen opportunities are best met when you have an allowance set aside for such possibilities.

Your Salary

Almost every small business "how-to" book or Web site you read will stress the importance of making sure that you "pay yourself first." The best way to ensure that you reach your business goals is to make your salary not only an imperative monthly expense, like the rent or mortgage, but the highest priority among your expenses. If, after you pay yourself, there's not enough to pay some other expense, then you know you have to somehow raise that extra money. This serves as the single most effective motivation to ensuring that you do what is needed to keep the business afloat.

How much you should pay yourself, though, presents another question. Business experts will advise that you consider two factors in determining your

salary: what someone else would pay you to do this work and how much your business can afford to pay you. Calculating this amount, multiplying it by the number of months you estimate it will take before regular income will cover this expense, and adding that into your start-up capital needs is essential.

On the other hand, many successful art dealers I know in both the secondary and the primary markets initially worked second jobs during the first, lean years of their new businesses. It's obviously difficult to build a new business if your day is so divided, but the conventional wisdom says that it can take three to five years for a new gallery to become truly profitable. If your start-up capital simply won't cover your living expenses, finding the right balance between the demands of another source of income and building the gallery is something you should consider carefully. At the very least, ensure that your business's monthly expenses include a token salary so that you're used to paying yourself something.

HOW TO FIND CAPITAL

Once you have totaled the expenses above, the next step is figuring out how to get that much money. Small businesses typically get start-up capital from one of four sources: 1) personal funds, 2) loans from friends or family, 3) outside-investor or bank small-business loans, and 4) government programs. It may be all but impossible to convince a government agency that your luxury retail business is a good use of tax payers' money, though, so I won't spend much time discussing that potential source.

Speaking from personal experience and tales told to me by friends, I can report that many banks do not seem particularly interested in loaning start-up capital to new art galleries. One agent at a high-profile bank I approached that specializes in small business loans told me that my business plan was one of the best he had ever read, but he still wouldn't loan me the money I requested. (A few years later, after I had proven that my business plan was indeed that good, his bank did offer me a significant line of credit, but that's a story for a subsequent chapter.)

If you feel it's worth approaching a bank for a loan, there are some things you can do to increase your chances. First and foremost, present a thorough and convincing business plan. By the time you've completed your business plan, you will be able to confidently answer any of the questions your bank may ask in the loan interview, and you will have a road map for how you're going to run your business. All of this will help convince the bank you are serious and well-prepared.

If a solid business plan was what banks considered most important, you'd be halfway there. In reality, though, nothing matters to your banker more in these interviews than ascertaining whether you will be able to repay the loan. With that in mind, one of the things the bank is going to want to see in your Personal Financial

Statement is that you have collateral. One form of collateral you can suggest that they consider is art that you own, but don't be surprised if they don't agree that the piece given to you by the emerging painter you plan to represent is worth what you say it is.

If the bank turns down your application, ask your representative whether having someone cosign your loan would make any difference. I'll discuss the considerations of borrowing money from friends and family below, but often, someone who is unable to loan you the money outright wouldn't mind cosigning the loan to help you out. If your bank still says no, you might have to move on and exercise another option.

The seeming reluctance on the part of banks may be partially because of the relatively opaque nature of the industry and the relatively few numbers of galleries compared with other businesses out there and partially because of how much any new luxury business depends on a strong overall economy to thrive. Whatever the final calculus may be, banks and traditional outside investors seem to view new art galleries as particularly risky investments. This should not be so surprising, since we've discussed that there are much easier ways to make money and that factors as difficult to measure as a good eye and a passion for art are important components of success in this industry. This may be why most galleries get their start-up capital from personal funds and loans from friends and family or investors who share the start-up dealers' passion for art or believe in their vision.

Reportedly, over 50 percent of all small business start-ups are backed with personal funds. That's not to say there's not still a bank involved, though. "Personal funds" used for start-up capital may include home equity loans, personal loans from banks, or personal credit cards. As unattractive as this choice may seem on the one hand, having a large personal financial interest in your business can work to help you secure a business loan later.

Loans from friends and family may be easier to get initially but can involve a degree of interpersonal stress that you should carefully consider before going this route. To help keep this part of your relationship with the person loaning you the money as businesslike as possible, present the same information to her that you would a bank (i.e., your business plan), have a written agreement detailing how it will be repaid, and keep in mind that she has every right to inquire about how her investment is doing, even when sharing that information may make you uncomfortable. In general, I would recommend this source of start-up capital only if you're confident it won't impact your relationship with your friend or family member. Remember, it can take years for a gallery to become profitable, and that can mean years of awkwardness with someone you care about.

Getting a loan from an outside investor may be the best of the non-bank options. Because realizing a profit can take so long, it is unlikely that many outside

investors without a passion for art or a sincere belief in you and your vision would back a commercial art gallery. In addition to that interest, though, what you want from an outside investor is someone who can bring connections, wisdom, and patience to the table.

Be conscious, however, that some financial backers may presume all the rights of a business partner. Outside investors with a passion for art have been known to assume that that they will have input into the curatorial or programming side of the gallery. After you've signed an agreement is not the time to discuss this at length. Have your attorney draft the terms of your loan agreement after you have explicitly explained your personal goals to him, including how you wish the relationship with the investor to eventually end if that is part of your plan.

SUMMARY

Underestimation of how much start-up capital a business plan requires is among the top reasons new businesses fail. The tendency to underestimate it is understandable. Excitement about launching one's venture can encourage an "I'll cross that bridge when I get to it" mentality, and success can often depend on your resourcefulness in finding solutions when things pop up. Still, working through a realistic assessment of how much start-up capital you will need for general business setup expenses, location costs, build-out costs, initial inventory, office equipment, and initial promotions is wise. Each of the possible sources of start-up capital has unique advantages and disadvantages, as well, which underscores the importance of considering your long-term goals in locating such funding.

6

Writing a Business Plan

Because it seems so daunting a task and can take weeks to do well, any new small business owner may be tempted to open without first writing a business plan. I won't waste time trying to convince you that a business plan is something you should spend your limited time writing, that it will pay off in all of your planning and management efforts, or that it can be the single most important thing you do to ensure that you stay in business. You'll discover yourself, as soon as you approach a bank or potential backer for financing, that without a well-considered, convincing business plan, your chances of securing such funding are pretty low. Fortunately, there are now very helpful online tutorials with templates and step-by-step instructions for writing a business plan, including one offered by the U.S. Small Business Administration (SBA) at *www.sba.gov/smallbusinessplanner.* Because commercial art dealers have considerations specific to their industry, in this chapter, I'll examine the typical sections of a business plan as they apply to an art gallery, including the executive summary, business description, description of the market, development and production, sales and marketing, management, and financials.

OVERVIEW

The SBA's description of how you will benefit from writing a business plan is among the best I have seen. It notes that a business plan will serve your business operations in three important ways: 1) communication, 2) management, and 3) planning.

*As a communication tool, [a business plan] is used to attract invest-
ment capital, secure loans, convince workers to hire on, and assist in
attracting strategic business partners. . . . As a management tool, the busi-
ness plan helps you track, monitor, and evaluate your progress. . . . As a
planning tool, the business plan guides you through the various phases of
your business.*[1]

There is no one-size-fits-all formula for a business plan. The following sections
should generally be included in any small business plan, but not all of them may be
entirely applicable to your particular business model. The key to any approach, how-
ever, is to be as thorough as you can. The more thoroughly you prepare your busi-
ness plan, the better it will serve you and convince others to invest in your dream. If
you find yourself unsure of how to apply the advice offered in a business plan tuto-
rial, keep in mind that a gallery is often best thought of as a service company. You
will find other arrangements of the following sections among the various online
tutorials and templates, but I feel the following one is well suited for a commercial
art gallery. It has been tailored specifically for art galleries from the free online tuto-
rial offered by American Express at *www133.americanexpress.com/
osbn/Tool/biz_plan*.

Executive Summary

Most explanations of the executive summary list the elements it should include
and then emphasize the importance of making this section as concise and com-
pelling as possible. That's because potential investors will read this part first with
the specific goal of deciding whether to bother even reading the rest. If they're
bored, confused, or unconvinced, they will not continue. In other words, you don't
want to skimp on the conviction or clarity in this section. Keep your executive
summary under two pages in length (not including the table of contents). The basic
information that should be in the executive summary includes:

- **Company information.** List your legal name, address (if known at this
 point), contact information, business structure (i.e., partnership, LLC,
 corporation, S corporation, etc.), banking information (address and a con-
 tact person who knows about your plans), and anticipated start date (if not
 already open for business).

- **Business concept.** This is the infamous "elevator-ride sales pitch." In one
 short, highly compelling paragraph, describe why someone would believe
 your business is a good investment. Describe exactly what kind of art will
 be sold to which collectors, and what you see as your gallery's competi-
 tive advantage. With all of that information, however, you should still keep

it to a maximum of three sentences. Also, keep in mind that the most compelling portion of your competitive advantage statement will most likely be why you personally are perfectly suited to making this plan work.

- **Mission statement.** This can have the same wording you use in the mission statement I mentioned in chapter 2. If it is done well there, it will serve you well here.

- **Financial features.** Describe the main financial features of your business, including estimated sales, profit, and cash flow. This is easier than it might sound at this point, because you will simply summarize the worksheets you complete in the financials section of your business plan.

- **Financial requirements.** Describe in detail how much start-up capital you will need, what it will be spent on, and how and when it will be repaid if borrowed.

- **Current state of the business.** What type of business is yours (legally), and when was it formed? This may also include a description of key personnel, but that can also be included in the next section.

- **Ownership.** Who owns the business and what, if more than one person, are their titles or roles?

- **Major achievements.** For a commercial art gallery, this may include awards or impressive exhibitions of the artists whose work you'll be selling. It may include your own accomplishments or acknowledgments of your expertise in the press. Also, mention why the location you have chosen will be a factor in your gallery's success, and other elements of your plan that will make you outshine your competition.

- **Final pitch.** Summarize your goals and advantages in an enthusiastic sales pitch that will leave your readers convinced that your business is a winning proposition.

- **Table of contents.**

Business Description

Much of the next few sections of your business plan can be written as a narrative. In several sections, you will literally tell the story of your industry or business. It remains important to be compelling throughout, but how concise you need to be will fluctuate depending on how complicated your plan is to describe. Remember that one goal of the business plan is to help you in the continued management and planning of your business, so the more detailed it is, the better.

Industry Sector

Begin your business description with a concise statement about which industry sector your gallery will be part of; most art dealers can simply write "retail sales." If applicable, add a specifying statement about the subsection of the industry sector you'll be working in, such as, "Retail sales; specifically, the emerging contemporary art market."

Description of the Industry

This is where you want to demonstrate that you know your industry well by offering your readers a detailed description of the art gallery business, including how it operates, how well it is doing at the moment, and how well it is likely to be doing in the foreseeable future. It is important that you cite reliable sources for your conclusions here and not simply offer your own opinions or conjecture. Popular online sources for up-to-date information on the current state of the art market and predictions include:

- **The Art Newspaper** (*www.theartnewspaper.com*). A London-based source of international art news.

- **The Beautiful Asset Adviser Web site** (*www.artasanasset.com*). Home of the Mei/Moses Fine Art Indices.

- **Artnet.com.** An online portal for buying, selling, and researching fine art, with a popular magazine and "Market Trends" feature.

- **Artinfo.com.** Online presence for Louise Blouin Media, which publishes the magazines *Art & Auction*, *Modern Painters*, *Culture & Travel*, *Gallery Guide,* and *Museums New York.*

- **The ART Newsletter** (*http://artnewsletter.artnews.com*). A bi-weekly report on the art market by the editors and writers of *ARTNews* magazine.

- **The Baer Faxt** (*www.baerfaxt.com*). Private art dealer Josh Baer's art industry newsletter.

- **Art blogs.** A growing number of art world insiders are getting real-time information (or at least one-stop shopping for links to the best articles) about trends in the art world from the leading art blogs. The list is long and growing, but three you might turn to for starters include Washington, D.C.-based Tyler Green's Modern Art Notes (*www.artsjournal.com/man*); New York-based **Carolina Miranda's** C-Monster (*www.c-monster.net/blog1*); and the multi-authored international Artworld Salon (*www.artworldsalon.com*),

founded by **Marc Spiegler** (a Switzerland-based journalist who became a director of the world's preeminent art fairs, Art Basel and Art Basel Miami Beach), **Ian Charles Stewart** (media entrepreneur, investor, and museum trustee based in Beijing), and **András Szántó** (a sociologist, journalist, and senior faculty member of the Sotheby's Institute of Art in New York). (I should note in the interest of disclosure that I am a contributing editor to Artworld Salon.)

Description of Your Gallery

Your description of your gallery can be as short as a few paragraphs or as long as a few pages, depending on how complex or innovative your business model is. Don't make this section any longer than it has to be to accurately describe your gallery, though. Begin this section by reiterating the legal form of your business (again, see chapter 3 for further discussion on which legal forms suit which business models): indicate whether you are set up legally as a sole proprietorship, partnership, corporation, or limited liability company (LLC).

Then, describe enthusiastically and confidently what type of art you will sell, to whom, via which channels, and how you intend to support this effort (e.g., via advertising, art fairs, promotional efforts, etc.). Also, point out your competitive advantage. Cite your expertise in the type of art you will sell; connections among collectors, curators, critics and other dealers; innovations you will bring to the traditional business model; and so on. Finally, answer the question any potential investor will be most interested in: Why are you sure this gallery model will turn a profit? Clearly, this will be mostly speculation on your part at this point, and that will be understood by your readers, but if you cannot demonstrate that you truly believe in this model, why should anyone else? Do a little cheerleading here. List all the smart choices you're making in setting up this business, why you are certain that now is the right time, and why your plan is the right plan.

Product Description

A term commonly used in the product description section of a business description is "Unique Selling Proposition" (USP), which loosely means the advantage of your product or business model that will lead potential customers, who can buy similar products elsewhere, to spend their money on what you're offering, instead. In the context of a commercial art gallery, your USP might be your artists (i.e., they are simply more talented or more important than the artists represented by competing galleries), your personal access to the best work by well-known artists (because of your connections or expertise), your deep pockets (suggesting that you can outbid the competition to secure the work that becomes available when it does), or your

innovative way of organizing or selling artwork (such as how you will uniquely harness the potential of the Internet or develop new channels to present or distribute artwork). Back up your assertions here with proof that your USP is significant. For example, cite the important exhibitions your artists have had or will have and impressive reviews they have received, cite important collectors or museums that have bought or exhibited these artists' works, or outline in detail why the market is ready for your innovative approach and what need or niche you will be filling.

The Market

In the market section, you should describe the specifics of how you're positioning yourself within the overall market in which you'll be competing. As is true throughout your business plan, your goal in this section remains to provide yourself with a road map, as well as to convince your readers that you have a firm grasp of this topic. To do this, describe who your customers will be, what their needs are, and how you plan to meet those needs; go into detail about the size of the market and how recent market trends will impact that size; provide a matter-of-fact evaluation of your competition, including a list of who they are and what their strengths and weaknesses are; describe how you plan to position yourself within the market; discuss how your pricing strategy will work to help you meet your goals; and explain how you arrived at your sales estimates based on these combined factors.

Customers

Describe the typical customer for the art you will be selling. Specify what your demographic will be (i.e., will you cater to collectors who are well informed about art, or will you make education a part of your mission? Will potential customers need to be very wealthy because the art you sell is expensive, or will you encourage patronage among people who might need to pay in installments? Will you reach out to collectors beyond your immediate area, via art fairs, advertising, or other such promotional efforts, or will you focus on people who live in the region and can visit your gallery frequently?). The more you can tell your reader about who you believe will buy art from you, the better you will demonstrate that you know how to go about targeting that market.

Market Size and Trends

The sphere of people or businesses whom you will try to convince to buy art from you can be broken into two segments: the total feasible market (people who could possibly become your customers—this market will be influenced by your price points and inventory) and your target market (the subsection of people within the total feasible

market you will advertise to or approach directly, because they are most likely to buy the kind of art you will sell). In order to be credible, your business plan should acknowledge that the total feasible market can only be counted on to buy from you if every conceivable variable aligns perfectly in your favor and your competition is remarkably unsuccessful in taking away their business from you. In other words, be realistic here.

The overall art market is notoriously opaque and has only a few sources (all somewhat vague) of information about the number of people who currently purchase art, including reported attendance at art fairs, the number of trustees or collectors' groups members at museums, reports on attendance and purchases at auctions, and anecdotal evidence from other dealers, such as the size of their collector lists. Taken together, though, none of this adds up to a highly reliable total, so your estimates here will be understandably subjective. Having said that, your readers will still be looking for a reasonable assessment of two factors: projected industry growth or decline (indications, if any, that more or fewer people will be buying art in the future) and potential conversion of customers from the total feasible market (how many people you can expect to start buying art from you).

Competition
Provide here an in-depth analysis of your direct competition. Present a list with their names, addresses, and Web sites, and a short summary of what you feel they do well and what, in your opinon, they fail to do well. Subjective assessments of the art they sell may be part of this discussion, but focus more on their business model and marketing strategies. This section should also explain what strategies you have developed or will develop to exploit your competitors' weaknesses, as well as what barriers you can set up to keep current or future competitors at bay in your market. Keep in mind while analyzing your competitors what skills or assets they possess or lack that have led to their positions in the market, and offer your reader your ideas on how you'll maximize this assessment to go up against them.

Positioning in the Marketplace
In this section, you should describe your chosen niche in the marketplace. Potential investors understand that no one does all things well, and so the more focused your positioning plans seem, the more convincing they will be. Highlight why this niche is perfectly matched with your business model as well as with your personal strengths, connections, and expertise. For this section in particular, you will likely be pleasantly surprised at how a clear focus here will help you make better hiring, location, advertising, pricing, and other business decisions.

Pricing

The basic tenets of pricing in any industry should be addressed here, if only to explain why they may not all apply to a commercial art gallery. For example, while it's widely understood in business that prices must cover costs, the standard in many other industries of lowering costs to help lower prices isn't necessarily applicable to all segments of the art market. Because art is a luxury item (meaning that it is generally priced via the "demand pricing" method—the more demand there is for an artwork, the higher the price you can charge for it), lower prices are not always a strategic advantage. More expensive art, which means art with a higher demand, will often sell more quickly than less expensive art, for which there is obviously less demand. Because keeping your costs lower here is still good (but rather than facilitating lower prices it may, mercifully, translate into more profit), you should still outline your plans for doing that here.

Depending on the type of art you plan to sell, there may be public records (usually auction results) for recent sales of comparable work. Present your research from these records to back up your assessment that your pricing strategy makes sense in your market. You will actually do the math in the next section, as well as in the tables and charts of the financials section. Here, you want to convince your readers that not only do you understand the price points for the art you intend to sell, but that you have designed your business model based on a thorough analysis and realistic assessment of those prices.

Estimated Sales

Pulling together the previous five sections (Customers, Market Size and Trends, Competition, Positioning in the Marketplace, and Pricing) with an introduction detailing how you arrived at your numbers, present to your readers, in units and dollars, your estimated sales for the first three years of your business, breaking down the first year into quarters. Unlike companies that sell uniformly priced widgets, many art galleries cannot simply multiply the number of works they expect to sell by the number of clients they expect to sell them to. The price of their various artworks may fluctuate considerably. Therefore, calculations here can require a bit more math. It is fair to assume that if all goes well, you will increase your sales considerably each of your first three years just by staying in business. Name recognition (for your artists, if you're working with emerging ones, and for yourself) takes time to build, but most galleries begin to see a significant accumulative effect from their promotional efforts around the third year of business. That still may not mean record-breaking profits at this point, but it is generally much more than they sold their first year. End this section with a table that summarizes your estimates and rationale for each of the first three years.

Development and Production

Typically, this is the section in which a business owner describes how she plans to develop and produce her products. For new-fangled widgets, that discussion is often a bit more direct than it can be for art. Unless you're selling your own art in your gallery, which is not unheard of but is also not the typical scenario this part of the business plan describes for the average gallery, the "product" you sell may not be anything you were even remotely involved in producing; it might be, as in the case of editioned works the gallery publishes, but generally, the dealer isn't involved in the decision-making process when the artist creates the work. Having said that, all the art you sell can be "developed." By development, in this context, I mean raising the profile and perception of the importance of the artwork you're selling by attaining press coverage, critical acclaim, and important exhibitions or other institutional acknowledgment. Because a gallery is also a service company, it's fair to describe development as the set-up and announcement of your space, the plans to raise awareness of your gallery identity and reputation, the schedule for tasks such as designing your logo and business cards, or plans to build your standing in the art industry by volunteering on a benefit committee.

Development Status

Here you want to describe where you stand in the development process with your product. For a commercial art gallery, this section might include mentions of upcoming exhibitions planned for your artists, catalogues you intend to produce, or press stories you have initiated for your artists. If your artist, Jane Smith, is emerging (that is, not so many people in the art world know about her work), you might indicate how you intend to raise her profile by presenting a solo exhibition of her work at an international art fair or by securing a high-profile public commission for her. It will be more convincing if you present a realistic schedule for such efforts. For example, you can include information such as, "Designs for the gallery logo, Web site, business card, and letterhead will be completed by June 1, 2009," or, "The ninety-page color catalogue for our inaugural exhibition, with an essay by leading art critic Jonathan Stone, will be delivered by September 1, 2009."

Production Process

Even if you're working with living artists, it doesn't make much sense to discuss production as one would for a uniform product that is produced with regularity. You might be able to discuss plans for publishing prints or completing commissions, but the art you sell will most likely already be complete or will be dependent on so many variables in your artists' studios that you'll find yourself stumbling through

this if you approach it as one would a manufactured product. You can still describe the process you'll follow for delivering service to your clients and artists in this section, though. A justification of your location decision, the hours you'll be open to the public, your exhibition schedule, the strategy you are using regarding staffing versus outsourcing (you'll see many templates refer to such decisions as "make or buy" strategies, and they are typically expected to be discussed in your production process section)—all of these things are important to highlight, particularly in the context of how they will contribute to your profit margin. Some components, such as gallery hours, may be industry standards, but you should note them, anyway, in case your reader isn't familiar with the quirks of the art world.

Cost of Production/Development
In this section, you should present and explain your budget for production and development. As with estimated sales, I recommend projecting for the first three years and breaking the first year down into quarterly estimates. In addition to including costs for catalogues or other such developmental materials, be sure to consider the money spent on designing and preparing your standard materials, any consulting fees you might incur in getting set up, and any training costs for yourself or your business partners. Summarize your production and development costs for your readers in a short table.

Labor Requirements
As we will discuss in chapter 10 on "Staff and Management Practices," most young art galleries only add staff as the need arises because of how long it can take to begin generating significant profit. Depending on the scale of your initial operation, you may not have more than one or two employees (and many art galleries are started with only the principals working in the space at the beginning). Therefore, to complete the labor requirements portion of your business plan, you will necessarily have to speculate on the size of the staff you need to get started and how quickly your business will grow, which will require you to hire help. Most tutorials recommend that in this section, you cover the skills or education you would expect potential employees to have, what training you expect you'll have to do, whether talented candidates will be easy to find in your area or will have to be recruited from elsewhere, and how you're budgeting for staffing based on your estimated growth and the quality of local workers.

Expenses and Capital Requirements
In this section, you will present three financial estimates: monthly operating expenses, capital requirements, and cost of goods sold. For the first two, you'll

present a table summary with your discussion; for the last one, depending on your business model, you may need just an explanation. You will elaborate on these assessments later in the financials section of your business plan, but within the context of production and development, they are helpful in demonstrating that you're thinking clearly through what it will cost you to reach the point where you can begin to make a profit. You may want to consult an accountant or an experienced art dealer for guidance or at least a reality check on some of your estimates here. Project your estimates for the first three years of operations.

Monthly Operating Expenses. Present your estimated monthly operating expenses in a table with three columns: item, cost, and notes. Then, simply total them at the bottom. If you're using your business plan to obtain financial backing, make sure that you note, front and center, how much of your monthly operating expenses include repaying your loan. Most tutorials recommend that you organize your monthly expenses into three categories: marketing, sales, and overhead. In the first business plan I wrote for my gallery, not really following that advice, the items I included were as follows.

- Rent
- Loan payment
- Utilities (electricity, water, phone, DSL, alarm system)
- Marketing (printed announcement and invitations, postage, catalogs, seasonal/exhibition-specific publication advertising, and Web site costs)
- Office supplies
- Hardware supplies
- Owner's salary
- Insurance

In subsequent revisions, reflecting both growth and expenses I hadn't anticipated, I have since added the following.

- Professional services (accountant, bookkeeper, attorney, consultants, and association fees)
- Staff salaries
- Framing and shipping
- Documentation (of exhibitions and artists' work)
- Taxes (prorated)

- Travel and entertainment (including meals)
- Art fair applications and expenses (prorated)
- Production expenses (artist's costs to produce their work)
- Donations/charities/benefits

Capital Requirements. In addition to expecting you to provide realistic assessments of how much capital you will need to get up and running, readers of business plans will look to this section for details on expenses (and depreciation estimates) for major equipment, which for an art gallery can include computers, printers, and copiers; a moving van or other vehicle; a boom lift (for changing lighting in high-ceiling spaces or assisting in installations); and even kitchen equipment, if you're including such facilities in your space. Present your estimates in a table with the same three columns you used for your monthly operating expenses: item, cost, and notes. In my first business plan, the items I listed under capital requirements were:

- Build-out costs
- Office equipment and furniture
- Move-in costs
- Launch of advertising campaign

Cost of Goods Sold. Your business model will determine what you include in this section. If you're a secondary-market dealer, you may purchase a good deal of your inventory up front. Primary-market dealers generally sell work on consignment, though, so they don't incur much in the way of inventory expenses. It is possible to include shipping other such expenses in "cost of goods sold," but you can also account for those under operating expenses. If you intend to purchase inventory, present a "Cost of Goods Sold" table that includes the following for each of your first three years:

- Opening inventory (if you have any)
- Estimated cost of purchases
- Estimated sales

S.W.O.T. Analysis

The final part of your development and production section should be what's called the S.W.O.T. analysis, which is a frank assessment of your business's strengths, weaknesses, opportunities, and threats. This could also be its own section, if you

prefer. In considering each of these, point by point, you will highlight how well suited your business model and development plans are for bringing you success.

Strengths. This section might include your expertise or reputation in the industry, the reputations and achievements of your artists, your art education, your sales experience, your pricing strategy, any business model innovations you're initiating, the advantages of your proposed location, and your personal skills and talents.

Weaknesses. Things you might disclose here include expected slow sales seasons (July and August are considerably quiet in some markets, but might be booming periods for galleries that cater to tourists), the strength of your direct competition, and the unique challenges you have in gaining market share.

Opportunities. Describe, using examples, why you're optimistic about the success of your business plan. Some questions you may want to ask yourself include: How will your location contribute to sales? Why is a luxury item like art a good product for the current economic climate (i.e., art remains a solid investment even while stocks decline)? How might plans to develop a high-end apartment building or office compound in the area translate into commissions for your artists? How might your participation in certain associations or institutions provide more name recognition for your business?

Threats. Examples you might want to share include the impact that a downturn in the economy would have on certain segments of the art market. Note why your segment may or may not be "recession-proof." Also, if you're working with living artists, acknowledge that any one of them might leave you for the competition. Other threats can relate to skyrocketing costs or rents. There is no point in not being blunt in this section; your readers will know what threats stand between your plan and its success. Their knowledge that you are taking these weaknesses into consideration will help build their confidence in your strategy.

Sales and Marketing

Perhaps it's the late placement of this section in most business plans or maybe it's the difficulty of doing such planning in advance of opening a business, but most discussions I've read point out that the sales and marketing section of most new business plans tends to be among the weakest. With that in mind, and knowing that you can't afford for any portion of your business plan to fail you, I advise that you set aside some extra time to work through these matters thoroughly. After all, by definition, a commercial art gallery is an entity focused on sales. In this section, you should cover the following three topics: strategy, method of sales, and advertising and promotion.

Strategy

Your sales and marketing strategy is an action plan for identifying who your clients will be and how you intend to convince them to buy the art you sell. As with your business description, the length of this section should be determined by the complexity of your sales and marketing strategy and nothing more. In other words, don't pad this section with useless information. Tell the story of your sales strategy clearly, compellingly, and in a fashion that will be supported by your subsequent sections on method of sales and advertising and promotions strategies.

Begin this description with a discussion of who your initial target clients are going to be. Right out of the gate, who will you try to sell art to? Define them as best you can, especially geographically. And what art will you attempt to sell them? It's probably more convincing to note that you're targeting people who are already involved in buying art. What your potential investors most want to know up front is exactly what concrete steps you will take, starting on day one, to bring money back into the business. If you don't know this yet, you may not be ready to open, and you are definitely not ready to describe your sales strategy. Matching potential clients with product is the first part of your sales and marketing strategy. The next part is describing exactly what you will highlight about your product in order to convince clients to start writing checks. Will it be the art historical significance of the art, or the transcendental qualities it possesses? There is a lot of art out there. Why is what you're selling a better buy, and how are you communicating this? Are quarterly newsletters or artist talks included in the gallery portion of your strategy? Finally, highlight any innovations you're implementing that will facilitate getting those clients to care more about your product.

Follow this up with a projection of where your future clients will come from and how you plan to attract them. For a commercial art gallery, it's good to note that client education is a big part of any sales strategy. Offering to accompany prospective clients to art museums or artists' studios or discussing the ins and outs of buying art on a panel are a few such strategies. What materials will you use to expand your client base, and how will you find their contact information? The types of mailing lists a new business owner might consider buying in order to market expensive cars or real estate might prove a complete waste of money for the more exclusive (that is, much smaller) client base that buys art. Then again, perhaps your strategy is to cast as wide a net as you can and have carefully considered follow-up plans to make that work. For many younger art galleries, meeting new clients at art fairs is a big part of the strategy.

Method of Sales

As opposed to your marketing method, which focuses on how you raise awareness of your product, your method of sales is how you physically get your product into

your clients' hands. Here, you can address typical small business questions, such as: Will you sell to your clients directly or use sales representatives or brokers? Are any third parties involved? Will your clients come to your location and take the product away with them, or will you ship from a warehouse or central location to wherever your clients reside? For example, I know of a gallery that successfully sells a good deal of art via the Internet and has it shipped directly from their artists' studios. The traditional commercial art gallery method of sales is direct-to-client selling, and shipping through an art handler if the work is too large to walk out of the gallery with or if the work is on exhibition and unavailable to be taken down until the show is over. Primary-market dealers often take clients to their artists' studios and then arrange for shipment from there, as well.

Advertising and Promotion

In this section, you'll describe your promotional strategy and provide details on which channels you will use to get the word out about your business. Questions you should answer here include: Which publications or other vehicles will you use for advertising? What kind of promotional materials will you develop? What is your public relations strategy? Will you hire a publicist or use a PR agency? If so, who are their other clients and what are their significant accomplishments?

If you already have samples of the kinds of mailings, ads, or other promotional materials you'll use for your gallery, note in this section that you have included them in an appendix (exhibits). Also, provide a sample press kit (if available) and describe which publications you intend to target in sending out announcements. If getting listings for exhibitions in your area is competitive, describe your strategy for gaining the attention of your target publications' listings editors. Discuss your other promotional plans here, as well. For example, list the art fairs in which you plan to participate, where and when they take place, and what your strategy is for standing out among the other galleries there. Finally, if your advertising and promotions strategy represents a significant expense, use a table to summarize how and where you'll be spending your money.

Management

Just as you did in your business description, be sure you sing your own praises in the Management section of your business plan. Most tutorials will suggest that you break this section down into subsections dealing with management description, ownership, board of directors/board of advisors, and support services, but for the average commercial art gallery, especially the younger ones, the first three sections would probably be redundant. As you would for a much larger company, though, make sure you describe how the talents of every person who will be working in your

space complement each other and add up to a strong and experienced team that is ready to take on the art world.

Management Description

However you structure this section, you will want to include descriptions of the expertise of and responsibilities for each member of your gallery's management staff. Potential investors will be particularly interested in the experience of the person ultimately calling the shots. That means you and any partners you have. So, highlight your education, prior business experience, sales experience, art expertise, and connections in the art world here. Personally, I wouldn't hesitate to explain that there is no one educational path to becoming an art dealer, and perhaps cite examples of previous careers that highly successful dealers had before opening their galleries. Additionally, your strong communication skills, talent for sales, and contagious passion for art are all well worth describing here. It's also customary to include the résumés of key management staff in the exhibits appendix. If you do not yet know who you will hire for a key management position, list the skills and experience you will look for in finding that person.

Support Services

Mentioning whom you have lined up as your gallery's attorney, accountant, PR firm, etc. can be impressive for potential investors, not only because it will indicate how seriously you're taking your business plans, but also because their respective business reputations will reflect well on you. So, play this section up. Convince the reader that having these professionals working for you will translate into your success. If you know that sales tripled when Gallery ABC hired the same PR firm you're hiring, be sure to note that here. Also, explaining how you're already budgeting for these will further demonstrate how thoroughly you've done all your planning—that you've considered which services you will hire full-time staff for and which you'll outsource, and that you have a good understanding of what responsibilities will fall to you and your staff.

Financials

For certain readers of your business plan, this will be the most convincing (or, potentially, not convincing) section. It is where you ultimately demonstrate that your plans will result in profit. For many people just getting started in business, the financials section of a business plan is the least appealing because it involves a fair amount of speculative math. Once you've been in business for a while, though, this quickly becomes the section you're most interested in seeing after each revision cycle. You might consider hiring an accountant to do these

calculations for you, or you might do them yourself and then have an accountant review your results.

Most banks that cater to small businesses are happy to give their customers free spreadsheet templates for these reports. You simply tailor their generic fields to match your business and enter your estimated costs. The totals are calculated for you. Still, if you are using your business plan to secure funding, you can be sure that this is the section potential investors will spend the most time poring over, so check these reports carefully, and then have your accountant check them. Also, note that some business plan tutorials will recommend discussing adding a risks appendix to this section. For a small commercial art gallery, though, the threats portion of the S.W.O.T analysis described above might be sufficient for this purpose.

Estimated Sales

You will have already discussed the logic behind your sales estimates in the market section of your business plan, but to make it easier for your readers to follow your financials, I would present them in table form here again. Provide your estimates for the first three years, breaking down the first year into quarters. Also, summarize your rationales for each estimate in a "notes" column in the table.

Cash Flow Statement

In a nutshell, your cash flow statement shows how and when money moves into and out of your business. It shows liquidity. You may find it helpful to think of the cash flow statement as parallel to your checking account statement from your bank. There are four main figures for each time period covered in the statement: the opening balance (how much money you have at the beginning of the time period), the cash inflows (income, or "deposits"), the cash outflows (expenses, or "withdrawals"), and the net cash flow figure (the new balance at the end of this period).

To an experienced reader of cash flow statements, an unrealistic estimate or spike in sales will stick out like a sore thumb, so curb your desire to overstate your expectations here, not only for credibility reasons, but also because if you're seeking financial backing it makes sense to convey how much money you're really going to need rather than to suggest you'll need less. After a short introduction, present your cash flow statement in a table broken down by month for at least the first year, then quarterly for the second year, and annually after that. For a start-up gallery, the first three years should be sufficient for any reader. Explain in the introduction any significant seasonal fluctuations. Summer can be fairly slow for art galleries in some markets, whereas many galleries can reasonably count on significant income after major art fairs. This information may not be obvious to your readers. Again, your bank may have helpful templates for organizing this.

Balance Sheet

The balance sheet is an annual report used to calculate your business's net worth at the end of your chosen fiscal year. If you're writing your business plan for a gallery that's already in business, you will introduce this report with your analysis of what it means. For a start-up gallery, potential investors want to see your personal balance sheet here, outlining your assets and liabilities. Here, again, it's recommended that you have an accountant review your report. Hopefully, she will be able to guide you to include assets that you might not have realized will help build your case.

Profit and Loss Statement

Whereas the cash flow statement shows how much cash you have or can easily have on hand at any given time, the income statement shows profitability. That is, it doesn't show just how much income you expect to come in during the year, but what's left over after you subtract all your yearly expenses from that amount. In any small business, you might have great cash flow a few months of the year, but if your ongoing expenses gobble up all of that throughout the rest of the year, you won't have made any profit. An income statement is designed to reveal whether your business plans will result in profit.

SUMMARY

If enthusiasm alone were enough to make a business thrive, far fewer of them would fail. As the length of the discussion above should make clear, there are so many variables to consider in running a commercial art gallery—expensive variables—that diving into it without taking the time to see how interdependent they are and how each contributes to your success or failure is willfully entering into a costly venture with blinders on. As time-consuming and perhaps daunting a task as writing a business plan is, the variety of helpful online tutorials and step-by-step advice available make it a no-brainer for the new dealer who wants to succeed. But don't take my word for it; try seeking start-up capital from a bank or a savvy investor without one.

7

Location and Build-Out Issues

One of the things I hear repeatedly from our clients—many of whom are high-powered executives or captains of industry—is that for them, collecting art is relaxing and fun. Usually, they have enough stress in their day jobs. When it comes to viewing and purchasing art, they want it to be as enjoyable and stress-free as possible. With that in mind, one of the most important factors in determining where to locate your gallery is how easy it will be for your clients to get there. There are, of course, stories of fantastic young galleries that started in hard-to-reach locations, but because of the quality of their programs, the art world beat paths to their doors. However, even those spaces generally move to a more convenient location as soon as they can afford it.

Other factors that will impact the location you choose will be your business model, the economy, what you can afford, and, last but not least, the type of art you intend to sell. If large, bronze sculpture is a big part of your program, for example, a fifth-floor space in a building with no elevators may not be a great choice. If you need to keep a large inventory, is it possible to dedicate much of your actual space to storage, or is there a qualified storage facility within relatively easy reach? What is the real estate situation in the area where you plan to open? Is space tight or plentiful? Where are the other art galleries in your area located? Is being near them a benefit or a drawback?

In this chapter, I'll examine what to look for in any potential gallery space, with an emphasis on the standard construction considerations and recommendations for

the classic "white cube" space. I'll delve into what to ask and look out for with regard to the players with whom you'll be working to get your space set up, including brokers, landlords, lawyers, architects, and contractors. Finally, I'll discuss how to incorporate your business model, program, identity, available funds, and business goals into your location and lease decisions.

WHAT TO LOOK FOR IN A POTENTIAL GALLERY SPACE

Although much of what will determine whether an available space would be right for your gallery will depend upon your program and business model, there are some physical considerations to keep in mind during your search, as well. Most galleries have four to five general areas:

1. Exhibition (or gallery) space

2. Reception and office space

3. Inventory space

4. "Comfort" spaces (restroom, kitchen, etc.)

5. Utility storage space (many smaller galleries combine this with their inventory space, but you may want to consider keeping them separate)

In the following sections, I'll look at what you should keep in mind for each of these general areas when considering whether an available space would make a good gallery.

Exhibition Space

Although there are some notable exceptions, the vast majority of exhibition spaces within new commercial art galleries today follow the "white cube" format. Long expanses of uninterrupted white walls, high ceilings, monochromatic (generally concrete or wood, usually uncarpeted) floors, and highly flexible lighting systems are seen as ideal. Whether or not to have any windows seems to be a highly personal preference, but as they consume valuable white wall space, they are generally limited. The appeal of the white cube is that it permits the space to be as inconspicuous as possible, which places the emphasis on the artwork (in theory, anyway). Some white cube spaces are so spectacular themselves, with soaring ceilings and pristine surfaces, that few visitors would walk away without having noticed them. Sometimes referred to as "cathedral galleries," they are often designed by celebrity architects and can be more readily identified in photographs by seasoned gallery-hoppers than can much of the artwork they may have on exhibit at any given time. Opening a cathedral gallery sends a particular message about the ambition and the

confidence of the dealer in her program, but can also be intimidating to newer collectors and potentially put off certain artists who fear that the space may upstage their work.

Even with the white cube exhibition space, though, there are many build-out decisions to be made, and considering them before you start looking at available spaces will help guide you through the process. The following standards and recommendations are designed to help you determine if a potential location is right for you. Some of these decisions are ones you'll only make after you have a space, of course, but knowing before you get started what you'll eventually want will protect you from unpleasant surprises.

Ceilings. The standard is a twelve-foot ceiling or higher. You can possibly get away with a ceiling as low as ten feet before the space feels too claustrophobic. To have flexibility in lighting your walls, though, you'll probably want fixtures that rotate or that are on tracks, and they will consume some of the visual wall space at the top. Therefore, anything lower than ten feet will really begin to impact how comfortable your viewers feel, as well as limit the size of the artwork you can exhibit. If the space doesn't already have one, your insurance company or the local government will most likely require that you install a sprinkler system, and that will take up some space at the top, as well. Sheetrocking the ceiling offers an elegant look and feel to a white cube but automatically lowers the ceiling and necessitates more expensive sprinkler solutions, which is why some galleries simply work with the exposed pipes and such, often painting it all white, if their ceilings are somewhat low already.

There really is no gallery standard for what might constitute "too high" when it comes to ceilings. Lighting solutions are available for just about any height in a space. Many dealers would be happy to deal with the extra lighting issues to have thirty-foot ceilings. The only consideration I would highlight here is to keep in mind how much it's going to cost to heat and cool your gallery.

Plywood behind sheetrock for walls. It is strongly recommended, regardless of what type of art you plan to exhibit and how light you think it will always be, that you place plywood ($\frac{1}{4}''$ is common in galleries, but museums use up to $\frac{3}{4}''$ plywood) behind the sheetrock of each wall in your gallery on which you will be hanging artwork to ensure that it can hold the weight. Anchors, while effective initially, will become less reliable over time, because each time you sink a new screw (let alone an anchor) into sheetrock, you weaken it. Drilling into plywood provides much more support. Plywood is undoubtedly an extra build-out expense, though, which leads some newer galleries to have their walls constructed with only

a strip of plywood running along the hanging height zone of their walls, rather than having it installed floor-to-ceiling (ideal, but obviously more expensive). As for what constitutes the "hanging height zone," personal preferences vary, but as many museums hang their artwork at about sixty inches on center (meaning, the center of the artwork is generally sixty inches from the floor), the hanging height zone in which only a strip of plywood is used behind the sheetrock is generally the area from fifty to ninety inches from the floor.

Reveals. A trendy feature of white cubes lately, because it's aesthetically interesting and offers the illusion of floating walls, is the treatment known as a "reveal." In this technique, the sheetrock doesn't actually meet the floor, but stops short about two inches above it, revealing a shallow cove. This treatment looks good and makes walls easier to repaint because you don't have to worry about cutting in where the wall meets the floor. The downsides of using reveals are that your floors have to be perfectly level (any imperfection will be magnified), and if you show artwork that hangs down from the wall and curves out into the floor, the graphic stripe of the reveal can be distracting.

Not all "whites" are created equal. The range of white colors available is remarkable, but hints of blue or yellow or green may not be as noticeable when your gallery is empty, perhaps, as they can be after you put artwork on the walls. Which shade of white you choose will subtly impact the mood in your space, affect how artwork looks in it, and influence the type of lighting system you will need to make the room feel the way you want it to feel. What is "right" for one gallery may not be for others, though. A cool sensibility (offered by whites with gray or blue tints) may be perfect for cutting-edge programs, whereas a warmer feel (offered by whites with red or yellow tints) may make more sense for galleries focused on accessible work.

Quality (or lack thereof) will show. Be very conscious during your gallery build-out that the sheetrocked walls are as smooth and level as possible. Hiring less expensive labor as a way to cut corners and save on costs may seem tempting, but you may regret not paying for quality work here. A very subtle shift in the straightness of a long wall might be imperceptible to the eye, but hang a wide painting on it, and you'll notice it immediately.

Lighting systems. Lighting preferences seem to be as diverse as art tastes in the gallery world. Natural daylight is seen by many as the ultimate way to view art, but others often want more control than having to rely on weather and time of day. As of late, a debate of sorts has played itself out in the lighting of new gallery spaces. The

central question in the debate seems to be: Is it better to light the art or to light the space? Traditional approaches that spotlight art now seem too theatrical for many dealers. Moreover, spotlighting artwork invariably seems to leave some parts of it "hotter" than others and can create monstrous reflections on work with frames or shiny surfaces. For most exhibitions, then, an even light throughout the exhibition space addresses these concerns and seems more honest and art-friendly. The trick to getting an even, diffuse light throughout the gallery with a minimum of shadows is not the type of lighting fixtures one uses as much as the number of fixtures and their distance from the wall.

For some exhibitions, though, more theatrical lighting might be appropriate. Bringing in such lighting after the fact can be very expensive, so I recommend that you plan for maximum flexibility in designing a lighting system. The problem of being able to create a good allover light that approximates daylight when appropriate but having the option of highlighting certain objects when needed is resolved by many galleries through a mixture of fluorescent lights and incandescent track lighting systems. An architect or lighting designer will have plenty of recommendations for you on fixtures and bulbs (I'll discuss working with architects below), but to find a lighting designer in your area, you can start at the Web site of the International Association of Lighting Designers (*www.iald.org*). Flexibility and aesthetics are important considerations when selecting fixtures, but there are far too many options for me to offer any specific recommendations here. If you intend to design your lighting system yourself, you might want to brush up on your bulb (or lamp) vocabulary, with an emphasis on knowing how to choose based on the quality of light they offer and how efficient or expensive they are to use.

The quality of light offered by fluorescent bulbs is measured by two main criteria: color rendering and color temperature. Color rendering describes how true the light source makes the color of something appear to the human eye. The Color Rendering Index (CRI) goes from 0 to 100 percent and tells you how close to natural light a bulb will make things look. The higher the CRI percentage, the more truly the bulb will render color, but also the more expensive the bulbs are in general. Other systems for measuring color rendering are currently entering the market, but CRI seems to be the most common as of this writing. On average, consumer fluorescent tubes have a CRI of about sixty, but specialty fluorescents are available with a CRI as high as ninety-eight.

Color temperature measures how a bulb looks when you're looking directly at it (as opposed to how it makes other things in the room look to you). The color temperature of fluorescent bulbs is generally measured in the unit Kelvin (K). Bulbs with a color temperature of about 2700K will look yellow. Those with a higher color temperature look more like daylight (a bluish white) and have a color temperature

of between 5000K and 7000K. Just as with CRI, the higher the color temperature, the closer you get to natural light and the more you can expect to pay. A color temperature of more than 5000K is recommended if you want your fluorescent lamps to simulate daylight.

Incandescent bulbs give off light via heat generation and are hence much hotter than fluorescent bulbs after they have been on for awhile. Because this is how they generate light, by definition, the CRI for incandescent bulbs will be virtually 100, but the color temperature will vary greatly. Galleries frequently prefer to use halogen bulbs for their track lighting needs because they are often designed to last longer, use energy more efficiently, and give off light of a higher color temperature. For maximum flexibility, you may wish to have bulbs of both the spot and flood variety. Spotlights will give you highly concentrated light, but as mentioned above, reflection or "hot" passages are often the results. Floods can be used more effectively to "wash" your walls with even lighting.

Flooring. Although most dealers would argue that walls and lighting are the most important elements of an exhibition space, flooring can bring it all together well or prove to be a very unfortunate distraction. Conventional wisdom holds that the more open space you have or the lower your ceilings are, the more important it is for the flooring to be clean, even, and inconspicuous. More than that, though, issues ranging from color to material to durability should be matched to the type of art you will show, how much additional construction (temporary walls, for example) your exhibitions may entail, and the overall image you wish to project.

Floors in many galleries will regularly take an awful beating, which is why concrete or epoxy coatings over concrete tend to be popular for contemporary art galleries. This look can be rather cold, though, so some dealers prefer wooden floors (sometimes painted). White terrazzo flooring is a high-end choice that is growing in popularity, but it comes at a high-end price.

Reception/Office Space

Few areas in your gallery will reflect your identity as readily as your reception area and office space. Whereas the conventional wisdom says an exhibition space should be as neutral as possible so as not to compete with the art on display, where you greet the public or conduct your business is an opportunity to underscore your vision. In many galleries, the reception area serves as the gateway to the office space, and the stereotypical velvet rope (or, even more coldly, a metal chain) serves to delineate the space that is open to all from the area that is reserved for invited guests only. More recently, however, many younger dealers seem to prefer to be seen out in the open, where they are available to answer questions and are accessible to all.

How much space you will need for your reception/office space depends on a number of factors, including how much privacy you prefer when conducting business, how much art you're actually selling, how big your staff is, and whether anything about your programming in particular requires extra space. The more artwork you sell, the more storage, handling, and support staff space you'll need. The bigger your staff is, the more computers and work space you'll need. Finally, if you sell large work or delicate work that requires particular care in handling or packaging, you may need extra room to accommodate that.

How you arrange your office workspace, particularly the area in which your own desk will be located, conveys a great deal about your vision for the gallery. Some dealers install a fair bit of inventory on their office walls, for example. Others have virtual libraries of catalogs, magazines, and artist archives on display. Still others go for the extremely minimalist look, which communicates a sense of confidence and power usually associated with a CEO of a large corporation.

The nature of how long some buying decisions can take in the industry persuades most dealers to reserve at least some wall space in their office area for displaying unsold work from previous exhibitions or previewing samples from an upcoming show. Some galleries create special viewing rooms within the office area, with comfortable furniture and even refreshments, where collectors can relax while the gallery staff bring in artwork from the inventory for their consideration. If you intend to display art in your office, the same walls and lighting considerations you made for the exhibition space should apply here.

Inventory Space

The amount of space you'll need to store artwork within your gallery depends on many of the same considerations you made about your programming, identity, and sales. The safety of the art while in storage is the paramount determinant of whether a space is appropriate for inventory. Obviously, you want to store art in a space that is dry, clean, not too hot or cold, not exposed to sunlight, and not likely to have pests (mice, insects, mold, etc.) set up home there. Next, perhaps, is ease of entry. Placing your inventory space where it causes constant interruptions to other parts of the business will get old very quickly. You will likely want your inventory space to be private as well so that work can be unwrapped behind closed doors and clients do not have to watch you or your staff struggling to prepare a work for display (bubble wrap, cardboard, glassine, and tape can be stubborn at times).

Some galleries keep a certain amount of uninstalled inventory unwrapped for ease in showing it to clients. Methods of keeping it safe include hanging the work on sliding racks or storing it in slotted shelves lined with carpet. For unframed works on paper, a flat file is common. As your inventory grows, which it will in both

the primary and secondary markets, you'll begin to see the wisdom of carefully labeling all the wrapped work therein, as well as ensuring that the labels can be seen without having to move all the other work. This usually requires arranging inventory space so that as many pieces as possible are visible from where you will stand upon entry, and it further determines whether a space within your gallery is ideal for this purpose.

Depending on how expensive your rent is, you may find it better to have some, if not most, of your inventory stored in an off-site location. A facility suitable for art storage in the vicinity, therefore, can be an important factor in choosing your gallery's location. Security and climate control are obviously as important off-site as they are within the gallery. A facility that includes delivery services can be a real plus, as well.

"Comfort" Areas

If you're like most new art dealers, you're going to spend very long hours in the gallery. Therefore, in deciding what to do with a smallish or odd extra room in the back of the location you choose, consider reserving it as a "comfort" area, such as a small kitchen or, perhaps, a shower stall. Neither of these are essential, obviously, but having worked in galleries that had such luxuries, I can tell you they are certainly very welcome at times.

You will need a restroom, of course, but many galleries manage just fine sharing public restrooms with other businesses. If you plan to have a restroom in your gallery, take into consideration as you lay out your space whether you'll make it available to the general public. Having a steady stream of guests file through your office area at a reception, for example, especially when drinks are being served, can be a disaster waiting to happen. (I once lost a laptop when a guest at an opening, waiting to use the restroom in the office, spilled his cocktail on it.) Many galleries combine their restrooms with their general utility storage areas. If this is the case for your space, consider choosing what is charmingly called a "slop sink" (i.e., a deep, industrial-sized sink) rather than one chosen for its aesthetic value. The amount of cleanup from construction, repainting of the gallery, or mopping of the floors that your sink is likely to see will make you wish you had forgone the designer basin.

When it comes to kitchens, I recommend at least a small refrigerator and perhaps a microwave for those long nights when all the convenience stores or restaurants are closed, or to keep a bottle of champagne handy for impromptu celebratory moments. I know of galleries with kitchens as luxurious as their exhibition spaces, including full-size refrigerator/freezers, stoves, dishwashers, and miles of countertop space. If your promotional events are catered, this is very helpful. An area other

than desks where your staff can eat is nice to have, as well. One Chicago dealer I know had a full apartment within her office area, including a private bedroom. Your business model, promotional strategy, and personal needs will influence much of what you decide here.

Utility Storage Space

In addition to storing art in your gallery, you will need to store supplies and tools. Given the hazardous potential of half-empty paint cans, mops, power drills, and the like, it may be wise to keep the two storage areas far apart. In evaluating how much utility storage space you need, keep in mind that although packing materials are much cheaper in bulk, if you do not have much room to store those huge rolls of bubble wrap, you will be moving them around constantly. As with your art inventory, depending on how much you are paying per square foot for your gallery, you may be better off putting some supplies in an off-site storage space. How frequently you change exhibitions; whether you store pedestals and other installation materials or have them tailor-made for each exhibition; and how much art you sell, pack, and ship out will all factor into how much utility space you should set aside.

WORKING WITH PROFESSIONALS TO FIND AND BUILD OUT YOUR SPACE

There is no city I know of in which there are more art galleries than, say, restaurants, clothing stores, or convenience stores. Therefore, it is not surprising that most professionals you may end up working with to find or build out your gallery space will likely be unfamiliar with the specific needs or preferences of art dealers. Ugly floor-to-ceiling pipes "can be hidden behind a curtain," they may tell you. Exposed brick, complex moldings, and architectural nooks and crannies "make the space feel trendier," you're likely to hear. Turning such a space into a white cube is possible, but you may be looking at more than you've budgeted to get the look and feel you're hoping for. Some challenges are to be expected, of course, but the floor or wall space you lose during complex build-outs will begin to add up. Therefore, it makes sense to explain in detail what your goal is and how the space needs to be as continually flexible as possible to each of the following professionals. Based on my experience and that of other dealers with whom I've spoken, here are some considerations for what you should explain and how best to communicate your objectives during the search and construction phases of opening your gallery.

Brokers

If you plan to open your gallery in an area where other galleries already exist, you may be fortunate enough to find a commercial real estate broker who specializes in

gallery spaces. If you are so lucky, hang onto that person with both hands. The number of entirely inappropriate spaces our first six "retail specialists" took us to see was very discouraging. When we finally found a broker who had experience working with other art dealers, the difference was remarkable. Not only was she well versed with our concerns about ceiling heights, entrance widths, freight access, and uninterrupted wall space, she instinctively matched what we told her about our identity with options that fit our budget and marketing strategy.

Real estate brokers work on commission, which means that although their fee structures may vary per market, the fee will typically be a percentage of the total dollar amount of the transaction, whether you are renting or buying your space. The tighter a real estate market is, the less likely it is that you will be successful in negotiating a better fee, but it is worth a try. Web sites with national information on brokers' commissions seem to place the average for customers leasing a commercial space at about six percent of the "aggregate lease value" (that is, your monthly rent plus the term of your lease). How long a lease you want depends on your situation, of course, but knowing that most art galleries do not become significantly profitable for at least three years, you will want to take that into consideration when signing.

Landlords

Again, because it can take years to turn a profit in this business, most new dealers do not buy their first gallery spaces. Therefore, it's helpful to know what you should discuss with potential landlords in considering whether to rent a space. Issues that we and our friends who have galleries have had to raise with our respective landlords after signing leases include continuously unhindered access during gallery hours since new clients often don't make appointments, continuously unhindered access during gallery hours; outside noise that competes with video- or audio-based work is tantamount to shutting off such art in an exhibition; and the an expectation among many dealers' clients that galleries maintain a certain decorum, including in their lobbies or entrances. On the other hand, be sure to mention to potential landlords that galleries make excellent tenants since they operate mostly in the daytime, are relatively clean, and host only the occasional party. Compared with nightclubs, bars, or other venues that seek out cavernous, warehouse-style spaces, galleries can be very attractive to most landlords.

Although most businesspeople will feel that this is obvious, new art dealers open with a range of previous business experience, so it bears noting here that regardless of how nice a landlord may seem, it is best to let your attorney handle all lease negotiations. Not only will this spare you from having to bone up on real estate law, but it leaves any tension that may come up during the discussions to the professionals and permits you to get off to as friendly a start with your landlord as

possible. One of the first points of contention (and something you'll definitely want your lawyer to negotiate) is how large a security deposit your landlord requires. Six months' rent is not uncommon in New York, for example, but that kind of payment can seriously drain your start-up capital. Some commercial leases stipulate that portions of a security deposit are to be returned to the tenant after a period, so long as they prove that they can pay their rent on time. Getting the best terms possible here is definitely worth the lawyer's fee.

Lawyers

Speaking of lawyers, the attorney you hire to help run your business may not be the best person to negotiate your lease. Consider hiring one who specializes in real estate if the initial terms you are offered are far from ideal. If you feel that they're close to what you can accept, you may want a lawyer who understands the nature of the gallery business to represent you. I'll discuss finding a lawyer with arts experience and what to expect in fees in chapter 12, but when negotiating your lease, the issues you will want your lawyer to emphasize include any seasonal fluctuations in your business hours, especially if you split utilities or other shared costs with other tenants; opening reception schedules, especially if there are elevators or doormen to consider; and exact architectural specifications if the lease includes any build-out responsibilities on the landlord's end. The issues discussed in the sections below on working with architects and contractors are well worth reviewing with your lawyer if your landlord will be handling any part of the build-out on your space.

One final thing you should consider in working with a real estate lawyer applies regardless of what type of business you're starting, but I will note it anyway in the interest of helping you avoid a costly mistake. If you have a business partner in your gallery, sit down together and work through all of your concerns about the lease (listing each and every conceivable point of disagreement and arriving at your joint decisions) well before you enter your lawyer's office. Trust me on this.

Architects

Every art dealer I speak with about architects tells a similar story. It can be a struggle to get them to understand that you do not want the exhibition space in the gallery to reflect their signature flair. Indeed, all my friends seem to have the same sense of how to work with an architect: tell them, "The façade or office spaces, sure, run with those, but the essence of a white cube is that it is functional, flexible, and *inconspicuous*." An architect who listens to you and hears you, especially on this point, is important.

Perhaps the best source for architects who have experience working with galleries is recommendations from other dealers. Simply asking another gallery

whose space you admire might be your fastest route to the right architect for you. You can also do a search on the American Institute of Architects (AIA) Web site (*www.aia.org*). Before you decide, though, I would recommend that you interview a few architects, request and then call their references (in particular, ask former clients how easy it was to work with them and whether costs got out of hand), go to see their work in person, and then ask for estimates for design alone vs. design-build fees (if the architect offers that combined service).

There are advantages to both models (design-build, in which your architect or her firm also manages the construction, and design-bid-build, in which your architect delivers the plans and then you take bids for a general contractor to manage the construction), but the design-build model can end up saving you a considerable amount of time. Regardless of what you decide, make sure you get everything in writing. You can find standard contracts for working with architects on the AIA Web site. Most commonly, an architect will complete a project for one stipulated fee or charge by the hour. As with lawyers, making as many decisions on your own time as possible can save you money.

Dennis Christie and Ken Tyburski own New York's DCKT Contemporary (*www.dcktcontemporary.com*), which recently moved from Chelsea to the Lower East Side. I asked Ken to share his and Dennis's experience in choosing and working with an architect to design and build out their new space. As do most new dealers, the DCKT partners asked around for recommendations and ended up choosing a firm whose architects were good friends with one of DCKT's artists. "Because [we had a] personal relationship and we knew their work," said Ken, "it was a very good fit."

They went the design-build route and had their architects do all the planning, from demolition to air-conditioning. "They started by giving us three or four ideas for the space, and we chose the things we liked best in each and combined them," noted Ken. "They filed all the permits and then they bid out the job. We had one contractor, as well. The contractor we ended up going with was by far the least expensive and quickest. He was so good that we recommended them to several galleries." The fee their architect charged was consistent with the design-build model: 15-20 percent of total cost. In hiring an architect for plans only, a set fee is more typical. Ken told me their total build-out costs fell within the range I noted previously for small galleries (between $100,000 and $250,000).

Ken's advice for what to consider in choosing an architect is so solid, I want to quote it verbatim: "Make sure you do a lot of interviewing, and pick the firm you can relate and discuss ideas with. Building a space, any space, is a very personal experience. You want to be able to candidly say what you want, but you also want them to be able to take your snippets of ideas and create something unique and

interesting from [them]. Often, the architect's ideas may be way off from those of the client. You must really look at their past work, current work, etc., to see if you like it. But you need to also make sure you get along with them. I suggest having a lunch or dinner. It's about creating a space you are both excited about. That takes a lot of communication."

Contractors

Constant communication with your contractors is perhaps the most critical part of avoiding costly mistakes or delays in building out your gallery. This does not mean that you should constantly get in their way, but rather ensure that they know you'll be around when a decision needs to be made. Time equals money, and a contractor may make a decision in good faith based on their own expertise if you are not available, which can lead to serious problems. Construction issues that might seem insignificant for businesses that later bring in all manner of furniture or fixtures can, for a gallery, greatly limit how flexible or pristine a white cube you end up with.

In fact, the concept of a white cube is something I recommend you explain in meticulous detail to each new contractor or worker involved in building out your space, even if you hire a general contractor whom you believe "gets it." Make sure you emphasize just how important it is that the walls are as uninterrupted as possible, floor to ceiling, throughout your exhibition space and any office viewing space, to each person involved with installing the phone line, alarm system, HVAC vents or controls, electrical outlets, and lighting switches. Even if it seems like overkill, respectfully make sure that they all hear the lecture.

During the recent build-out of our Chelsea space, for example, after we held careful discussions with our electrician about where our track lighting and fluorescent fixtures needed to be, he subcontracted the installation of the conduits to another group of workers. When I saw their first attempt, I was not pleased. They assumed that the tubing would be painted white to match the walls, making it barely noticeable, and they opted to save me money by cutting straight across the top of an exhibition space wall (rather than bending it to fit along the series of ceiling beams). They were also surprised that I was so displeased about the fact that they installed the light switch in the middle of the wall rather than in the obviously less convenient corner.

Keep in mind that you're working toward a pristine exhibition and office space, and when you request bids from contractors, ask that their written outlines of scope of the work include costs for preparation work, care to protect the rest of the space, and cleanup. For the contractor who paints your walls in particular, make sure the bid specifies how the surface will be prepared (priming is highly recommended); the number of coats of paint needed; the precise brand, finish, and color of the paint; and

what care should be taken to protect the floors, other areas, etc. In considering bids, you will likely be happier in the end with a contractor who breaks down the total price into clear and understandable costs. This helps ensure you that they understand the job at hand.

Make sure any contractors you hire are licensed and insured. Make sure as well that you get a signed contract that includes the scope of work, costs, start date, and estimate of when they'll finish. Also, ask that the bid include payment schedule details and stipulate that the final payment will be made only after you have inspected and agree that the work and cleanup match what your contract said.

FINAL CONSIDERATIONS

Every commercial real estate broker I've worked with shares the same advice about finding a space to rent or buy: be prepared to sacrifice something on your wish list or be prepared to look forever. In most markets, you are not likely to get everything you're looking for in a location. Still, if you've taken the time to prioritize your needs in a space based on your business model, program, and identity, as well as your available funds and business goals, you will be less likely to wish you had simply looked longer after a few months.

Markets like New York regularly see shifts in the epicenter of the gallery world; from Fifty-Seventh Street to SoHo to Chelsea to the Lower East Side, "the place to be" keeps moving. Of course, "the place to be" depends a great deal on the identity you are cultivating. Cutting-edge galleries tend to congregate in one type of neighborhood, conservative galleries in another, and those targeting tourists as clients in yet another. Despite the occasional success story of the gallery located far off the beaten path, there are considerable benefits of having overflow traffic from other galleries casually pop into your space.

8

Managing Cash Flow

For most small New York commercial art galleries (those with a staff of three or fewer employees), anecdotal evidence suggests that monthly expenses generally fall between $8,000 and $20,000. There are galleries that find ways to get by on less, but there are also small galleries whose expenses are much higher. However, since the art gallery industry is notoriously non-transparent, there is no easy way even to guess what the average monthly income is for small art galleries, even for those that manage to stay in business, because of the number of galleries owned by independently wealthy dealers who support the endeavor with their own funding. It might be safe to assume that once a small gallery's monthly income consistently outpaces its monthly expenditures, it will evolve into a larger gallery by taking on more staff, more artists, a bigger space, etc., but even that would not be a reliable indication of how much of a profit they are making. A smaller gallery may simply be the owner's preference. One thing is certain, however, and that is that unless you are wealthy and willing to use your own money to fund your gallery indefinitely, managing your cash flow well will be the most critical factor in ensuring that you stay open for business.

The essence of managing your cash flow well is making decisions that serve to ensure that more money is flowing into your bank account than out of it each month. In a nutshell, that means selling enough art to cover your expenses and hopefully make a profit, but it can also mean delaying what money you pay out as long as you can while making sure that the money due you comes in as quickly as possible.

In this chapter, I will briefly discuss the basic concepts of good cash flow management. Then, we'll look in detail at what you should expect in terms of monthly expenditures for a small art gallery, including expenses that may not be obvious if this is your first small business. We will look at monthly income expectations separately, though, because the variables that play into this are perhaps unique to the commercial art world. Finally, we will examine how to calculate your monthly cash flow and what actions you might consider if it is negative.

BASICS OF GOOD CASH FLOW MANAGEMENT

If you research the best practices for managing your business's cash flow, you'll find plenty of advice that does not exactly pertain to the consigned-inventory business model of the average primary-market art gallery. Business tips that do make sense regardless of your business model, though, include hiring an accountant who is familiar with your industry, choosing the right bookkeeping/accounting software program, being very familiar with your books yourself, reconciling your bank account monthly, and updating your cash flow spreadsheet and other financial statements on a regular basis. Other standard small business practices are important for a commercial art gallery, as well, such as reserving the authority to sign checks for yourself, never using money withheld for sales taxes or other taxes for other purposes, never mixing your personal assets with the gallery assets, being careful not to overestimate your projected income or overestimate your projected expenses, and not waiting until you are desperate for it to establish a source of credit. Unexpected things will happen when you run a small business, things that cost money. Establishing credit *before* they crop up is, therefore, a critical part of making sure you have access to money when you need it most.

Monthly Expenditures

Through a discussion with several dealers who run smallish galleries (fewer than five employees) about what they spend money on each month, I arrived at the following list. This list is probably not exhaustive, but here is what a gallery must typically shell out cash for each month (or set aside the money to pay for quarterly or yearly):

- Rent
- Staff salaries
- Owner's draw
- Electricity/heating/AC
- Invitations
- Postage

- Insurance

- Advertising

- Opening reception refreshments/entertainment

- Phone lines (2-3)

- DSL

- Installation costs

- Accounting/bookkeeping fees

- Banking fees

- Subscriptions

- Professional fees

- Storage rent

- Sprinklers/HVAC maintenance

- Shipping/crating

- Framing

- Photographing work

- Entertaining collectors

- Office supplies

- Travel expenses

- Gas/water

- Garbage collection

- Alarm system

- Special events/charity events

- Corporate taxes

Because many of these items are self-evident, I limit the following discussion to those for which a commercial gallery has particular considerations. Where applicable, I note how some dealers have worked to minimize these costs, as well.

Rent

In New York, at least, rent can be the largest monthly expense for a small gallery. Rents for ground-floor spaces in Chelsea range from $30 per square foot to $90 per square foot (meaning, from $3,750 a month to $11,250 a month for a 1,500-square-foot

space). So far, these prices have shown no signs of being significantly impacted by the national downturn in real estate, but that can change, of course. Still, the difficulty of coming up with that much money for rent has led many younger galleries to open in arguably out-of-the-way locations like the Lower East Side, Brooklyn, Queens, or Harlem instead of Chelsea or Fifty-Seventh Street (although obviously, sometimes a location choice is simply a part of the gallery's identity). Real estate prices are much more reasonable in other parts of the country, but regardless of where you plan to locate your gallery, there are ways of minimizing this expense.

One trend that has launched several highly successful galleries in New York is opening a space in the same place you live. Chelsea's Zach Feuer, for example, famously began his art dealer career with a highly acclaimed exhibition in his former Boston apartment; New York's Schroeder Romero gallery was originally located in the Williamsburg loft of co-owner Lisa Schroeder; and Daniel Reich ran his gallery for two years out of his 200-square-foot Twenty-First Street apartment. Each of these dealers works with emerging artists, however, something that may make an untraditional exhibition space less of an issue than it might be for someone selling Old Masters. Each of these dealers has since moved into much larger, ground-floor spaces.

Another means of coping with expensive rent is to share a space. Successful models to this approach range from renting rooms in the back as artist studios, to chopping a commercial space into sections and subletting portions of it to other businesses, to having two separate galleries take turns presenting exhibitions in the same space. Renting out your gallery for parties or other such events can be yet another way to help cover your rent. Each of these approaches may violate the terms of certain leases, however, so be careful to check with your lawyer or landlord first.

Staff Salaries

As noted in chapter 1, the gallery system is infamous for not paying its employees as much as other industries do. A quick Internet survey of starting salaries revealed a range from $30,000 per year in Chicago for a full-time assistant to the gallery director (bachelor's degree required) to $42,000 per year in New York for a full-time, art gallery-experienced bookkeeper. Add to the modest salaries the fact that, as the advertisement for the bookkeeper put it, the gallery expects the employee to be able to "work in a fast-paced environment" and to "multitask," and you'll understand that few people who want to work in a gallery do so because it's an easy way to make lots of money. Generally, people who apply for gallery jobs are enthusiasts. What you can afford to pay some staff can be offset with benefits or other income opportunities. One thing some galleries offer employees is commission on sales (although this seems to be rare among our colleagues, we have found it a valid practice).

Your Salary or Owner's Draw

Regardless of how much profit you generate in your new gallery, there are always more magazines you can advertise in, more promotional documents or catalogues you can publish, more travel for networking, more museums to become a member of, more services you can offer your artists, and on and on. At a certain point, though, all the work you're doing has got to be worth it to you personally, or you'll eventually run out of steam. Whether you pay yourself a salary or take an owner's draw is a decision that you should make with your accountant, and will likely be influenced by whether or not your company is a corporation.

How much you pay yourself as the owner often comes down to what's more pressing: your needs or the business's needs. During your early years as an art dealer, you should expect to need to tap into another source of money for your living expenses, even if you start off selling well. When you do start paying yourself, though, it's recommended that you do so on a regular schedule and think of it as just another business expense. For more detailed information about what to consider in determining your salary, I recommend the advice offered by Susan Jacksack on the Business Owner's Toolkit Web site (see *www.toolkit.com/news/newsDetail.aspx? nid=fairwage*).

Invitations and Postage

Most art galleries still produce and mail out printed invitations to each of their exhibitions. In chapter 11 on promotions, I discuss the rising trend of scaling back the number of announcements sent via regular post (versus e-mail), but the fact remains that many collectors still respond to a well-printed image they can hold in their hands, put on their desks or refrigerators, or stumble across later. Conventional wisdom holds that an invitation in an envelope, which thereby requires the recipient to take more action to look at it, will make a bigger impression than a postcard they can glance at and toss, but, of course, envelopes add to the cost and time it takes to get your mailing out.

The size, complexity, and quality of your printed invitations will determine their cost, just as the size of your mailing list will determine what you pay for postage. We spend about $1,200 per exhibition for design, printing, envelopes, and postage, and I know from asking other dealers that that is low. In trying to save money here, don't hesitate to ask another dealer whose invitations you admire where he gets them printed. Quality is important, but shop around for better prices. Also, be sure that you continuously edit your mailing list to avoid sending cards out to people who have moved or whom you conclude are not likely to visit. Postcards that measure 6″ × 4″ cost less to mail than those 6″ × 9″ or larger, and that may be the number one factor that has made them very popular among younger galleries.

Advertising

After an initial advertising campaign to announce your grand opening, you will likely need to experiment a bit to see where the biggest return on your investment comes from. Artwork that sells well may justify spending more to advertise such shows. Moreover, different events or exhibitions may be better suited for audiences of different publications or channels. Advertising in an architecture magazine might make sense for one exhibition, whereas an ad in a trendy lifestyle magazine might be money well spent for another show. Most commercial galleries tend to limit their advertising to the arts publications or general newspapers of their cities. Monthly art magazines tend to be viewed as the most prestigious channel; they usually offer discounted rates based on the amount of ads you purchase within a given year. Using one example of a magazine in which many contemporary art galleries advertise, ad rates in *Artforum* magazine as of this writing break down as follows:

FULL-PAGE AD	single-issue	5 times/year	10 times/year
4-color	$5,500	$5,000	$4,500
2-color	$4,900	$4,500	$4,000
b&w	$4,300	$3,900	$3,700

Prices for premium placement in the issue are higher.

HALF-PAGE AD	single-issue	5 times/year	10 times/year
4-color	$3,550	$3,250	$3,050
2-color	$3,100	$2,800	$2,500
b&w	$2,450	$2,300	$2,100

QUARTER-PAGE AD	single-issue	5 times/year	10 times/year
4-color	$2,250	$2,100	$1,950
2-color	$2,050	$1,800	$1,700
b&w	$1,500	$1,450	$1,350

If you do the math, you will see that an advertising campaign across multiple magazines and multiple months can add up to a considerable sum. Whether opting to

maintain a constant presence in certain channels or to concentrate your advertising money to promote certain exhibitions or events, you should still calculate the total amount and divide by twelve to ascertain what you spend per month so you can ensure that you set it aside.

Opening Reception Refreshments or Entertainment

Rather than changing shows every month, most galleries opt for five- to six-week exhibitions, meaning they have opening reception costs about eight times a year on average. Depending on what refreshments you choose to serve (the fairly decent wine we serve at our gallery costs about $60 per case), the actual opening reception costs can be minimal, but an after-party or dinner for the artists, collectors, and friends can add up to quite a bit for each exhibition. Budgeting here is something we do in conjunction with the costs of each installation and other considerations (shipping, artist travel and accommodations, etc.), although we also consider projected sales in deciding how elaborate a celebration we should plan. Other galleries might have a set amount that they spend for opening entertainment regardless of how well the show may sell.

Client relations (both artists and collectors) factor into what you decide to spend here, too. If an important collector is traveling some distance to be at the opening, you will probably want to make extra room for her at the dinner party. Likewise, in trying to woo an artist to consider long-term representation, a little splurging can go a long way. Everyone likes to feel special at such events, and within reason, the money will usually come back to you consistently. Budgeting $1,000 for an after-reception event is generous for a young gallery. Spending less than $200 is probably not going to make the effort worth it. Deciding what you can afford before the libations begin to flow, and discussing this with the establishment hosting your event in advance, is always prudent. Many opening attendees assume the gallery has deeper pockets for events than may be the case.

Installation Costs

Our gallery is probably a bad example to use in estimating your starting-out installation costs. We build out new walls, paint the entire space a different color, build multiple pedestals, rent or purchase (but, more happily, borrow) tons of audio/visual equipment, and have installation-specific furniture or other features built more often than many galleries I know. Indeed, I find myself envying those spaces in which the gallery owners can swap out one painting exhibition for another each round, but, alas, that's not our program. What we pay for such services depends on who happens to be available when we need them and whether the installation freelancers we hire have connections and ideas that save us money. Finding someone to work

for you who is handy, creative, and connected is critical if you intend to present complex installations on a regular basis.

Local artists, who are often highly skilled, will generally understand better what you are trying to accomplish, and because they prefer this work to other ways they might earn a living often offer competitive rates. Soliciting their services is one way to save time and money here. What they may charge will depend on the work required, so it is difficult to provide ranges of fees. Asking for estimates will quickly give you a sense of what the going rate is.

Learning to do simple repairs or installation tasks yourself is another means of saving money. Because it is often assumed that as a dealer you're an expert on installing artwork, your collectors may ask you to help them do so from time to time. Sending someone else over is probably preferable if you're not highly skilled yourself, but the extra face time with a client can be priceless. Especially for new dealers who are still pumping profits back into the business, learning the basics of installing the work you sell is recommended.

Other Costs

As noted above, many of the monthly expenses you will have as an art dealer—such as electricity or an alarm system—are not really art gallery-specific. Framing, shipping, crating, and photographing artwork are, but we'll discuss those in detail in the next chapter. Three other costs you should budget for are travel (to visit colleagues, artists, and clients in other cities), charity events (which are not only a good way to give back to the community but are also good networking opportunities), and entertaining clients. Each of these is something about which you should be more creative than lavish in your gallery's early years, but each plays an important role in building your business, so consider them monthly expenses and set some money aside for them.

MONTHLY INCOME EXPECTATIONS

Back when there was a more reasonable pace to art buying than Chelsea saw during the boom of 2003-2008, an art dealer once told me I would sell out the inventory of an artist's first exhibition during their second exhibition. Obviously, when the market is sizzling, you can sell out an artist's first solo exhibition the day of their opening, but the truth of that dealer's statement becomes more apparent when things slow down. Essentially, it hinges on the notion that a big part of what helps to sell artwork is confidence that the artist is the "real deal." One good solo exhibition may convince a certain type of collector, but many who have been collecting for a while will wait to see what an artist produces next before buying.

This is a big part of why a new gallery working with emerging artists will take three to five years to become profitable (that is, it will be three to five years after

they open before most of their artists will begin to have their all-important, convincing second or third solo exhibitions). At that point, estimating monthly income becomes much easier because you will be working with a roster of artists whose markets you understand better, and you can shuffle around their exhibitions to keep the income flowing regularly. Until that point, though, most new dealers will see huge fluctuations in their month-to-month incomes. One terrible review for a show, one miscalculation on your part as to the appeal of an artist's work, or one exhibition in which you take a big risk that pays off in critical acclaim but does not result in strong sales—these will happen to even the very best new dealer.

If you will be working with more established artists, it will be easier to estimate income from the start. Keeping in mind that you will split each sale with your artist and that your collectors will likely attempt to get you to offer them discounts, you can calculate what income is likely to come from each exhibition by totaling the work in the show that you're certain you can place. With more established artists, many sales will be made long before the opening reception, which means that the only unknown in budgeting for the show is how successful you will be in enticing new collectors to purchase the remaining work. Here, again, bad reviews, unexpected reactions to the work, and miscalculations on your part can negatively impact your goals.

Naturally, what sells out of any given exhibition is only part of the gallery's potential income during that show. There are two other main sources of income you will need to ensure are well supported by you and your staff. First is other work or inventory, including work by the artist whose show is currently up and any artwork that a collector might have had her eye on, encountered during a previous visit, or decided to buy after you had forwarded an image and information entirely independent of your current exhibition. Second is income from art fairs, commissions, sales during studio visits, or other such events that are also independent of gallery exhibitions. When sales from these other sources are strong, taking risks on your exhibitions becomes more feasible.

Even the best reviewed galleries will admit that they deliberately balance the exhibitions for their best-selling artists with their highly acclaimed ones. Keeping your income at or above the level of your expenses is the only way to stay in business. This requires constant monitoring. In the next section, we'll look at the terminology and means of calculating your cash flow so you are able to make the decisions necessary to maintain that essential balance.

CALCULATING YOUR CASH FLOW

According to the business Web site Bankrate.com (*www.bankrate.com/brm/news/ biz/green/19991129a.asp*), monthly cash flow is calculated by adding your "starting cash" (what you have in the bank at the beginning of the month) to your intake for

that month ("cash in") and then subtracting your expenses ("cash out"). The resulting figure is your "ending cash," which then becomes your next month's "starting cash." The difference between your starting cash and ending cash in any given month is known as your "change in flow." That figure then becomes your "cash flow" for that month.

Here's an example to illustrate. These figures are perhaps realistic for a rather small New York art gallery, but are used primarily for ease of calculation. On September 1, your gallery has $10,000 starting cash in the bank. During that month, you sell $8,000 in art and receive a payment of $2,000 from a previous sale. Your cash in for September, then, is $10,000. After you total your rent ($6,000), payroll and owner's draw ($2,500), and overhead/supplies ($1,200), you have $9,700 cash out. Subtract your cash out ($9,700) from your cash in ($10,000), and you get a $300 change in flow. Add this change in flow to your starting cash, and you find yourself on October 1 with a new starting cash amount of $10,300. Your cash flow for September, then, was +$300.

Too many months with a negative cash flow will eat away at your starting cash and leave you unprepared to handle the unexpected when it occurs. Just how negative your cash flow turns out for any given month may determine what corrective action you take. Sometimes it's enough to trim your expenses (e.g., taking out only a half-page rather than a full-page advertisement for your next exhibition). But sometimes, you'll have to redouble your efforts to bring in more money. In the next two sections, I discuss typical strategies for doing both.

TEMPORARILY TRIMMING EXPENSES

Among the typical monthly gallery expenses listed above, some certainly fall into the "nice to have" category: entertaining your collectors, traveling to visit colleagues, and attending and hosting charity events can easily be suspended without too much trouble when times get tough. When that's not enough to put you into the black, though, you will have to make a few more difficult decisions. Shuffling exhibitions around so that a potentially lucrative one happens sooner than originally planned is always an option, but there are many other people's schedules to consider in contemplating this. Usually, art galleries will announce their schedules months in advance, so moving shows around can not only cause confusion but will potentially be read as exactly what it is—a sign that you're in trouble—and that can have far-reaching implications, mostly negative.

Despite the constant refrain you'll hear from some business gurus to "always pay yourself first," an art gallery is a passion and a business. Letting it go under just to stand by some business principle will thus disappoint you in two ways. As unappealing as it may seem, your salary is one place you might consider trimming

temporarily. Your invitations and advertising plans are, as well. Until your cash flow is positive again, you might want to target only your most essential audiences (and by that, I mean the people most likely to write about or buy from your exhibitions). Less expensive invitations, smaller mailings, and fewer ads will undoubtedly interrupt your plans for growing the business but, within the framework of a year's exhibition schedule, will not really be noticed by many visitors.

RAISING CASH QUICKLY

Some of the advice in this section includes things I do not recommend you do on a regular basis. Offering substantial discounts to encourage sales, for example, will set expectations that you may later seriously regret. Then again, it is often possible to explain to your collectors, many of whom are undoubtedly businesspeople who understand all too well the ups and downs of cash flow, precisely why this is a one-time offer. If you take care in choosing a collector to approach for such an offer, and do it infrequently, it will generally not have any lasting impact on your credibility or ability to stand firm on prices later.

In addition to extending enticing discounts on artwork, when money gets tight, some art dealers will simply ask their collectors for loans against future purchases. Again, you'll undercut a collector's confidence in you if you resort to this request too frequently, but you can also use such a request to build a closer relationship with someone who is predisposed to support your gallery. Many collectors enjoy being part of a gallery's inner circle, and some are truly happy to be able to help. You should provide an agreement of the terms of such a loan, including when you'll pay it back should the collector decide by a certain date that they don't wish to make a purchase, and never forget the generosity of such a gesture when dealing with that collector down the road.

Renting out your gallery for events is another way to raise some money quickly. Scheduling such events so they don't interfere with your programming or pose any threat to the artwork up at the time is very important, as is ensuring that the contract for the rental includes a security deposit and cleanup costs. If your gallery is large enough, you may consider this option as a normal revenue-generating part of business. Many dealers would rather not deal with the hassle, but some see it as yet another means of promoting their programs.

Finally, selling from your private collection of your artists' works (something you should be building as a matter of course; think of it as the art dealer's 401(k) plan) is often a heartbreaking way to raise money in a pinch, but as you are well positioned to buy another piece down the road, it can be a quick way to get the extra money you need from time to time. The upside of this tactic is that often, no one need know that the work is one you previously owned, so there are no awkward social

components to this choice except, of course, with your artist, but he will most likely believe that you could no longer resist the persistent pleas of the collectors demanding you sell them that piece. A commercial gallery is, after all, a business, and tough choices will have to be made now and then.

SUMMARY

As I write these final thoughts, the art market across the world is experiencing a swift and significant downturn. Galleries are closing throughout the United States, and most remaining dealers are implementing cuts in overhead, staff, and other expenses. The key to surviving this extraordinary economic situation is to focus on cash flow. Getting caught without enough income to cover expenses adds to the difficulty of staying afloat. Therefore, as many galleries are being keenly reminded these days, knowing how to calculate your monthly cash flow and what actions you can take if it is negative is more than solid business practice; it's the essence of staying in business.

9

Logistics: Crating, Shipping, Framing, Photographing, Managing, and Insuring Artwork

Even with all the passion and potential historical importance of the artwork sold in art galleries, much of the drama or anxiety any art dealer must contend with centers on the seemingly mundane issues of logistical concerns. The following scenario is one I've heard time and again. You get a call from a collector whom you have only met once, at an art fair over a year ago. They tell you that they hadn't opened the piece you shipped them twelve months ago until just now. When they did, the piece was damaged, and they're insisting that you refund their money. You know the piece left the gallery in perfect condition and was professionally packed and shipped. You want to ensure that they're happy with the service the gallery provides, but you also know that the contract they signed with the shipper required them to open the package and inspect it within ten days; you don't know where or how it had been stored or handled until now, and you don't know whether they're embellishing a bit about how the damage actually occurred. Again, you barely know these clients. What do you do?

Well, if on the day you gave the clients the invoice for this work, it included clear terms about which responsibilities fall to the gallery and which fall to the purchaser with regard to crating, shipping, and insuring the artwork in question, you simply discuss it from that point of view. There's usually more to it than that, though, and you should always think long term in such situations, which includes weighing what you might lose in terms of reputation and future sales if you don't

resolve this to the clients' satisfaction. Still, a little up-front clarification can go a long way toward both avoiding such problems and resolving them when they do occur.

Not every part of the logistics of running an art gallery is fraught with such potential problems, though. Often, the relationships you'll develop with the professionals you hire for crating, shipping, framing, and photographing the artwork you sell will be among the most enjoyable ones you have as a dealer. Many of the people working in such businesses share your passion for art or may be artists themselves. Until you can hire in-house employees to handle the daily tasks related to such services, it behooves you to have a working vocabulary of the issues involved, as well as to know where to find qualified professionals to hire. In this chapter, I will discuss what you need to consider when choosing such service suppliers for your gallery. The central assumption guiding this discussion is that these tasks will be done in the gallery at certain times and outside the gallery at others. There may be no need to send an unframed drawing out for a crate, for example; packing it in-house is generally more than safe and obviously less expensive. Crating a delicate lead crystal sculpture, on the other hand, is something best left to those with many years of experience. We'll also look in detail at the methods and tools available for tracking the artwork in your inventory. Finally, I'll discuss issues related to insuring both the artwork in your inventory and your business.

THE IMPORTANCE OF BEING CLEAR UP-FRONT

In most of the logistical concerns and situations I present below, the impact of inevitable situations on your relationships with your clients (artists and collectors) can be minimized by being very clear and up-front about your available resources and who is responsible for what. These issues can always be negotiated, but not as easily after the fact, not as easily. Fortunately, there are two standard gallery documents through which you can clarify how you see things and get buy-in from your clients before artwork exchanges hands: consignment forms and invoices. Each of these documents should include terms that specify what the gallery is responsible for and what the client is responsible for when your gallery takes work on consignment or sells it.

As we'll discuss in more detail in chapter 14 on working with artists, the terms of your consignment agreements are the perfect place to spell out what you can and can't afford to pay for when exhibiting or taking work into your inventory. Expectations among artists of what the gallery will pay for range from the customary if not obligatory (such as insuring the work while in the gallery) to the obviously more negotiable (such as a per diem for the artist during the installation week). Some galleries will use agreement forms to define the terms of an exhibition, as well, but that is rare.

In discussing the typical logistical matters, I'll approach each with four basic questions: When would a new dealer need such services? How can you find a qualified provider? What fees are typical for such services? What should a new dealer consider when trying to choose a provider? For most of the advice in each of the sections below, I went straight to the source: I interviewed the professionals whose services we have used or whom we know to be highly respected in their fields.

CRATING

Custom crates are often essential for transporting fragile artwork. Because they can be expensive, though, it's important to be smart about when you need them. Often, the type of crate needed, if one is required at all, depends on how the work is being shipped. Sending artwork via FedEx or a similar carrier might be cheaper than using a fine arts shipper, and in some instances may be fine, but if you go that route, you'll need to ensure that the work is very carefully packaged. On the other hand, a qualified art shipper can sometimes safely transport even highly breakable work with only bubble wrap if door-to-door delivery service is an option. In all art handling situations, it is unquestionably better to be safe than sorry. Even though insurance may cover a piece that gets damaged, the loss to your credibility—with both artist and collector—when work is ruined has much longer repercussions, and the follow-up work it takes to get payment and smooth things over with your clients will make saving a few pennies initially seem like a terrible bargain.

Who pays to crate fragile artwork to and from an artist's studio to the gallery or, when it sells, to a collector can often be negotiated. In larger or more successful spaces, all costs in getting the artwork from the studio to the gallery are generally expenses that the gallery absorbs. For smaller or younger spaces, though, depending on what type of artwork you're shipping and how much it might sell for, crating can seriously eat into your proceeds from sales at an unsustainable rate. Ensuring that the work can be safely shipped at a minimum expense is something a dealer should discuss early on in the process of bringing the work to the gallery. Erroneous assumptions here can get the relationship off on the wrong foot. If an artist believes the gallery has ample funding for high-end crating, he will, of course, prefer the best that money can buy to cradle his creation. Being transparent about your shipping resources with an artist is the best beginning to getting the work to the gallery safely.

When it's clear that you need to crate work, you may still have options (we have hired artists who work with wood to make a few custom crates for us), but ultimately, you'll want to establish a relationship with a professional art handler. Art handlers generally offer both crating and shipping services. Tomasz Nazarko, who recently left one of the best known art handlers in the country to become director of operations at the newly founded Artship Fine Art (*www.artshipfa.com*) in

Brooklyn, New York describes art handling as "a high-end, specialized service requiring a practical and historical knowledge of fine art, the aptitude to safely design and engineer elements intended to protect and preserve objects, the experience and versatility to work with unprecedented materials and objects in unexpected situations, and the trustworthiness to be responsible and ethical towards the art, its cultural significance, and its limitless potential value." Indeed, most art handlers we work with also work with regional museums and are accustomed to providing the highest quality of crating services. Nazarko also suggests, and I fully agree, that having the same company that packs or crates the artwork also deliver it is often the safest and most efficient way to go.

For crating specifically, though, Nazarko offers the following considerations and best practices for art handlers. I've added a few thoughts based on my own experience throughout.

- Fine art packaging should be as unique as the piece it is intended for.

- Custom crate designs should take into consideration the dimensions, medium, and condition of the work. They should include the artist name, title, year created, final destination, and projected duration of time the work is intended to remain in the crate.

- For more delicate or complex work, it might be wise to ask an art handler to do a site visit and examine the artwork in need of crating before they provide an estimate.

- Ask for an estimate that includes an itemization of crate features and costs, a date of completion, and finished crate dimensions. Some options for shipping the work may be more feasible if the crate falls into a certain volume range. Knowing the planned final dimensions may lead you to reconsider certain approaches to crating.

- Ask that the art handler router the edges of the crate, including handles (your hands will thank you, believe me). Also, ask that they foot it on skids measuring at least $2'' \times 3''$.

Types of Crates

Fine art crates generally fall into two categories: museum-quality and gallery-quality. As Nazarko tells me, "Museum-quality crates are sometimes intended to participate in rigorous traveling exhibitions for years at a time, and additionally require hardware intended to accommodate repeated opening or movement (such as bolt-plates instead of wood screws to seal a lid)." For shipping artwork from a studio to the gallery or from the gallery to a collector's home, "gallery-quality"

crates are often more than secure enough. Gallery-quality crates are the most common crates and are generally what your art handler will assume you want unless you specify otherwise. Because gallery-quality crates are not continuously opened or designed for years-long storage, they are usually made from lighter materials and with less costly hardware, and as such, they cost less to make and ship. Nazarko explains what to look for in ordering gallery-quality crates:

> *Gallery crates are not intended for repeated use in traveling exhibitions or prolonged storage, but they are an economical way of sending valuable artwork internationally. $^3/_8$-inch plywood is fine for these applications, but the crate should include two-inch foam all the way around, handles, etc. Always make sure that wood is bound with glue and screws. Be wary of shops that produce "all-plywood crates." This is a way of getting around international regulations, but without lumber to act as an armature, the crate's structural quality can be compromised.*
>
> *Industry standards for fine art crating are surprisingly straightforward. All works are packed into their crates with a two-inch foam buffer separating the work on all sides from the wooden interior. When multiple flat works are packed into one crate, they are separated by dividers (or "trays") typically made of $^3/_{16}$-inch cardboard or Foamcore. Individual pieces are secured to the tray by enclosing the piece with blocks of foam (e.g., ethafoam, Styrofoam, or polyethelyne). Sculptures are generally secured to a plywood tray at the bottom of the crate using cotton strapping or foam padded 2″ × 4″ lumber stock. This packaging ensures that the work does not shift within the crate itself and that it is isolated from the dangers of the shipping environment.*

Another crating option worth knowing about, although it is not recommended for international shipments without an additional wooden crate around it, is a "travel frame." These custom-built frames with four- to six-inch slats across the face and back of the artwork are typically used to "float" paintings that are either still wet or fragile and therefore cannot have any pressure or friction on their faces. Travel frames, or "T-frames," are also sometimes covered with Coroplast, a brand of plastic corrugated sheet that provides some resistance against UV fading, accidental scratches, or punctures. Nazarko recommends that you ask your crate shop to use thick brass foldable plates called "Oz Clips," which are screwed into a painting's stretcher bars, rather than screwing the stretcher directly into the T-frame to float it.

If the work you're shipping is extremely valuable or fragile, you may also want to consider using one of the tamper-resistant damage indicators available. These are

considered specialty items that need to be ordered (and, as such, can be expensive), but for certain work, it's better to be safe than sorry. Popular damage indicators include the "Shock-Watch," which tells you whether the crate has ever been dropped; the "Tip-n-Tell," which will alert you to whether the crate has been tipped beyond forty-five degrees; humidity indicators, which can be particularly important for artwork made from delicate electronic media; "Cold-Snap," which will tell you if your crate was ever exposed to freezing elements; and "Telatemp," which will record any heat to which your work was exposed while in the crate and is frequently used with encaustics or other wax-medium work.

When you order a crate for an exhibition, for an art fair, or for a client, keep in mind that certain times of year, art handlers are extremely busy. Further, the completion time in an estimate will generally not include the time required to get the work to the art handler or to conduct a site-visit at the gallery or artist's studio. Nazarko notes, for example, that if the crate shop at Artship Fine Art is not at capacity, a typical-sized crate will take two to four days to complete once the artwork is on-site. Allow for extra time during the period two to three weeks prior to and following the major art fairs in cities with many galleries (see chapter 13 for art fair schedules). Art handlers are often beyond capacity during those times, and mistakes are more likely then.

Costs and Other Considerations

When you ship artwork internationally, and to Europe in particular, you may be asked to ensure that your crate meets "European standards." That often implies museum-quality construction, but it always means that the wood used must meet European customs regulations. Nazarko explains, "In order to clear customs in the EU (and many other nations around the world now), the wood must be stamped with the official logo and an identification number certifying it as being free of bugs, molds, fungi, etc. This is a must, so be sure your crate shop is certified to 'bug-stamp.' Many are not certified, as [certification] is expensive, and the process involves monthly inspections of the shop's lumber."

It is impossible to generalize about costs for crating, as how much or how complicated a crate you need will be determined by what you are shipping. Like many services you will need as an art dealer, though, crating is one for which you should request estimates from multiple sources (at least three) until you have built a solid relationship with a professional whom you trust. When comparing estimates, gravitate toward the company that gives you the best advice, as opposed to the best prices or schedules. If they're always available, that may be an indication that they are not pleasing too many customers. Then again, it might simply mean they're new. As Nazarko suggests, "If you're a young gallery with plans to build a successful

program and continue expanding, try to find an art handling company that is doing the same—[it'll] understand your needs better than some high-volume corporate company could."

SHIPPING

As noted above, the most efficient and least ulcer-producing method of shipping artwork is to use the same art handler you hired to crate it. The efficiency of this option is frequently worth any minor additional costs and should be weighed against what it would cost to get a crated piece from that shop to another transport company. If you need a shipper for a piece that is already crated or that does not require a new crate, or the shop that created the crate cannot provide the shipping services you need, there are several factors you will need to consider, including how far you're shipping the artwork and what means of transportation are safe for it to travel by.

Overview

For a commercial gallery's purposes, fine art shipping generally falls into one of three main categories: international, domestic (also called "national" by some providers), and local services. Within these options, the most common means of transporting artwork is trucking, except, obviously, during certain legs of the journey for some international destinations. It is important to understand the details of "freight forwarding," which indicates that your shipment needs to be handed off from one carrier to another because it can imply several things for any given shipment, including that your art may not be transported by an art specialist for part of the trip. If your shipment will leave the care of your art handler to move on by ship, plane, or other common carriers (including trucks), you will most definitely want to ensure that it is crated appropriately, first.

Shipping costs are generally determined by the size and weight of your shipment; the distance and location of the final destination; the actual vessels to be used for the transportation (trucks, ships, airplanes, etc.); scheduling issues (such as how quickly you need it to get there or how much your shipper has going to that same location at the same time); and special needs or arrangements. When you request an estimate, most shippers will ask that you e-mail or fax them complete details, including sizes and weights for each item. In supplying these to your shipper, take care to be precise. Art handlers will take their own measurements and charge you according to their findings, regardless of estimates based on yours.

Many art handlers do not like to provide insurance for shipments. To persuade their clients to get independent insurance, they will charge very high rates. No art handlers I have ever worked with include insurance in their estimate, so be sure you always request it if you need it. Even if you purchase insurance, exclusions such

as acts of nature or damage to a part of the shipment that was concealed in advance are common. Furthermore, you may be asked to have the value you declare for damaged artwork independently verified when making a claim.

Local Shipping

"Local shipping" tends to refer to shipments that involve only a truck, a few handlers, and fairly straightforward scheduling. Artship Fine Art's Web site (*www.artshipfa.com*) describes its local services and addresses the issues most dealers will want to know about as follows: "We provide regular service to NYC, the Tri-State area, and beyond. Our technicians and drivers are not only some of the most skilled and professional handlers you'll find in town, but they're also the nicest. Our trucks are designed exclusively for the transport of fine artwork and offer full climatic boxes, air-ride suspension, the highest rated anti-theft devices available, and remotely monitored GPS tracking." If you are moving fairly small artwork locally, you might also ask your shipper about "courier" service rates.

Domestic Shipping

More advanced planning is typically required for nonlocal shipping. Many of the larger fine art shippers offer "shuttle services"—regularly scheduled runs with trucks—along regional routes that stop at major arts centers or major cities. Being flexible enough to ship via a shuttle schedule can result in significant savings. Domestic shipping without the luxury of time or to places not along a shuttle run may require "freight forwarding" to planes or other carriers, so, again, be sure your packaging is designed to accommodate such handling. Most shippers arrange "exclusive" door-to-door art handler shipments outside their regular routes, but as you might guess, these are considerably more expensive.

International Shipping

International shipping is by far the most expensive of the options, and it is also the most complicated. Importing and exporting forms offer a steep learning curve for most new dealers, and incorrectly completed forms can cause extremely frustrating delays, especially in shipping artwork to or from an international art fair. Hiring an experienced art handler to help you with these forms is definitely money well spent, in my opinion, even if you're sending the work by freight. Which forms or documents your particular shipping needs require will also be determined by whether the work has already been sold or is being shipped with the intent of selling it at the destination, such as during an art fair. International shipping almost always involves foreign third parties, as well, and the fees they charge can be impacted by changes in currency exchange rates, which can make an estimate you

get today very different from your final charges. Constant communication with your art handler representative is important in keeping tabs on such issues.

Storage Services

Finally, many of the larger art handlers offer short- or long-term art storage as well as crating and shipping. Many offer regular or climatized storage, the latter, of course, being important for more delicate artwork. Among the higher-end storage services some firms offer are analysis of the type of art storage your work needs and assistance in finding other off-site storage options, which can be helpful for large, public sculpture-sized pieces.

FRAMING

A working vocabulary of the processes and materials used to frame artwork is essential for any art dealer whose inventory includes two-dimensional works. Even if you and your artists choose not to frame artwork of certain media, such as paintings, for your exhibitions, your collectors may still wish to do so once they purchase it and will likely want your advice on what will look best. You can, of course, tell them that the artist's preference is that it not be framed, but a collector may have any number of reasons for why they wish to frame it, regardless.

Most new art dealers find their framers through recommendations from more experienced colleagues. It is recommended that you choose a framer who specializes in the type of artwork you will most often be framing. Establishing a solid line of communication between your registrar and a framer who offers trustworthy advice, consistent quality, and reliable schedules is far more important than finding the least expensive price. Keeping that in mind, however, frames are a considerable expense, so it pays to shop around.

The subtleties of framing politics can be a bit tricky, and this is one area in which new dealers may find that they spend a great deal more money than they wish to until they work out some important strategies. The reasons for this are twofold. First, artwork you take on consignment may not sell, and although you may pay to have it framed, it still belongs to the artist. If the consignment agreement or your relationship with that artist ends, you must then decide what to do with the frame. Most custom frames are not easily repurposed. Second, collectors may not like the frames you choose and may not wish to pay for them when paying for the art, a situation that necessitates taking the work back out of the frame and probably having an empty frame to deal with. Rather than getting stuck with a large inventory of custom, expensive, museum-quality frames, you may want to discuss less expensive—but still safe and presentable—options with your framer for much of the work in your inventory. Less expensive frames are less of a loss in the event that you must

later separate them from the artwork. You may even find it cost-effective to throw them in as part of the sale when closing a deal, if only as a safer way to transport the piece. When such a piece does sell, though, be sure you let the collector know to have it reframed with a higher quality, archival frame.

Often, framing artwork is a decision in which your artists will wish to play a major role, if not control entirely. Many artists have very specific opinions based on aesthetics or conceptual concerns that inform their preferences. You may wish to designate whose opinion is final in your consignment agreements. When you're certain that the work you're going to frame will sell, and that collectors will agree that the frame the artist chose is the right one, I recommend sticking with the artist's advice. Because of the costs, though, when you are consistently paying for framing—as opposed to having your artists pay to frame consigned work and then reimbursing them for their costs before commission splits—you should discuss the aforementioned concerns with any artist who insists on expensive framing options.

The overarching principles for making framing decisions have traditionally been ensuring that the work is well protected, the frame design is suitable for the piece (meaning, usually, that the frame doesn't overwhelm or compete with the work and complements it aesthetically), and each material or process used is archival and reversible. For contemporary art, this last guideline is sometimes ignored. Photographs back-mounted on Plexiglas or face-mounted on aluminum, for example, are trendy choices and are recognized now as valid choices by fine artists, but are also entirely irreversible.

The main decisions to be made when framing fine art include mounting, adhesives, mats, glazing, and moulding style and materials. If you find a qualified framer, he will certainly steer you in the right direction for most of these, but he may have questions based on various pricing options. It behooves you to understand what it is they are asking. The descriptions below are mere summaries designed to provide you with survival-level understandings of the issues and vocabularies used in frame shops. That said, you should only choose a framer who is willing to patiently answer all your questions about the myriad choices and options.

Mounting

"Mounting" is how the artwork is attached to a board within a frame that touches it and holds it in place. As noted, the guidelines for fine art have traditionally dictated that each mounting choice (the mount board, adhesive, hinges, and surrounding substances) be reversible and only use archival materials, which generally means materials free of acid and lignin. The overwhelmingly preferred choice among mounting options for fine artworks on paper is known as "conservation mounting" or "hinge mounting," in which a series of small, acid-free hinges (often made of a

pure Japanese paper known as *kozo*) are placed along the top edge of the work only so that the artwork hangs down from the mount board, which minimizes the amount of other materials (especially adhesives) that actually touch it. This mounting is commonly used whether a mat covers the edges of the artwork or not, but recently, corner supports or edge strips (which do not require the use of any adhesive on the artwork) have become popular—if the treatment includes a window mat that conceals them.

In "float mounting," a decorative backing is seen behind all four sides of the artwork, and spacers hold the work away from the mount board to create the illusion that the artwork is floating within the frame. None of the allover mounting methods—such as "dry mounting," "wet mounting," or "spray mounting" (in which the work is permanently attached to the board with an adhesive applied to the entire back of the artwork)—is reversible, and therefore, none are recommended for fine art unless such a treatment is considered part of the piece.

Adhesives

In the nearly two decades during which I've been taking fine art to be framed, I have never once had a conversation with a framer about the type of adhesive she uses. But then, I only go to framers I know I can trust, so when I indicate that the frame needs to be conservation-level quality, I know that they understand what kinds of adhesives fit that bill. There are somewhat competing issues when it comes to adhesives, though: they must be strong enough to keep the artwork safely in place, but they must also be removable without causing damage to the artwork. Starch-based paste is generally recommended by conservators because it is strong, does not discolor with age, and is reversible. Household glue will not discolor, but it becomes less reversible with age. Rubber cement or animal-based glues (mucilage) are not recommended.

Mats

The top board within a frame that has a hole cut so that the artwork can be seen through it is called the "mat." The hole is also called a "window," and your framer may ask if you want a "window mat" or not when framing works on paper. A good deal of contemporary art on paper today is framed without a window mat (also known as "close framed"), but there are times when a window mat may look best. A window mat includes a top board and a backboard, which are held together with one strip of cloth tape, usually along the top, but sometimes along the left side. Many dealers who store unframed works on paper have them matted for safer handling. When a piece in a mat is not framed, it should be covered with a protective sheet, such as transparent polyester film. If the surface of the piece is delicate, though, as in pastels or some work in graphite, tissue paper is preferable.

Color and thickness will be the primary decisions you'll need to make when choosing a mat board. The general guideline is that the color chosen should lead the eye into the artwork, which is a polite way of saying that the shade should not be so jarring that it distracts from the artwork. The thickness of the mat board is another decision that will be influenced by aesthetic concerns, as are the style of cut you choose for the window and whether the inside of the board will be seen. The thickness of the artwork and whether the frame relies on the mat board to keep it from touching the glazing (or whether spacers are used under the frame rabbet) will impact the thickness of mat board treatment you choose. Four-ply board is most typical, but window mats can be built up with layers for additional distance between the artwork and glazing and for decorative effect. Mat boards and all materials that will touch them in a frame should also be acid free.

Glazing

Although paintings or other, less fragile artwork may be framed without glazing, it is highly recommended when framing works on paper or delicate work. I also recommend that your artwork be framed so that it is held away from the glazing to allow for air circulation and movement. The main choices to be made in selecting glazing include glass versus acrylic glazing such as Plexiglas, normal versus a nonglare option, and normal versus an option that offers protection against ultraviolet (UV) light.

Clear glass is the traditional glazing material. Its advantages include low cost, total transparency, non-distorting reflection, and scratch resistance. Its disadvantages are that it is heavier than acrylic options, it is easier to break, harmful UV light passes right through it, and it is highly reflective. Various nonglare glass options are commonly available now, but they cost more and can distort an image (especially the further back from the glass the work is situated within the frame), so they are recommended only when reflection is a significant problem. Also available now is "antireflective glass," which is all but invisible to the human eye, but as you can imagine, it is much more expensive. Brand names of antireflective glass include Den Glass and Image Perfect.

The advantages of acrylic glazing include that it is lightweight (making it especially attractive for larger works) and that it doesn't break as easily as glass. Its disadvantages include the fact that it costs more than glass, that it is prone to scratching (although there are now wipe-on products that do wonders for repairing scratched acrylic), and that, just as with glass, UV light passes right through it. Both glass and acrylic glazing are readily available in UV-protection versions (for more money, of course). Because UV light causes severe fading, though, it has become common in framing. Acrylic glazing also comes in nonglare versions.

Again, crylic's ultimate advantage over glass is the fact that it is much lighter. One final consideration you should make in choosing acrylic glazing is that, unlike with glass, static is potentially a big problem, since it attracts dust and possibly even draws the artwork forward within the frame.

Moulding Styles and Materials

The main choices for moulding materials in contemporary art frames today are wood, metal, plastic, and acrylic. Specialty mouldings are always available, and indeed some contemporary art is identifiable as readily by its frame as by the image, but gold and other such costly materials are not commonly used for frames by most new art dealers. Of all the decisions you will make in framing artwork, moulding is the one your artists will generally have the most interest in having input in. Although mats and even glazing can impact how an artwork looks in a frame, nothing will clash with or complement a piece as strongly as the moulding. Simple white frames are therefore a popular choice, and they serve to keep the focus on the work much the same way that the white cube works for the gallery space. When in doubt, ask your artist and your framer for advice.

Because of the range of colors and shapes, wood is perhaps the most popular moulding choice. Metal frames are generally a bit less expensive and now come in a wider variety of colors and shapes, but many dealers still seem to prefer the look of wood. Plastic is the least expensive of these three main options, but it is not as strong as wood or metal and therefore not recommended for larger pieces. Finally, acrylic boxes are commonly used for "framing" three-dimensional artworks, but the same considerations with regard to scratching and UV protection apply here as they do in using acrylic glazing.

PHOTOGRAPHING WORK

For the most part, gone are the days of documenting the work in your gallery's inventory with slides and 4″ × 5″ transparencies. Those more expensive, slower-to-produce formats were art industry standards until fairly recently. The advent of fine art-quality digital photography has made taking and distributing images much faster and less expensive than ever. Slides can still be produced from digital images for those remaining institutions or clients who insist upon them, but such requests seem to have all but vanished in the past few years. In most galleries, two digital formats are generally created for each artwork or installation shot: 72-dpi JPEGs for Web sites and 300-dpi images (JPEGs, TIFFs, etc.) for print. The size of the digital image you need depends on where and how the image is ultimately presented, but it's better to archive larger digital images, which can easily be reduced, than ones too small to enlarge later without a significant loss of quality. Most arts publications will ask

for images that are no less than 4″ × 6″ when printed, which roughly translates into 1.5 to 2 MB-sized files, which can often be e-mailed to the publication. For higher-quality image needs, such as printing in catalogues, the typical full-sized TIFF is roughly 57 MB, which is too large for most e-mail services to handle. If you are sending a file that size, you can often use an FTP application (if the recipient has an FTP server), burn it to a disc, and drop that in the mail, or use an online service for delivering larger sized files, such as You Send It (*www.yousendit.com*).

The responsibility of documenting the work in an art gallery's inventory falls to the person serving as registrar. In some smaller galleries, the registrar might double as in-house photographer. If your in-house photographer is gifted in capturing high-quality images of the artwork and installations in your gallery, having one can be a real time saver, but high-quality images are so important to the promotion and selling of artwork that most galleries hire freelance photographers to document their inventories and exhibitions. Most dealers find their photographers by asking other galleries or their artists for recommendations.

Many freelance photographers who document artwork for galleries are fine artists themselves. Etienne Frossard of Brooklyn, a photographer who has shot work in our gallery, explains that he fell into the profession of documenting other artists' work almost by accident. The artists and galleries he now works with quickly recognized his talent for solving tricky lighting and composition issues in complex installations, and he is now in high demand. Frossard notes that although he will sometimes go to an artist's studio to shoot a piece or body of work, a gallery is the ideal setting for shooting. The setting can impact the fee a photographer will charge, so that should always be taken into consideration when scheduling a shoot. Frossard says, "First, I always try to make sure that I understand what the work includes and what is expected of me. I will then explain that my fee will vary slightly depending on the conditions that will surround my work. The more complicated the set-up, the more I will charge per shot. For installations, I prefer to take more shots than [are] requested and let the artist decide afterwards the number of images he [or] she wants. I will then charge depending on the number of images ordered."

Typically, a photographer will deliver all images to a gallery on a CD-R or DVD disc. You should request that he provide two copies (most do automatically). Some photographers offer a download service so you can get images directly from their Web site, which is often faster than waiting for a disc but can lead to complications depending on your Internet connection. You should request that your photographer provide both high-resolution (300-dpi) TIFFs and low-resolution (72-dpi) JPEGs (for Web sites or e-mail distribution). TIFFs can be saved in either RGB or CMYK (color modes), and although images intended for a Web site must be in RGB, the

printing industry is evolving so that it no longer always insists on CMYK (most post-card printers still do, though). With a digital image program like Adobe Photoshop, you can easily change from one mode to the other, so I recommend accepting whichever color mode for your high-resolution images your photographer can provide more quickly.

Mark Woods (*www.markwoodsphotography.com*) is another artist and fine art photographer who is in high demand among New York galleries for his document-ing talents. Woods' photography rates (found on his Web site) are very clearly broken down and represent an excellent reference for what you should consider or ask about when hiring a photographer. First, be sure to ask if the rates include materials costs, transportation to the gallery or artist's studio, and delivery of final discs or other products. Most photographers have a minimum on-site charge, which is not a fee on top of work done, but rather, according to Woods, "just the smallest bill (not including travel and delivery fees) that I'm willing to charge to make a visit worth my while." Woods' current charges are in line with what most New York photographers charge: "$25 per digital SLR camera photo of a unique view (resolution: 300 pixels per inch at approximately $8\frac{2}{3} \times 13$ inches). Includes any file format you request, corrections for color space, white balance, contrast, sharpness, noise reduction, perspective, and squaring of rectangles. Files are opti-mized and reproduction-ready." Woods also lists prices for slides and trans-parency formats, as well as scanning services, but again, those formats are being used less frequently all the time. One final pricing consideration is that complex installations, especially those with video or motion picture works, will generally incur additional charges, as will shooting framed work with reflective glass or shooting in cramped environments. Such situations create particular lighting challenges for the photographer and can require considerably more time, not to mention patience.

INVENTORY MANAGEMENT

Most commercial art galleries eventually need a database to manage their inventory. Among the most popular gallery-specific databases is GalleryPro by ArtSystems (*www.artsystems.com/products/gallerypro.htm*), but because it is rather expensive, many new galleries will opt to develop their own systems in FileMaker Pro or Microsoft Access, at least initially. The dealers I know who have developed their own systems will be the first to admit that their database does not do everything they would like it to, but since primary licenses for GalleryPro cost $2,500 as of this writing and additional licenses cost $795 (not to mention additional yearly charges for maintenance packages), getting by with the limitations of a homegrown system for a while is fairly typical.

What makes GalleryPro so popular is its excellent integration of management tasks such as recording the location and exhibition or purchase histories of each work with your collector or museum contact records. It also automatically updates all related records when any change is made. Most helpful (and usually the feature homegrown systems cannot do anywhere near as well) is that it pulls data from inventory and contact records and automatically places it into invoices or reports, as well as its "Search Wizard" function that lets you search any field easily. Finally, GalleryPro is designed to help automate the creation of documents for catalogues or catalogue raisonnés.

Advice on how to build your own system could fill another book, but the general data you need to record for each work include:

- A unique inventory number (most galleries build their inventory numbers using the artists' initials, the year of the work, and a sequential number, such as jd2008-003 for the third work entering our inventory by artist Jennifer Dalton made in 2008)

- The artist's first and last name (as well as birth and death years where applicable [mostly for secondary-market artists, to distinguish them from other artists who may have the same name])

- Full title of the work

- Year it was created

- Edition size and number of specific work within the edition, if applicable

- Brief description of the work (this is particularly helpful if work is untitled)

- Full description of media

- Dimensions (it is helpful to record them in both inches and centimeters, especially if you have many clients outside the United States)

- Retail price

- Location (including storage unit [if you have more than one], other gallery [if re-consigned], museum or institution [if on loan], or collection [if sold])

- Provenance and/or catalogue appearances

- Condition

- History of transportation (when and where it traveled when outside the gallery, such as to another gallery for limited re-consignment or to a conservator for repair)

- Associated expenses (photographing, shipping, repair, etc.)

INSURANCE

When choosing insurance for your commercial art gallery, you will need two types of coverage: one for your inventory (including work on consignment) and one for public liability protection. While there are many options available for art dealers, we have used a program designed specifically for galleries offered by Art Insure (*http://lambros.cfluent.com/artserv.php*) that combines both types of coverage. We have also found its agents very helpful.

For your inventory coverage, you will want a policy that covers transit and exhibition exposure as well as storage. Questions most insurers will ask in determining the costs of your coverage include whether you have had another policy canceled or nonrenewed within the past three years (and if so, why), what percentage of your business is retail, how large your gallery is, how long you have been in business, what type of work is in your inventory, and what percentage of your inventory is considered "fragile." They will also ask about your procedures for keeping inventory, how many exhibitions you have each year, how often you transport work domestically or internationally, and what method(s) of shipping you most typically use.

You will be asked to calculate how much coverage you believe will be sufficient for your on-site inventory, transit, office equipment, and art fair inventory (including transit). They will also typically ask what your preferred deductible is. Obviously, the lower the amount you provide for inventory and equipment and the higher a deductible you accept, the less your coverage will cost, but not having enough coverage can lead, of course, to insufficient coverage. Finally, most insurers will ask about the construction of your gallery space, including materials used, year built, distance to the nearest water source, sprinklers, alarm systems, and any losses you have had in that space in the past three years, whether you were insured or not.

Most art fairs require that you include their organization as "Additional Insured" on your public liability policy for the duration of the fair or that you purchase liability coverage from their insurer. Such coverage will not include your artwork or personal property. To include an art fair on your policy, you simply send your agent a request for a certificate of insurance naming the fair's organization as an additional insured. Most fairs will provide you with a form you can send to your insurance agent.

10

Staffing and Management Practices

One of my favorite anecdotes in *The Art Dealers* (see chapter 1 for a detailed discussion) was offered by Ivan Karp, who opened his own space in 1969 after having worked at Leo Castelli Gallery. In discussing the earliest days of the new gallery he named "O.K. Harris," Karp recounts his first opening event: "Early on opening day, I walked out to the street and swept the sidewalk in front of the gallery as an act of proprietorship. I had never owned a business before, and it seemed the right thing to do."[1] I've never forgotten that sentiment, and it brings a smile to my face every time I find myself sweeping the sidewalk in front of my own gallery today. I could ask someone else in the gallery to do the sweeping (and I sometimes do), but in addition to being an act of proprietorship, I like this simple task because it reminds me that there are plenty of unglamorous chores to be done in running a gallery and that initially, the person to whom they're most likely to fall is the owner.

Once a gallery begins to grow, however, it becomes impossible for the owner to do everything that needs to be done. Even if you are able to hire one, though, you most likely will not need a full staff all at once. Typically, a young gallery must get by with a bare-bones staff because of how long it can take to become profitable. Who you will eventually need to hire and when will depend mostly on which of the day-to-day tasks you can no longer afford to do yourself or to out-source. In all hiring decisions, you should be guided by the principle of ensuring

that you first delegate the tasks that are keeping you from your most important responsibilities as the owner.

In this chapter, I'll discuss those responsibilities as well as the more traditional divisions of labor in a commercial art gallery. I'll look at typical job titles and job descriptions and which of the many tasks you, as owner, should delegate to ensure that your team is working as efficiently as possible. To provide some structure, albeit arbitrarily, I consider a "small gallery" one with a staff of one to five employees, a "medium-sized gallery" one with a staff of six to eleven employees, and a "large gallery" any with more than twelve staff members, including the owner. Through a close look at how three galleries of different sizes structure their staff, I'll highlight the importance of flexibility in your thinking about who does what each time you bring on a new employee. Finally, I'll explain how to find qualified candidates for the positions you have open.

OVERVIEW

It is possible to group the endless number of things that have to be done for a commercial art gallery to run smoothly into three main categories: 1) sales and management, 2) operations and logistics, and 3) support. As the owner, your top priority should always be sales, and then management. Operations and logistics are important, no doubt, and you have to manage well those tasks and the people who carry them out, but always with the goal of then being able to focus on generating sales. Even curatorial or programming concerns (part of operations, in my opinion) come second to sales for the owner. You can always hire curatorial experts to ensure that your program is relevant and important, but only if you make enough in sales to pay them. Of course, you can hire sales staff, as well, but managing them then becomes your most important priority.

TRADITIONAL GALLERY JOB TITLES
AND RESPONSIBILITIES

The specific business model and program of your gallery, as well as what you as owner most need to delegate in order to remain focused on your top priorities, will guide how you tailor your staff's titles and responsibilities to suit your most pressing needs. With that in mind, the job titles and broad responsibilities you will commonly find in commercial art galleries include:

1. **Owner**: The person(s) who legally owns the business.

2. **Partner**: If there is more than one owner, a partner is defined as one of the people who shares in the profits of the business.

3. **Director**: This can be the owner or an employee. The director is the person who typically focuses on sales and on the curatorial program.

Generally, a director will be the primary contact for gallery artists. Larger galleries may have multiple directors, sometimes called "co-directors."

4. **Assistant or Associate Director**: This is an employee who assists the director(s) in his responsibilities and serves as a secondary contact for gallery artists.

5. **Registrar**: This employee receives, documents, and manages the storage, conservation, and preservation of all artwork moving in and out of the gallery's inventory. The registrar also writes and sends condition reports upon receiving work to ensure that the state in which it arrives at the gallery is communicated immediately to the artwork's owner.

6. **Archivist**: This is an employee who manages the records of gallery artists' works, sales, exhibitions, press, awards, etc. This person is the main contact for press outlets or publishers of catalogues seeking images or other materials for publication.

7. **Exhibitions Manager**: This employee organizes the delivery and installation of artwork for exhibitions. Depending on the needs of the exhibition, this may include major construction within the gallery (such as building additional walls or rooms).

8. **Art Handler / Shipping Manager**: This is the employee who organizes all crating and shipping of artwork in and out of gallery inventory. In small- and medium-sized galleries, these responsibilities often fall to the registrar.

9. **Bookkeeper**: Many small and medium galleries get by with part-time, freelance bookkeepers because the volume of sales at commercial art galleries doesn't come close to what it can be for other type of merchants.

10. **Receptionist**: This employee is often the first that gallery visitors encounter and as such can communicate the overall tone or expected behavior within a space. Who serves as the receptionist is therefore often a philosophical decision within a gallery. The spectrum of approaches to this decision runs from a bright-eyed entry-level employee all the way up to the actual owner. While chilly or even rude receptionists are notorious in fiction about the art world, and perhaps not entirely unheard of in real life, they tend to be more mythical that ubiquitous. As of late, gallery receptionists are also somewhat derogatorily referred to as "gallerinas" (or, to be politically correct, "gallerinos").

11. **Gallery Assistant**: This entry-level position includes employees who provide general support to other gallery employees. Although most typically a clerical position, responsible for answering the phone, sending

e-mails, making photocopies, running errands, and the like, the gallery assistant can be called on to help with installations, paint gallery walls, package artwork, etc.

12. **Intern**: This is a sometimes paid, but usually unpaid, entry-level position. Often filled by students wishing to get experience working in a gallery, interns are often compensated with free lunches and travel expense reimbursement, but not salaries. In some galleries, this is the quintessential "gopher" position (with responsibilities ranging from getting coffee for the owner to reorganizing the storage area to sitting in the gallery telling visitors not to touch the art), and as such, it tends to have a high turnover rate. Some dealers, however, rely on interns for more substantial tasks and often choose their full-time employees from among the interns who work out well.

Because smaller to mid-sized art galleries have a staff of eleven or fewer people, and there are twelve positions listed here, you can deduce that overlap is required. As a result, when hiring someone who has experience at another gallery, you cannot assume that the title of your open position alone will convey what you see as all of their future responsibilities. Any listing you publish for new staff, therefore, should carefully describe the responsibilities.

HOW TO STRUCTURE YOUR GALLERY STAFF

Throughout the following discussion of how to structure your gallery staff at any given point in your business's growth, we will assume that:

1. You will start your gallery with as little staff as possible to keep costs down, and then only hire new staff once it's obvious you can no longer do certain tasks efficiently with existing employees or via outsourcing.

2. You will decide which positions to fill (i.e., which tasks to delegate to your new staff) based primarily on what is keeping you or your existing staff from getting their top priorities accomplished.

3. You will keep in mind that each new hiring requires flexibility in your thinking about who needs to do which tasks. The unique skill set of a given qualified candidate may lead you to redefine your staff positions and responsibilities.

To help illustrate how organically gallery staffs can grow and how mutable the division of labor can be while expanding, I interviewed three New York art dealers, of

various job titles, from different contemporary art galleries with staffs of small and medium sizes. Each of these galleries has been in business for more than ten years, and each is highly successful in its own right. The size of each staff reflects, more than anything, personal choices about the type of gallery the owners wish to run. Our conversations focus on how they manage the division and overlap of the twelve possible positions listed above, as well as what they view as their own primary responsibilities and how they decide what and when to delegate among them.

Margaret Thatcher, owner of Margaret Thatcher Projects (*www.thatcherprojects. com*), runs her gallery with two full-time employees (including herself) and two part-time or freelance employees, including her husband and part owner of the business, the artist Richard Thatcher. As the owner and director of the gallery, Thatcher prioritizes her primary responsibilities as follows: sales, curating the exhibitions and program as a whole, and client relations (meaning, both artists and collectors). She also does most of the company's bookkeeping. The responsibilities of her one full-time employee position, associate director, are prioritized as administration, sales, and client relations, although the person in this position also helps with registrar, archivist, shipping manager, and receptionist tasks. In addition to the priceless moral support and advice he provides, Richard Thatcher also acts as part-time exhibition manager by overseeing the installation of each exhibition in the gallery and at art fairs. The final position on their staff is a part-time gallery assistant, whose responsibilities include tasks that fall under the registrar, shipping manager, and exhibition manager categories. This model is highly efficient and includes a fair bit of overlap, but as with many small-staffed galleries, it requires hiring freelancers from time to time when the four employees are simply unable to be in two places at once, such as during art fairs, complex installations, or heavy shipping periods.

Rachel Gugelberger is co-director of Sara Meltzer Gallery (*www. sarameltzergallery.com*), which she explains has five full-time employees, including owner Sara Meltzer and two co-directors: herself and Jeffrey Walkowiak. Gugelberger explains that, as owner, Meltzer's main focus is overseeing and managing the business as a whole. That entails being involved in many of the daily decisions, but also empowering her co-directors to make certain executive decisions on their own. Gugelberger and Walkowiak each focus on a subset of artists in the gallery roster, managing their sales, archives, studio visits, catalogues, and exhibitions (both in the gallery and in other locations). This specialization becomes necessary the busier your artists' careers become. When a gallery becomes overwhelmed moving art in and out of its inventory, one of the first positions for which many new dealers decide to hire a full-time staffer is that of registrar. Meltzer has a full-time registrar, who assists both co-directors, and a full-time gallery assistant.

Much of the gallery's installation and shipping tasks are handled through a network of freelancers. Indeed, many medium-sized galleries hire freelance installation staff as needed. In cities with many art galleries, finding someone at a second's notice is generally not too difficult, but for stability (and peace of mind), it's generally better to find a reliable installation team that you hire regularly and can plan well in advance with.

Sikkema, Jenkins, & Co. (*www.sikkemajenkinsco.com*) has eleven full-time positions in their gallery, including those of Brent Sikkema (principal), Michael Jenkins (senior partner), a partner, two directors, a registrar, an archivist, an installation manager (or exhibitions manager), a shipping manager, a gallery assistant, and a bookkeeper. When Jenkins first joined the gallery in 1996, though, the entire full-time staff consisted of him and Sikkuma. As the gallery grew over the years, new full-time employees were added, generally one by one and with a careful shuffling of responsibilities among existing staff. Each partner and director specializes in managing the careers of a subset of artists within his or her roster. Generally, there is a long-standing relationship that determines which artists work most closely with whom.

In addition to the regular duties associated with the position, the registrar at Sikkema, Jenkins, & Co. has also managed special projects for the gallery, which have included hiring freelancers and coordinating the production of a large publication for one of their artists. Their installation manager is the employee in charge of the physical plant and ensures that walls and lighting figures are in perfect working order, and manages any contractors who need to be brought in for special installations. Although their bookkeeper is officially full-time, Jenkins noted that her schedule actually fluctuates according to the amount of work there is, which suits her personal schedule just fine.

Because of the volume of requests they receive for materials and how busy their artists are with exhibitions in other institutions around the world, they also employ a full-time archivist who handles all the requests for visuals that come from the press, institutions, or people who have bought their work. She often also helps the partners and directors in sending out the visuals for the artists they are working with, when needed. Furthermore, she keeps the artists' bios and files with catalogues and printed materials up to date and works with a freelance graphic designer on the gallery's advertisements.

The full-time art handler (or shipping manager) they have on staff is in charge of any artwork that is shipped into or out of the artist's studio, to an institution, or to a collector. Jenkins explains that once a work has been paid for, it pops up in their gallery management system as a report the shipping manager can pull. That signals him to contact the collector and then get it out the door. Until the process required

specialization, though, the shipping manager and installation manager had been one combined position.

The progression in the number of full-time staff members represented by these three galleries seems fairly typical. Early on, when the total volume of work is lower, each employee tends to have a wider variety of responsibilities. As things speed up, however, specialization becomes necessary. Sales and interpersonal relationships remain the owner's least delegable responsibilities, and recurring tasks— things that are process-oriented, such as organizing and sending out visuals, mailing packages, and shipping artwork—become the most delegable.

Each new employee you add to your staff represents an opportunity to consider whether restructuring makes sense, but so much will depend upon who applies for your open positions and what their skills or limitations are. A qualified shipping manager whose responsibilities leave him plenty of time to also serve as installation manager, for example, may seem an obvious choice, but if your only candidate's skills make that arrangement less than optimal, you might have to reconsider hiring a freelance shipping manager until you have enough work to justify the full-time position. On the other hand, a new gallery assistant who is also a talented photographer might well enable you to create a new job description, stop paying a freelancer to take your inventory photographs, and use the money you save to pay your new hire a bit more than you had planned. Should that person eventually resign, however, the odds of you finding another talented photographer willing to do the exact same job are probably going to lead you to redefine that position once again. Remaining flexible is the key to spending your payroll dollars wisely.

FINDING QUALIFIED CANDIDATES

The pool of qualified candidates for any position you have open will depend heavily on whether its responsibilities involve promoting the gallery's program or not. Non-public-facing employees should nonetheless be good matches for your business's identity and culture to ensure that you are all happy working together, but for directors or other positions for which expertise and a shared vision are important, the pool will be considerably smaller. Networking with like-minded galleries, museums, and university programs, therefore, is the first step in finding qualified candidates. Letting your colleagues know you are looking for someone is generally how most dealers initially attempt to fill an open position.

If word of mouth efforts don't pan out, though, advertising is as good a method as any. Obviously, the more art-related the channel in which you advertise, the more qualified the applicants who contact you will be. We art dealers in New York are very fortunate in that the New York Foundation for the Arts (NYFA) hosts

a classifieds section for jobs and internships on its Web site (*www.nyfa.org*). NYFA job listings must be arts- or culture-related, and all ads cost the same regardless of whether the organization placing them is commercial or not. As of this writing, their rates ranged from $32 for a one-week ad up to $415 for a six-month ad. For galleries outside New York (or if an NYFA listing isn't working out for you), there are other online art-related job listings services, such as Artsearch.us and others specific to certain regions. There are always regular job-listing channels, but I assume that the further away from an arts-specific context you go, the more likely it becomes that you'll receive applications from unqualified candidates.

SUMMARY

Because the average commercial art gallery operates with a fairly small staff, overlap in responsibilities is common. Because specialization contributes to efficiency, however, this creates a catch-22 in deciding how best to build your gallery's team. Most commercial galleries' staffs grow organically, as a result, and the owner delegates the least important tasks for which she no longer has the time or for which it no longer makes sense to freelance out. These considerations serve as the guiding principles for when to add staff and what new positions to create.

NOTES

1. *Laura de Coppet and Alan Jones,* The Art Dealers: The Powers Behind the Scene Tell How the Art World Really Works *(New York: Cooper Square Press 1984), 145.*

11

Promotional Efforts: Publicity and Advertising

As noted in chapter 2, art galleries tend to be more dignified in their promotional efforts than many other small businesses. A sense of decorum, if not exactly gentility, is still expected of most art galleries, partly because dealers want the art they sell to be taken seriously, but ultimately because art is not a commodity many people buy on impulse. In fact, it's not the kind of commodity many people buy at all. Art has a very small market compared to most other products. The sort of mass-appeal approach that convinces throngs of people to give a new supermarket a try, for example, makes sense because nearly everybody shops at supermarkets and most of the products you can buy at any given supermarket are interchangeable with, if not identical to, the products you can buy at every other supermarket. Supermarket promotions seek to convince large masses of people that they're better than the competition because they need a high volume of customers to do well. Art galleries, on the other hand, trade in rare, unique, expensive objects, and because the owners are generally interested in seeing them enter particular collections, they seek to convince a more select group of people that their gallery is better than the competition. Mass appeal efforts, therefore, are not only frowned upon as undignified, but mass appeal itself is generally not the goal. (Of course, as in all things, in the hands of the right dealer, this promotional tenet can change.)

In marketing strategies, promotional efforts are generally broken down into the categories of publicity, advertising, sales promotion, and personal selling. I'll discuss

sales in more detail in chapter 15. In this chapter, I'll discuss the basics of getting publicity for your gallery, including how to craft your announcements, press releases, and story pitches; who to send them to and how; and what to consider when hiring a publicist. I'll also look at the way galleries use opening receptions, special events, and regularly scheduled events to raise awareness about their programs. In addition, I'll talk about advertising, with an emphasis on how your program determines where your money is best spent. Further, I'll explore how new online tools like blogs, social networking sites, and e-mail marketing services are enhancing the traditional channels through which galleries can get the word out or get press. Finally, it should be noted that the following discussion is merely a summary of the issues involved in promoting your gallery. This topic could fill an entire book. In fact, it has. For a more in-depth perspective on publicity and the art world, you should check out *Fine Art Publicity: The Complete Guide for Galleries and Artists* by Susan Abbott (Allworth Press, 2005).

PUBLICITY BASICS

Publicity is the art of getting other people to talk about you in the press, via word of mouth or some other channel of communication. The beauty of publicity is that for the most part, the adage holds up: there is no such thing as bad press. Unless a story is questioning your integrity or business practices, anything at all that gets your name out there can ultimately be helpful. The two main advantages of publicity over advertising are that you're not paying for the distribution of it, and that because you're not paying for it, it carries the kind of credibility you can't get elsewhere. Therefore, even more than advertising (which can be a considerable expense), getting free publicity is the predominant promotional goal for many younger galleries.

Among the tools Abbott recommends in her book that every gallery develop are an up-to-date media list, readily available images and captions (including digital versions, which are quickly becoming the only version publications want), a library of the publications in which it will seek publicity, a background release on the gallery and the director, and a generic press kit that can be quickly tailored to suit each situation. (A press kit should include a press release, images, and background fact sheet.)

It is also widely recommended that you to develop a twelve-month "publicity plan" (as part of your overall marketing plan) for your business. This might be easier if you can afford a publicist, but the truth of the matter is that many opportunities to get publicity require that you get the information into the right hands months before the piece comes out. Just as developing a mission statement and business plan can keep you focused on your most important goals, a publicity plan will

require you to define your publicity aspirations. A good understanding of those is the best way to ensure that getting your story out there benefits the business.

CONTROLLING THE MESSAGE

Just getting your story out there is not the ultimate goal of publicity efforts, though. Controlling the story that gets out there as best you can is where to focus your energies. The main way galleries try to control the story is to suggest—via announcements, press releases, and story pitches—how it should be told. I'll show some examples of these below, but first, some clarifications are in order. An announcement is any message you send out to the public, whether it is in the form of an e-mailed message, printed newsletter, or hand-written note. Because announcements can have a wide range of potential audiences, each should be tailored to the target reader. (Not every announcement you send out will be in search of publicity, per se, but because many of the questions about how and to whom to send them are the same, it makes sense to discuss announcements of all kinds in this section.) Press releases, as the name suggests, are specific announcements directed at the press and should provide the basic facts of your story in a way that piques journalists' and critics' interest and provides quotable passages that make it easier for them to recount the story in your strategically chosen words. Story pitches are suggestions you send to publications—generally magazines—for an article their readers might find interesting, which also just so happens to promote your artists or gallery, of course.

The advent of affordable e-mail marketing services has greatly improved the ability of small business owners to gauge the effectiveness of their e-mailed announcements and reveal which clients seem happy to keep receiving their news and which are either not opening or responding to it or are possibly annoyed by it. I'll look at how such services tell you all that in more detail a bit later, but the technology- and channel-independent fact remains that it is possible to turn off your audience, whether they are publication editors or your clients, with too many or irrelevant messages. Therefore, you want to consider carefully how often you communicate with your audience and tailor your messages to appropriate portions of your audience, but reach out often enough to ensure that they continue to understand that their business and interest are important to you. In short, the right balance is fundamental.

ANNOUNCEMENTS

As discussed in chapter 2, any gallery communication should reinforce your identity and mission to its recipients. Therefore, each time you announce a new artist you're working with, new staff, a new location, recognition from major art

institutions, significant press, summer hours, or even merely a warm hello, never miss the opportunity to underscore the essence of your mission in both presentation and message. To illustrate that, let's look at the mission statement of an imaginary gallery:

> *Catering to a well-educated pool of regional collectors, Gallery XYZ is a contemporary art gallery representing local young artists working in a wide range of media. By promoting their work to museums throughout the region and facilitating an ongoing dialogue between these artists and the public, Gallery XYZ will work to encourage patronage of local artists throughout our community and beyond.*

Suppose one of the artists represented by Gallery XYZ is having a solo exhibition at a major museum. The announcement sent out to share this good news is a good place to highlight that this event is evidence of the gallery's success in accomplishing its mission. The other opportunity here is to translate the museum exhibition into furthering other goals of the mission, including promoting your artist via press, a commitment to dialogue and, yes, even sales. We'll look at a sample press release below, but because "publicity" channels include word-of-mouth storytelling, this first announcement example is one directed at collectors.

> *Dear Collector Jones,*
>
> *I am pleased to tell you that gallery artist Jane Smith will be having her first solo exhibition, "Tomorrow's Meaning," at the Regional Contemporary Art Museum (RCAM) in Anytown, June 25-September 21, 2009. Featuring selected works from Jane's past four exhibitions at the gallery as well as new work commissioned by RCAM, the exhibition will include a 200-page catalogue with an essay by Famous Critic. In addition to a lecture at the RCAM on July 10, I would like to invite you to join us in celebrating Jane's exhibition with a private reception at the gallery July 30, 2009, from 6-8 pm. Jane will speak briefly about her work, and we will be unveiling a new body of photographs Jane has just completed. [Followed by details of the exhibition and private reception.]*

Although this announcement might seem rather informal and perhaps even chatty by some standards (or perhaps not; it depends on which gallery announcements you're accustomed to reading), it still underscores the gallery's mission in three hopefully somewhat subtle, but not too subtle, ways. First is the statement that artwork that was first exhibited in the gallery will be included in the museum exhibition. The mission statement goal of promoting work to museums is therefore highlighted. Second is the invitation to the lecture at the museum and the

artist talk in the gallery, which lives up to the gallery's commitment to "facilitating an ongoing dialogue between these artists and the public." Finally, the not-so-subtle subtext of the announcement that new photography will be unveiled at the private gallery reception is, "here is your opportunity to buy this work before the general public gets a chance." This complies with the mission statement's goal of catering to a select group of collectors.

You should note also that this announcement's message is crafted to ensure that the gallery's role in your artist's career is front and center in the word-of-mouth portion of your publicity campaign. Regional collectors will most likely receive this news from other sources that will not highlight Gallery XYZ's years of investing in and support of this work. In other words, by announcing the news in such terms, the gallery is controlling the message. When "Collector Jones" tells other people about this news, he is now more likely to pass along the gallery's point of view because it is framed in this way.

Press Releases

Announcements directed at the press should be more formal and follow a specific format to make it easy for publication editors to get the information they need quickly so they can make decisions about their interest in your news. Whether the goal of the press release is to encourage a listing of your upcoming exhibition in a local newspaper's culture section or to entice a high-profile art critic to visit (and hopefully write a review of) the show, the recipients of your press releases get thousands of such announcements and will resent the communications that require them to search for the portion that applies to them. The elements of any press release typically include the following.

- The notice (in all caps) "FOR IMMEDIATE RELEASE." There may be occasions in which you're sending a press release before you want the news to be published in order to give the press a "heads up," but in ten years of writing press releases, I've never really seen one.

- Dateline: the city from which you're sending the press release (more important if you have multiple locations) and the date on which you are sending the press release.

- Compelling headline: every article on how to write a press release emphasizes that you should only send one out when you have something truly newsworthy; otherwise, you'll burn through the goodwill your recipients retain for your business. The headline can simply be the title and artists of the exhibition you're announcing, but it should definitely capture your readers' attention.

- Essential facts: names, dates, times, places. Put them at the top. The editor of a free online gallery listings site in New York once noted that whether this information is at the top of and easy to copy from the press release greatly impacted not only her decision about whether to list an exhibition, but also how she felt about whether to later review the exhibition.

- Lead paragraph: like the headline, this needs to be compelling and should probably be succinct, but it should also contain the relevant essence of your story, including the who, what, when, why, and where, as they say.

- Text: here is where you tell your story in more detail. An important thing to keep in mind is that many opportunities for publicity include places where underpaid, overworked writers "borrow" heavily from press releases rather than rewrite the stories entirely. This is fine. You want the press. So, tell your story in a way that makes it easy to retell through clarity or quotable phrasing.

- Contact information: who, exactly? Give the name of someone to contact for more information, with a direct telephone line and e-mail address.

Regardless of how good your press release is, missing the publication's deadline will render it pointless. Be sure to research the publication cycle of the periodicals you're approaching and make sure you get your press releases to them with plenty of advance notice. At the very least, your goal with new exhibitions' press releases is a listing in the publications that offer them. Therefore, research who the listings editors are at those publications and send listing requests directly to them. If they don't publish your listings, a personalized note asking whether there is some other preferred format or delivery method is a nicer way to ask, "Hey, what gives?" It never pays to offend or insult an editor. Even entry-level editors can go on to be more powerful players in the press, and they seem to have remarkably good memories.

Also, beyond listings, it bears repeating that with all editors and writers to whom you reach out, the implication of your press release is that it contains information that is newsworthy. If you are not certain that it is newsworthy or appropriate for the specific publication, don't send it. You want the press to think highly of you and your gallery. If you gain a reputation for "spamming" an editor or a writer, the odds are more likely that they will begin to simply delete or throw away your communications without reading them, let alone writing about them.

As with announcements, each press release you send provides another opportunity to retell your main story (e.g., how this new exhibition contributes to your mission). Further, if the editor does decide to write about your news, you want them to report your story in the way that suits your goals. With that in mind, below is an excerpt from

a sample (fictional) press release for a new exhibition at Gallery XYZ that demonstrates how to control the message by providing quotable passages and underlining your mission:

FOR IMMEDIATE RELEASE *August 1, 2009*

The Landscape Reconsidered

Featuring new work by Jane Smith, Bobby Baker, Reginald and Mary Foster, and Donna Davidson

September 5 – October 5, 2009

Opening Reception: Saturday, September 5, 2009, 5:30 – 7:30 pm

Gallery Hours: Tuesday – Saturday, 10 – 6 pm

Gallery XYZ is very pleased to open the 2009-2010 gallery season with "The Landscape Reconsidered," a group exhibition of gallery artists Jane Smith, Bobby Baker, and Donna Davidson, and introducing the husband-wife team of Reginald and Mary Foster. Through painting, photography, and multimedia installations, "The Landscape Reconsidered" presents a mini-survey of how regional artists are interpreting the time-honored subject of landscapes through the prism of contemporary life.

In this age of widespread concern about the impact of modern life on the environment and raised awareness about the need to "think green," the traditional ideal of nature in the history of American art—generally portrayed as wide open spaces of untouched beauty—is being reexamined by younger artists. Do the romantic metaphors that inspired the Hudson River School painters or photographers like Ansel Adams still hold true? Have industrialization and pollution made the hope represented by such idealized vistas seem naive, or do such scenes still have the power to move us? "The Landscape Reconsidered" takes these questions and their inferences as its starting point.

In a new series of photographic diptychs, Jane Smith juxtaposes holiday photos taken during her childhood family vacations eighteen to twenty-three years ago with photos of the exact same locations last year. In some of these works, the differences are startling. In "Route 28, 1988-2008," strip malls dot the county highway seen from a mountain top where only twenty years ago there was only one small farm. In other works, however, the scenes are virtually unchanged. [The press release continues to describe the other artists' work, of which, as it doesn't actually exist and I'm not an artist, I'll spare you my fictional description.]

Throughout the exhibition, the participating artists will be writing about their work and how they personally try to make a difference in

protecting the environment, and answering your questions on the gallery's blog, http://xyzgallery.blogspot.com. *Be sure to check back frequently for updates and insights into a topic that's important for us all.*

[Many galleries end press releases about upcoming exhibitions with very short biographies of the artists in the show. For large group exhibitions, though, this is not customary. Typically, this section is in italics.]

Jane Smith received her BFA in 2002 from UCVA and her MFA from the Institute of Art in 2004. Her work has been exhibited widely throughout the United States and Canada, and concurrent with this exhibition, Smith has a solo exhibition at RCAM. [The other artists' short bios go here]

For more information, contact Mia Gallerist at 555-333-2212 or mia@xyzgallery.com.

In telling the story of this new exhibition, this press release references the gallery's mission statement in four ways: first, by noting that the artists are young, come from the local area, and work in a wide range of media. Second is the reminder in the biography section that Jane Smith is having a solo exhibition at the regional museum. Third is the emphasis on the idea of a "contemporary" vision, not only because the artists are living and young but because the subject of the exhibition is timely. Finally, the invitation to join in a dialogue about the exhibition and the issues it raises on the blog lives up to the gallery's mission to connect the public with the artists. None of these references are so overt as to distract from the central message about the exhibition. They are interwoven, consciously but subtly. Again, the better you understand your gallery's mission, the more you'll automatically craft your announcements like this.

STORY PITCHES

Some galleries seem to use this promotional approach to great effect. Others either have not mastered it or do not feel it is the best use of their time. Whereas gallery announcements and press releases tend to be tailored to a predominantly insider audience, and despite the fact that most gallery promotional efforts usually target a select audience, reaching out to the general public via the mainstream press can still pay off for a commercial art gallery. It may be more difficult to measure the effectiveness of such efforts, but because it is highly unlikely that all potentially interested visitors already know about your program or even know that you exist, it may make sense for you.

The same advice applies to pitching a story to a magazine as it does to sending out your press releases: make sure what you're sending is going to be

appropriate and compelling to the person to whom you're sending it. Many story pitches begin as a phone conversation or e-mail to an editor. Being fully prepared before you negotiate that initial contact is important. The best time to contact an editor is at the beginning of their publication cycle—in the middle of the day, as opposed to when they first get into the office or are heading out the door. Again, it's a good idea for you to research the publication cycle for the publications you wish to approach.

Human interest stories are generally your safest bet for general press. Keep in mind that the most irresistible human interest stories revolve around three topics—birth, love, and death—because of their universal appeal. It's questionable how applicable such stories might be to furthering your gallery's goals, though, so you may want to focus on other story ideas, such as major commission projects, a local artist getting international attention, rising art stars, and the like.

Every freelance writer will tell you that the key to having your story pitch accepted is finding the right "angle" for the publication you're approaching. Who is its audience? What are their interests? How does your story idea match those interests in a fresh way? Another key to success here is considering what it is the editor wants from a story idea. Don't hesitate to make his job easier in this regard. Suggest which section of their publication your story is a good fit for, make it clear that people they may want to interview are available and willing, and demonstrate that you understand their time is limited by being succinct and well prepared, even well rehearsed, before you contact them.

If your pitch is successful and the publication assigns someone to write your story, you will still want to control the message as much as possible. That won't be as easy to do as it is in texts you write, of course, but because it's a story about your gallery, you are among the top candidates for an interview. Being prepared for the writer when she wants to talk, then, is important.

Furthermore, being interviewed is one situation in which you can most easily see how the time you took to craft your identity and mission statement can truly pay off. Understanding backwards and forwards both the short-term goals that led you to pitch this particular story and your longer-term business goals will help you to connect the dots between any question you're asked and the answers you'd like to see in print. You may have to be quick on your feet, though. You can't always guess what a writer will ask you, and it may not be wise simply to force phrases from your mission statement into your answers each time. Good reporters do their homework and will have likely researched what you've said in other interviews and on your Web site. If you truly understand your mission, however, this normally won't present any problems.

HOW AND TO WHOM TO SEND
YOUR ANNOUNCEMENTS

When I first started in the gallery business, most announcements were either faxed or mailed (via regular postal service) to their intended recipients. Faxing back then meant one number at a time, generally with personalized notes, if not personal full-length letters. It also meant that you were never quite sure the message got through unless the recipient contacted you. Regular mail is still quite common for sending gallery announcements (although concerns about the environment are making it somewhat controversial lately), but the widespread use of e-mail has made what used to take hours with a fax machine possible in mere minutes.

E-mail marketing services that you control via the Internet have also become very affordable since I started in the business and have made sending announcements much less likely to bring to mind images of black holes. Such services can provide a suite of helpful tools for maintaining your contacts; categorizing your contacts into subgroups; timing when your e-mails get sent (this is helpful if you need to prepare announcements in advance and want them to go out while you're away from a computer); and seeing how many of the e-mails you sent are opened, bounce back, get a "click thru" (to some link you embed in them, such as to your Web site), or lead your contact to unsubscribe from your list. Compared to the days when you simply hoped your fax went through, this kind of instant feedback is extremely satisfying, not to mention helpful in balancing how often and to whom you send which announcements.

Even if you don't have the most impressive e-mail list, thanks to technology, you can still reach thousands of art world insiders with your announcements—for a price, of course. Art-specific electronic information services, such as e-artnow (*www.e-artnow.org*) or e-flux (*www.e-flux.com*) will forward your announcement to their entire list of subscribers; e-flux and e-artnow both report having nearly 50,000 arts professionals as readers. As of this writing, e-artnow offers to send the first announcement for free and then charges 100 Euros per announcement after that. Also as of this writing, e-flux instructs interested clients to e-mail them for their current rates. One downside to such services is that what recipients see in their inboxes before opening your message is the service's e-mail address and your subject line. Most art dealers, if not most art world professionals, will tell you that they probably delete more of such e-mails that they receive than they open or read, so clearly, the subject line you choose to use in such approaches is very important.

Announcements sent out to 50,000 or so anonymous arts professionals represent a net cast rather widely, though. If you want your announcement to bring about a particular result, you'll need to ensure that it arrives in the right

mailboxes. No one will know better than you which collectors should receive which announcements, but what about contacts at publications or museums? Again, remember that publicity includes word-of-mouth channels as well as press. Who in particular should you send your announcements to at such institutions?

It is possible, of course, to simply send an announcement care of, for example, the Museum of Modern Art or *Art in America* magazine. You can easily find their mailing or general e-mail addresses on their Web sites. The odds of your announcement actually being read by someone who will care are not very good if you go that route, but you never know. A better approach is to target the people in such organizations who are most likely to be interested in your announcements.

For arts publications, this means you should learn which editor or writer is most in tune with the kind of art you represent. For museums, this means researching which curators are most likely to be interested in the art you exhibit. In both cases, get specific names from their Web sites, recent issues, or annual reports. To make sure that curators are interested in the genre and period of art you exhibit, research the exhibitions they've curated in the past. A curator who is new to a museum is less likely to already have her exhibitions planned out for the next decade or more, so it might pay off more to focus on them if you're not already sure who will be interested in your artists' work. Approaching the editors or critics who are new to a publication can also pay off in this way.

WHAT TO CONSIDER IN CHOOSING A PUBLICIST

The prevalence of young galleries who hire publicists (either as in-house employees or through an agency) is difficult to gauge. Few list such a position on Web site staff or contact pages. Although retaining the services of a publicist seems to be more common when the market is hot, there remains a bit of a stigma attached to it in certain quarters because art is supposed to be above such blatant manipulation of the public's attention. "If the artwork is good, it will get the attention it deserves" is the general sentiment. This might be a bit more sour grapes than pure integrity, though. Publicity agents can be expensive, and younger galleries often don't have the staff budget for a full-time, in-house position. Generally the gallery director becomes the de facto publicist until the business takes off. This can be a bit of a catch-22, though, as getting more publicity is one of the keys to growing the business. Because some of the recommended publicity tools every gallery should have can be created once and then reused for years with a bit of tailoring, young galleries might consider hiring publicists for a short time just to get them set up.

More established galleries are open about the fact that they employ publicists for general interest news items, but even they don't advertise the fact that the four-page profile of their artist in a glossy fashion magazine was carefully orchestrated by a professional with connections at the rag. Specifically seeking out publicity for an artist that is seen as frivolous has traditionally been looked down upon by the more "serious" members of the art world. Indeed, you need to be as careful in maintaining the reputation of your artists as you are that of your business. That means controlling the context in which their work is discussed.

To that end, therefore, it is important to hire a publicist with strong ties to and a solid understanding of the art world. Good connections and respect among the arts press are vital qualities in whomever you hire, of course, but understanding what kind of publicity can have negative repercussions among curators or important critics is critical, as well. As you might expect, it's also important to choose a publicist who understands your business model and goals. Having a well-crafted business plan you can share with your publicist is a good way to give her the insights needed to do her job well.

STANDARD PROMOTIONAL EVENTS

One of the first things you notice about human nature when working an art fair is how collectors who casually enter your booth will often gravitate toward the artwork in which other people already talking with you had expressed an interest. Indeed, you will frequently sell two or three pieces by an artist in quick succession because seeing one collector make a purchase seems to encourage others to go ahead and buy, as well. If there were no other reason than this phenomenon to encourage groups of people to visit your gallery at the same time, it would be energy well spent, but there is in fact a range of reasons for galleries to host events. Whether the focus is celebrating an artist's achievement at an opening reception, providing more structured education or interaction opportunities, or fulfilling some other part of your mission statement, events help generate buzz and allow art dealers to give back to their communities.

Opening Receptions

As I mentioned in chapter 3, opening receptions are an opportunity for your clients to meet your artists, as well as for their friends and family to celebrate the achievement an exhibition represents. Receptions at many galleries are also designed to help get visitors into a festive mood with the intention of facilitating sales. Scheduling your openings to coincide with others in the neighborhood is generally a good idea, but that must be weighed against your other objectives for the event. In addition to when your neighbors are opening, research what their shows are.

If you're presenting a scholarly exhibition, for example, having the rowdy crowd from the edgy gallery down the street stream through might not contribute much to the atmosphere you're going for. If, on the other hand, your plan is to host a reception with high energy and high spirits, you might want to rethink opening the same night as a somber show at the gallery next door. We send out our opening announcements to arrive in the mailbox of our invited guests one full week before the opening reception. In markets like New York, this seems to be an optimal time. Much sooner than that, and guests might forget, but any later than that they may have already made other plans. Again, refer to the standard practices and strategies for opening receptions discussed in detail in chapter 3.

Regularly Scheduled Events

Many galleries host regularly scheduled events in addition to their opening receptions as another opportunity to assemble a crowd within the space and continue to build the buzz about their shows. Gallery districts around the country are known to organize simple group events on a monthly basis. Branded with names such as "First Thursdays" or "Gallery Walk," they typically center on all the spaces in one area staying open late to generate a more party-like atmosphere and community awareness. A volunteer committee representing all the dealers or a gallery association often organizes promotions for those events.

Individual galleries often host regular events beyond their openings, as well. The best use of this type of promotion is in underlining a central part of your mission or identity. If, for example, video art is a big part of your program, hosting monthly screenings of young video artists might not only help bring in and educate a devoted clientele, but also demonstrate that your gallery is a vital forum for this relatively untried medium, building confidence and awareness. Obviously, it will also help you stay abreast of trends and developments among younger artists and possibly lead you to new additions to your roster.

Giving back to the community is an essential part of many galleries' missions, as well, and having a space large enough to host events makes doing so an easy way to fulfill that goal. Other regularly scheduled events I know of that galleries have hosted include poetry readings, musical performances, political meetings, philanthropic interests, and networking opportunities. As you might expect, such events tend to reflect a passion of the art dealer beyond the work he sells, but in getting more people into the space to see the work on exhibition, they also contribute to creating awareness of the show that is up at the time. Advertising regularly scheduled events is something many galleries do in conjunction with the press releases and announcement cards for their exhibitions. Special e-mail announcements and, of course, notices on the gallery Web site are helpful, as well.

Special Events

As with regularly scheduled events, special events can reflect the gallery's mission or an interest of the dealer, but they are often held specifically to promote the exhibition that is up at the time. Examples of such events include a fancier, private opening before the public opening; a lecture by the artist about her work; a book signing for a monograph published in conjunction with the exhibition; or a performance or special screening of additional work by the artist. Your overall schedule will determine whether it makes sense to roll such events into the opening reception, but the general thinking is that creating as many opportunities to get crowds back into the space as possible is preferable, so long as each attracts a significant enough crowd to avoid a discouraging turnout.

A private special event can be a nice "thank-you" for your top collectors, but be careful that what you bill as "exclusive" actually seems that way to the invitees. Collectors I know have complained that they set out for a private opening, assuming that it would permit them advanced access to the artist's latest work, only to find the gallery had also invited the entire group of other collectors with whom they are always competing for the best pieces. Although this competition may seem to be a winning proposition for your sales goals, it can eventually backfire by alienating collectors who might not have felt that way had the event not been promoted as "special."

HARNESSING THE INTERNET

With Internet technology advancing the way it is, there will likely be new ways to promote your gallery before this book comes out. In the past five years alone, art dealers have harnessed new channels such as blogs, social networking sites, and podcasts to reach a wider audience and more effectively promote their programs to their existing audiences. Matching the right channel or technology to your program and identity is as critical here as it is in any other promotional effort, but much of that can be addressed in branding and design.

The power of blogs is something with which I am familiar, having created one that gets about 30,000 hits per month and has turned out to be one of the most effective promotional efforts for our gallery. Like any ongoing promotion, the blog takes time and effort to keep people interested in it, but because of the services that can track who visits a blog, I can report that people from every major museum and arts publication, as well as collectors from across the country, have read it at one time or other, and many return daily. This type of continuous feedback on who is paying attention to your promotional efforts makes the time investment seem a bargain and then some. You can get a blog for free (*www.blogger.com* is one such

provider). You can upload images and post your press releases or news about your artists, all the while climbing up the results pages of most search engines, which crawl blogs much more vigorously than they do other Web sites.

Another advanced means of communicating with your gallery's audience that is growing in popularity is podcasts (that is, digital audio or video programs distributed over the Internet). The San Francisco-based gallery Marx and Zavattero (*www.marxzav.com*) has been producing some of the most high-end and entertaining podcasts of any commercial gallery. They focus on a range of music, art, and literary topics, but always tie back into the gallery's exhibitions. As with blogs, podcasts take time and a certain medium-specific aptitude to produce well, so if radio-style productions are beyond you, you might want to focus your energies on promotional efforts better matched to your skills set.

Another, easier online phenomenon that galleries are just starting to take advantage of is Facebook (*www.facebook.com*). There are similar social networking sites, many with more mature approaches than the highly spirited and sometimes downright silly offerings on Facebook, but the art world seems to have taken to this particular service with gusto over the past year. In addition to creating a presence for your gallery as a "group" or a profile for yourself as an individual, you can use Facebook's messaging tools to send out and track RSVPs for invitations to special events or receptions, publish your press releases and other announcements, and, best of all, find a way to communicate with people in a less formal (i.e., less threatening) way than you can through telephone or e-mail. Art world luminaries who might not readily return my e-mails have been more than happy to accept me as a "friend" on Facebook and sign up as a "fan" of the gallery.

SUMMARY

As the art market goes increasingly global and technology increases the options for interconnectivity, the best means of promoting the work you're selling in your gallery continue to evolve. Print options remain popular (this is an industry that trades in "visual" art objects), but gaining the attention of your target audience may require keeping up with new means of communication and developing systems within your gallery of getting more information out more quickly. Naturally, the importance of having something of interest to say in such communications will never change, no matter how much technology does.

12

Getting Expert Advice and Professional Assistance

It is often said that a man who represents himself in a court of law has a fool for a client. Indeed, for any arena in which the consequences of amateurism can be costly, the fees of a specialist are generally quite the bargain. In a small business, like a commercial art gallery, where you often find yourself wearing multiple hats out of necessity, it still applies that certain tasks are best left to professionals. In this chapter, I discuss the range of outside consultants and professionals you are likely to need or want to hire in running your art gallery. Although it is possible to categorize such experts into those with extensive knowledge about art and those with extensive knowledge about business, whenever you can find someone with at least a working vocabulary of the other domain, you will likely save yourself time and money. For the purposes of organization, I'll discuss finding and working with art experts (scholars, independent curators, and conservators) and then business experts (lawyers and bookkeepers or accountants). For each expert, I'll explain why you might need to hire them, where to find someone who is qualified, how much their services tend to cost, and what considerations any new art dealer should be aware of when choosing and working with one.

SCHOLARS

Although as an art dealer, you are presumably an expert in the artwork that you sell, there will be situations or opportunities to make a sale for which scholarly advice

will be of great help. For secondary-market works, you may wish to consult a scholar to help authenticate a piece. Furthermore, the opinion of an independent authority can serve to bolster your claims that an artist or particular body of work is important. The need for such opinions is obviously much more prevalent among secondary-market dealers, but primary-market dealers who come across a piece for which they believe they have a client may wish to find answers to questions about historical context, provenance, authenticity, and so on. You may also wish to hire a scholar to write an essay or other text for an exhibition you present or a catalogue you publish.

There are several ways of finding scholars when you are unsure who the leading experts in the subject area are. The easiest and most recommended is asking other galleries that deal with the same artists or type of artwork. Blue-chip galleries in particular will generally have well informed, full-time staff members who may be able to point you in the right direction. Consulting curators or other authorities at a university or museum is another way. The Web site for the American Association of Museums (*www.aam-us.org*) is one place to begin if you're unsure about which museums might have such information. Finally, researching a known scholar's previous books, reviews, or essays on your subject can lead to their Web sites, or at least their publishers, who may be able to connect you with those experts.

Authenticating artwork or other such requests that may require a written statement from a scholar are difficult to establish average fees for. Those will depend upon the prestige of the scholar you approach and whether or not what you are asking is of particular interest to them. There are standard rates for catalogue essays or other such writing projects, but the scholar's interest in the topic can influence what they will charge you. Generally, the current commercial gallery rate for such services ranges from $2 to $4 a word, which is widely known to be more than scholars will charge institutions or nonprofit spaces. The assumption is that commercial galleries can more readily afford a scholar's top rates and, as such, should pay them.

INDEPENDENT CURATORS

The following advice and recommendations are culled from interviews with three independent curators I know and with whom I have had the pleasure to work in and out of my gallery. Omar Lopez-Chahoud is a New York-based independent curator with an international list of exhibitions mostly focused on cutting-edge emerging artists; Courtney J. Martin is an art historian and curator, currently based in Los Angeles, specializing in twentieth-century British art; and Berit Fischer is an independent curator based in London and Berlin who has worked for a number of private and public institutions around the world. Each of them has curated exhibitions for commercial art galleries.

The main reasons a dealer, who is essentially serving as curator of his gallery program, might hire an independent curator are to help bring new artists to the gallery that he might not otherwise have access to; to provide an independent point of view in highlighting an artist or some aspect of the program in a determined manner; and, because curators typically have their own followings of writers and collectors, to widen the gallery's audience. As Martin notes, "Curators can also create exhibitions that seem less commercial and more museum-like; sometimes this garners more press and attention, which can ultimately affect the way that a gallery is viewed (a very useful attribute in the competition to be accepted into national and international art fairs and work with international collectors)."

Each of the three tells me that the most typical way dealers find qualified independent curators is via networking. As Fischer puts it, "Collaborations between commercial galleries and independent curators usually come through social discourse and out of common interest in a particular artist or conceptual subject matter." I typically meet and get to know most curators socially long before I do enough research to feel I understand their work or how it might relate to our program.

Compensation for curating an exhibition for a commercial gallery generally takes the form of a fee or a share of sales from the show. Lopez-Chahoud explains that "a flat fee or 15 percent [of] the total of art sales from the show" is average. All agree that a fee is preferable. Having curated independently before I opened my gallery, I can attest to the fact that the amount of work involved in bringing an exhibition to a gallery is considerable, and we have begun offering independent curators we work with both a fee and a percentage of sales. Also, as Martin notes, "Both curators and dealers should insist upon a contract for the exhibition that is unrelated to the works of art and the artists; that is, a contractual agreement that is strictly limited to the service and the provider." Moreover, within that contract, it should be stipulated that, as Fischer puts it, "if sharing of sales is decided upon, and as a code of ethics, the share should be applied to any subsequent sales that the collaborative project might generate."

In addition to ensuring, just as you do when selecting your gallery artists, that your vision and the vision of a curator with whom you work are a good match, there are practical considerations you should work out in advance when hiring an independent curator to produce an exhibition. More experienced curators will ask you up front, but if they don't, you should still discuss who is responsible for installing the work (and if it is gallery staff, be clear about their skill sets and limitations); who is expected to provide equipment for any media-based artwork (for a group exhibition, it frequently is the artist in young galleries, but the curator

may assume it is the gallery); and who is responsible for writing the press release, designing the invitation, and communicating with the press. Finally, as Martin well states, "Dealers should treat curators as invited colleagues, specialists who perform a specific job, not a member of staff. By the same token, curators should respond as professional guests, with clear limitations about the work to be performed."

CONSERVATORS

Sandra Amann and Elizabeth Estabrook own Amann + Estabrook Conservation Associates, one of New York City's most prestigious conservation firms specializing in twentieth-century, postwar, and contemporary painting. Estabrook talked with me about why primary-market art dealers might hire a conservator to inspect, repair, or advise on a work of art that has a physical problem. "Well, there could be anything from structural to aesthetic issues. It could be something vague, like, 'it doesn't look right; the colors don't seem right.' It's the same kind of question as 'why contact a doctor?'" Indeed, Estabrook draws a convincing parallel between the two professions. "Conservation is not unlike medicine in the sense that you're treating something," Estabrook says, "and within that same analogy, conservation of twentieth-century and contemporary art is not unlike pediatrics in the sense that you're dealing with 'children' that haven't formed."

It is not surprising that conservators and doctors speak about their "patients" in the same tone and with the same vocabulary. Most conservators have a combination of art history or art criticism background, a significant amount of chemistry (often the same as premed chemistry) education, and a certain amount of hand skill from studio practice art. If their focus requires it, they may also have studied anthropology or related social sciences, as well. In short, they are highly specialized experts, and it is usually wise to heed their advice.

Most art world insiders assume that secondary-market dealers would need the services of a conservator much more frequently than a primary-market dealer (because you can always go back to a living artist if something happens to their work), but Estabrook explains that it depends on the type of problem. "It's a real discussion that the dealer or the owner needs to have with the artist about what they can do to fix the problem, whatever you perceive the problem to be. Artists make things. Their area of expertise is making, not fixing. So, it's just that they may do things that are not terribly appropriate. And in some cases, it doesn't really matter and can be just all kind of stirred into the concept of 'this is how this piece is,' but in some cases, if it's a painting and it has a tear in it, they can do an indelicate job of repairing it that someone else cannot revisit because they've botched it in a way that you can't undo and start again."

In addition to asking other dealers for recommendations, Estabrook notes that you can locate a qualified conservator in your area via the excellent search function on the Web site of the American Institute for Conservation of Historic and Artistic Works (*http://aic.stanford.edu/*). It is difficult to provide pricing information because there are so many variables in each particular job. Estabrook explains why: "In one painting, you could in-paint something the size of a quarter on the work of one painter and it would be relatively straightforward, or you could do the size of a quarter on the work of another painter and it would be virtually impossible because in trying to duplicate the color, the sheen, and the texture, you have no tolerance. They all have to be so close. One could cost giant sums of money and the other could cost virtually nothing. It's all about the picture, what are the variables, and how difficult is this problem."

Generally, a conservator will complete an examination of a piece and then report back to the dealer with an assessment, usually written, of the problem. Their recommended solution can often involve several steps or options. It is then up to you, the client, to decide what steps they should take. As long as the conservator agrees to your plan, that is. "In some cases you could say, 'I only want this part of the job to be done, and I don't want that job,'" explains Estabrook. "Our point of view is always to stabilize something, so if they say, 'I just want the loss to be in-painted and so then it will look nice,' but the truth is that all the paint is unstable, we [will] probably say we won't do it, because the bottom line is that you'll lose original material, and that's what the art is."

Whether a conservator charges for such analyses depends on a number of factors, as well, but in general, it comes down to how much time and work it requires. "[For] something that I [don't] have to put a giant amount of effort into," Estabrook says, "then maybe I'll say, 'Never mind. It was nice to meet you, and hopefully some business will come some other day.' But if you've asked me fifteen times to do this and no business ever comes, then I probably will charge you."

Finally, I asked Estabrook what she recommends that new dealers consider when hiring a conservator. "I guess that I would like to know that the conservator has worked on similar art objects, that this isn't all new to them," she says. "And I think it would also be interesting to know how much they are aware of current thought in the field. Do they attend conferences, are they in touch with their colleagues, or are they working in isolation? In this field in particular, Modern and contemporary, there's a lot of unbelievably weird materials. And there's no way that one will have worked on everything. On the other hand, since you haven't worked on everything, you need to know how to get the information and who to tap on the shoulder. So, who are your network of colleagues that you can talk to, and how connected are you? That's incredibly helpful."

LAWYERS

M. Franklin Boyd, Esq., is a New York-based arts attorney with a unique point of view on the gallery system. With her partner, Jonathan T. D. Neil, Boyd also runs the art consultancy Boyd Level (*www.boydlevel.com*). I talked with her about why a new dealer would need to hire a lawyer, and like the brilliant attorney she is, her thoughts on the topic were remarkably well organized and clear. There are four main reasons you would need a lawyer for an art gallery, she told me: general business set-up, gallery operations, art world issues, and arrangements that a dealer can facilitate that help himself or his clients. I'll discuss each of these in more detail below, but because this relationship is one of the most important you will have with another professional, I'll first look at what you should consider when choosing an attorney to work with.

As with most experts you will hire, recommendations from other dealers are the single best way to find an attorney who specializes in the arts. You might also find recommendations via your local branch of Volunteer Lawyers for the Arts (VLA). Being a commercial art dealer, it is unlikely that you would meet VLA's qualifications for pro bono assistance, but the organization will possibly be able to point you in the right direction. For a national listing of their branches, see *www.dwij.org/matrix/vla_list.html*.

After the general business set-up phase of running your gallery, it is very important to find a lawyer who is familiar with the art business. As Boyd points out, "Attorneys who are not familiar with the art world can make mistakes that can be costly or get frustrated very quickly. Not only do you have to have a patience factor because they don't understand why the artist doesn't like certain things or can't commit to these things, they want contracts to be more like you have when you have two people talking about widgets. If you are drafting, for example, an exhibition agreement, and have no sense of the art world, you might not understand whether it's critical or not to have announcements, and how many announcements there are, and who pays for that. You may not understand that an artist or a gallery may feel very strongly about who has the right to approve the installation, or if somebody needs to be on site to install. Non-arts attorneys may not understand the significance of shipping costs. They may literally think that it's the cost of a FedEx box as opposed to a fine arts handler's crate, and not understand that when you're talking about relatively inexpensive artworks, that can eat into a huge chunk of it. Those sorts of points make it very helpful to have somebody with some art world knowledge." If you open your gallery in an area in which it's difficult to find an attorney with such experience, you might consider hiring an arts attorney from another location to draft basic agreement templates, but you will need local counsel to review and refine them.

General Business Set-Up

Although a few of the general business set-up tasks for which you need an attorney may be influenced by the fact that you will be running a commercial art gallery, they are not unique to the industry, per se. In that regard, you do not need an arts attorney for the following, but having a lawyer guide you in each is recommended.

1. **Incorporation.** Your attorney can help you incorporate and decide what kind of corporate entity is best for you in order to minimize potential future personal liabilities.

2. **Real estate.** Your attorney should review your lease.

3. **Operating agreements.** If you have business partners, you should consider partnership agreements. Particularly important here is looking toward the ends of such agreements. As Boyd notes, "Sometimes people fail to do this because the optimism and excitement of starting a new business takes over, but it's very important while there are still good feelings among all parties to start thinking about what should happen if you need to dissolve the business, or, God forbid, a partner passes away or becomes incapacitated. Oftentimes in small businesses, you don't necessarily want the estate or the spouse or the children to all of a sudden become your business partners, so you need to think through all those different life cycles of the business, and an attorney can help you do that."

4. **Agreements with employees.** Although rare in the contemporary art gallery business, there may be times when you will want certain agreements, such as confidentiality agreements or non-compete agreements, to be formalized with your employees. Usually, you can sit down and hammer out an agreement without a lawyer, but a non-compete agreement, as Boyd notes, is "one of those things that it helps to have not downloaded from the Internet."

5. **Miscellaneous contract reviews.** When in doubt, have your attorney review any contract, such as insurance contracts or supplier contracts.

Gallery Operations

Unlike general business set-up, gallery operations include things more specific to the art industry. Here, you want an attorney who is familiar with the art world, somebody who at least knows, for example, what an art fair is and that there are multiple venues for selling.

1. **Artist contracts.** Whether you choose to delineate between consignment agreements and representation contracts, you should still have

your attorney review, if not write, the contracts you use to manage the artist-gallery relationship.

2. **Exhibition agreements.** You may find it wise to develop a contract that spells out the details, such as who is responsible for what, for one-off exhibitions (when working with an independent curator, for example, as discussed above).

3. **Loan agreements.** If your artist has been asked to loan work to a museum, as opposed to re-consigning work to another gallery, a loan agreement is generally used to clarify the responsibilities of each institution. When the terms of the loan are straightforward, you probably don't need to involve your attorney. You can simply modify a loan agreement template your attorney created or at least initially reviewed. When there are complex installation issues, however, it is best to have your attorney carefully consider the artists' goals and expectations and ensure that both parties agree to them.

4. **Consignment agreement.** I'll discuss consignment agreements in detail in chapter 14 (also, a sample template is found in appendix A), but your attorney should review the basic terms to ensure that they comply with state art consignment laws.

5. **Bill of sale.** There is more information on bills of sale in chapter 15, but the important issues your attorney should review here can include when the title passes, and who is responsible for any in-transit damage to the artwork. Again, getting your attorney's blessing on the terms you put on your bill of sale is invaluable.

Art World Issues

Regarding contemporary art in particular, in which many artists are pushing the envelope with regard to new approaches to art making, Boyd explains, "Issues that would generally be seen as more of an artist's problem can quickly become your problem if you're displaying the work or have it up on your Web site." The following types of issues are ones that I highly recommend that you hire an attorney specializing in the arts to advise you on.

1. **Legal problems.** These can include issues involving copyright, trademark, "moral rights" under the Visual Artists Rights Act (VARA), First Amendment issues, or charges of obscenity or child pornography.

2. **Title issues.** Even if your business will not likely bring you into contact with looted art, you may run into family-related title issues. For example, a

client brings you a work to resell, and you sell it, only to then learn he didn't have the right to sell the work. Although it was in his possession, it actually legally belonged to his mother-in-law, and she didn't want to sell it. If such works are very expensive, there may be liens put on them. If that seems a possibility, you will want your attorney to do a Uniform Commercial Code (UCC) search before you take the work on consignment.

3. **International Royalty Compliance.** If you're transacting business in European or South American countries that have a *droit de suite* law, you should be familiar with that, and your agreements should take it into account. If you're going to consign work to or buy work from a London auction, for example, you may ask your lawyer to help you determine who owes what to whom ahead of time.

Other Complex Issues and Arrangements

It is not recommended that you advise your collectors on the following types of issues yourself, but by having familiarity with such things, you can add value to the transactions with your clients by suggesting that they speak with their attorneys. You can gain that familiarity by discussing them with your lawyer. Examples of complex arrangements with which it can pay to be familiar include trust and estate issues, tax issues, and the "1031 exchange" (also known as a "like kind exchange").

Fees and Other Considerations

There are three main ways that most art lawyers structure their fees: an hourly charge (generally between $300-$500 per hour, presuming you want an experienced attorney); a negotiated flat fee (more typical for general business set-up or other straightforward needs); or, if you're lucky enough to be working with an attorney who also collects art, barter (that is, pay them with artwork). As Boyd notes, though, "Don't expect to be able to pay entirely in barter because your attorney owes taxes on that art as income, and he needs cold hard cash to pay the government. And he has expenses, too." Because an hourly rate is most typical, though, it is important, especially when other people are also involved, to hammer out as many of the business points up front to help reduce your legal bill. For a lawsuit, a contingency fee might be possible, but it's not typical.

Even if your business and agreement templates are all set up, situations can arise that necessitate touching base with your lawyer, such as when laws that impact the art business change. In 2005, for example, Massachusetts amended its consignment law, changing a gallery's responsibility to pay an artist within a certain number of days. Galleries operating there were subsequently responsible for ensuring that their

agreements were in compliance. There have been changes in federal laws, such as the adoption of the Visual Artists Rights Act in 1990, and international laws, such as the United Kingdom's recent adoption of the artist's royalty right, the droit de suite. In each such case, you are better off asking your attorney to review your standard contracts.

Finally, although litigation is something most new art dealers really don't want to think about (they have enough on their plates just building their businesses), even being really careful up front does not guarantee you won't end up in court. "Lawyers don't bullet proof you," Boyd says. "Just because you have a really good consignment agreement doesn't mean you won't get sued. Hopefully, you'll win, but just because you have stated that something wasn't doable in your agreement doesn't mean they won't still do it. And then what you have to do is decide whether it's worth it to go to court. And maybe you decide that it's worth it to symbolically go to court once to scare them. Then again, is that really a healthy relationship to have?"

BOOKKEEPER AND ACCOUNTANT

As noted in chapter 6, either your accountant or your lawyer can handle your incorporation and other general business set-up matters. Most new art dealers I have spoken with, though, do not contact their accountants on a monthly basis, but rather use a bookkeeper (often a freelancer) for monthly financial record-keeping, and then call on their accountants for matters such as checking their bookkeepers' work, end-of-year taxes, and special issue consultations. This arrangement is mostly due to the fact that accountants' fees are considerably higher than bookkeepers' fees. Although it is important that both your bookkeeper and your accountant understand your business, it is crucial that whoever sets up and whoever does your books understand how an art gallery business model differs from that of other retail businesses. In particular, having your books reflect the difference between inventory you own and inventory on consignment is critical.

We asked our accountant to set up our books initially, and then hired him to train our gallery manager (who is also an experienced bookkeeper) to ensure that they speak the same language and are continuously on the same page. Today, most commercial art galleries set up their books in a software accounting program, such as Peachtree or QuickBooks. (Anecdotal evidence suggests the most popular program for commercial art galleries is QuickBooks.) Although it is highly recommended that you, as owner, do your own books initially so that you are very familiar with them, other responsibilities will eventually overwhelm you and make doing the books something best delegated to an experienced bookkeeper. However, regardless

of how experienced your bookkeeper may be, it is sound business practice to have someone regularly check his work.

Recommendations from other dealers are the best means of finding a freelance bookkeeper with commercial art gallery experience. Freelance bookkeepers' fees vary based on how much work you throw their way and their experience. In New York, fees range from $35 to $50 per hour and up.

There are standard business practices that apply to commercial galleries as much as to any other small business of which your bookkeeper should be aware so she can help you stay on top of and manage them. These include the importance of having only one person who signs checks (this is especially important in partnerships, where two people writing checks can quickly lead to major problems); the importance of having your bookkeeper reconcile your checking accounts and credit cards each month; and the importance of generating profit-and-loss statements regularly (monthly is recommended, but at the very least, you should be reviewing them quarterly). Among record-keeping issues to which commercial art galleries in particular should pay close attention are those involving out-of-state shipping and sales tax issues. The importance of keeping a paper trail, in addition to your software records, becomes critical when you realize that QuickBooks can't store shipping documents. It is, therefore, very important that for each sale you retain a physical copy of the invoice, a copy of the check or other payment record, and a copy of the shipping document. I highly recommend you staple these three together and then organize and safely store them by year. Commercial art galleries seem to be frequently audited by the Internal Revenue Service.

Depending on how complicated they may be, your quarterly sales tax reports are something your bookkeeper can prepare for you as well. In New York, after paying sales taxes for a while, many young galleries will be offered the opportunity by the state to pay sales taxes on a yearly, rather than quarterly, basis. There are advantages and disadvantages to both. This is one of the issues on which you should consult with your accountant.

Finally, because of the nature of the business, many small commercial art galleries are opting for newly available online credit card payment systems, like PayPal, rather than credit card merchant machine services. The advantage of the machines, of course, is the ability to swipe a client's card and print out a receipt for them immediately. The disadvantages include a generally higher fee, maintenance and supplies for the machine, and the need for an actual phone line to use it. At art fairs in particular, where most dealers have access to wireless connections but not easy access to a phone line, PayPal services can get that money into your checking account much more quickly.

SUMMARY

Being able to rely on the competence, talent, and advice of the experts with whom you work is a true advantage in running a commercial art gallery. Finding ones who are a good match for your business, though, requires a solid understanding of what you need them for, how to measure the quality of their services, and whether their fees are in line with industry standards. Reaching out to your fellow art dealers is generally the most effective means of finding top-notch expert services.

13

Art Fairs

In December 2008, there were more than twenty separate satellite art fairs organized to take advantage of the legions of super collectors who flock to Miami each winter to attend the main attraction, Art Basel Miami Beach. Taken together, this represents participation by more than 1,000 art galleries from around the world. Attendance at the main fair alone in 2008 was reported to be about 40,000 people (many of whom may still be recovering from the relentlessly ritzy after-party schedule). Despite all the glamour associated with them, though, art fairs are essentially trade shows. Vendors pay to display their wares in booths for a few days in hopes that the concentration of them and special programming involved will attract clients who are interested in their goods, that they will make connections with like-minded vendors, and, of course, that they will make lots of sales. To participate in these trade shows, galleries either must be invited privately or be selected from an open application process. There are also juried art fairs and "arts and crafts" fairs that offer spaces directly to artists, but for the purposes of this chapter, I will limit what I mean by "art fair" to the events that predominantly bring together commercial art galleries.

In the mid-2000s, art fairs became a major source of income for many younger spaces. They have also become somewhat of a status symbol. For younger galleries, getting into the right art fair signals to collectors, critics, artists, and other dealers that you're moving up the food chain, moving in the right direction, and doing

something right. This can then become a self-fulfilling prophecy. You'll meet a wider array of powerful collectors. Your current collectors will trust your eye a bit more. Artists will want to work with you more often. Everyone in the know will take you a bit more seriously.

Because getting into the right art fairs (or not) can truly change the fate of a gallery, dealers are spending more and more of their time strategizing and networking with this goal in mind. Most major art fairs have selection committees made up of other influential art dealers. Getting the attention of those dealers when hundreds of other galleries are vying for it as well has become a priority for younger galleries anxious to benefit from the exposure the major art fairs will bring. A 2007 interview in *TimeOut New York* with founders of the Lower East Side's CANADA gallery notes, "The gallery applied unsuccessfully to [a major art fair] last year; this year, it didn't wait for the selection committee—six top gallerists from the U.S. and Europe—to make up their minds. [Gallery co-founder Phil] Grauer flew to London and sought out members of the committee at [another major art fair]."[1] Grauer's lobbying worked. CANADA was invited to participate in that major fair that year.

In this chapter, I'll discuss art fair hierarchies, including which art fairs are generally seen as the major ones and which are the second-tier (but still important) ones, and what their organizers say they look for when selecting participants. I'll look as well at the satellite fairs and explain why, even if you have your heart set on getting into a major fair, they're still worth considering. Then, I'll look at the application process for a typical art fair. I'll also discuss the politics of being accepted to, and then working, an art fair. Just because you get accepted one year is no guarantee they'll invite you back. Finally, I'll examine the logistics of taking your show on the road and what should be in your Art Fair Survival Kit. The amount of work involved in setting up a temporary, mini version of your gallery in another location should not be underestimated. Fairs can be exhausting. Knowing what you're getting into ahead of time can save considerable expense and frustration.

LISTS OF UPCOMING ART FAIRS

Sources for art fairs around the world include the magazine on Artnet.com (*www.artnet.com/magazineus/frontpage.asp*), which has a link to updated lists of "Art Fairs and Biennials" for the current year. Another Web site that lists fairs and international exhibitions is Art Fairs International (*www.artfairsinternational.com*). Click on its "Calendar" to see what's upcoming. There is also a guidebook published twice a year by Artmediaco titled *The International Guide to Art Fairs and Antiques Shows;* its Web site (*www.artandantiquesfairguide.com*) was a bit out of date as of this writing, but the copy I just received in the mail seemed current, if not exactly exhaustive.

ART FAIR HIERARCHIES

Depending on what type of art you sell, your opinion on which fairs are more important may differ from those of other art dealers. Further, certain galleries seem to thrive in this or that minor fair for any number of reasons (usually related to a strong pairing of product and specific audience), when other galleries merely do so-so there, and this particular success will perhaps skew the perceived hierarchy for their business. Still, most dealers can tell you where any given fair falls in the pecking order of the choices available for any given market. I should note up front, however, that my rankings are perhaps skewed toward the contemporary art market (my gallery's focus) and you should check with other dealers specializing in your chosen market for more nuanced opinions.

Major Art Fairs

All the fairs discussed in this section include an international array of galleries. There are no fairs I would consider "major" that limit their attendance to regional or national galleries. You'll find that a majority of galleries participating in any fair may be local, but more and more fairs seem determined to broaden the mix, and newer galleries can often get accepted into a major fair because of their unusual locations.

Arguably the world's most important art and antiques fair is The European Fine Art Foundation (TEFAF) fair that takes place each March in Maastricht, the Netherlands (*www.tefaf.com*). In addition to Modern and contemporary art, TEFAF Maastricht (as it's most commonly referred to) hosts galleries specializing in an incredibly wide range of objects, including decorative art; arms and armor; books, manuscripts and maps; classical antiquities; coins and medals; clocks and barometers; furniture; jewelry; medieval sculpture; Asian art; porcelain and ceramics; primitive and pre-Columbian art; textiles, carpets, and tapestries; and more. The only unifying criterion for the fair is extremely high quality. Indeed, the fair is among the most difficult to secure an invitation to because, as their Web site states, "every item is checked by one of twenty-four vetting committees made up of over 150 internationally respected experts."[2] Because there remains a considerable waiting list for this fair among even well-established galleries, TEFAF have recently launched "Showcase," a strictly one-off participation for galleries older than three years but no older than ten. The vetting process is just as stringent for Showcase as it is for the rest of the fair, though. Also, like most major fairs with a "junior" component to them, TEFAF relegates the "showcase" galleries to a special pavilion.

The world's most important fair limited to Modern and contemporary art is Art Basel (*www.artbasel.com*), which occurs in the charming city of Basel, Switzerland, in

early June each year. Called "the Olympics of the Art World" by the *New York Times*[3], Art Basel attracts the most powerful contemporary art collectors from every corner of the globe, and in doing so serves as a solid indication that a participating gallery has reached "the big time." The fair celebrates its fortieth anniversary in 2009.

Applying for Art Basel has become much easier since it implemented an online process, but like TEFAF, there are far more galleries hoping to participate than booths available. Art Basel has gone much farther than most other fairs in providing opportunities for younger galleries to participate, though. In addition to their main section, which hosts almost 300 of the world's leading galleries, Art Basel has the following components:

- Art Edition (for publishers of editioned works)

- Art Premiere (projects presented by galleries of any age that juxtapose works by two artists)

- Art Statements (projects by galleries by one young artist)

- Art Unlimited (projects that don't fit into the standard booth format, such as video projections, large-scale installations, big sculptures, and performances)

- Public Art Projects (projects presented in the Messeplatz exhibition square)

- Artist Books (magazines and other publications produced by artists)

- Art on Stage (program of performances in association with the Theater Basel)

- Art Film (films by and about artists)

In 2002, Art Basel branched out and launched Art Basel Miami Beach (*www. artbaselmiamibeach.com*), also known as ABMB. This second-city version of the fair was originally slated to begin in 2001, but was canceled in the wake of the September 11, 2001, terrorist attacks. When it finally opened in early December the following year, it was an instant smash success. The combination of South Beach sun and fun, glamorous parties, celebrities, and high-profile art made ABMB an overnight sensation, and it's not at all hyperbolic to note that, coupled as it was with a historically strong art market, the fair heralded a dramatic shift in how art was being sold worldwide. (For a while, at least.)

When tales of ABMB's opening reception feeding frenzies—at which galleries sold out their booths in mere hours, if not minutes—spread throughout the art world, galleries everywhere became very interested in participating. Satellite fairs in

Miami sprung up like mushrooms. Collectors also got caught up in the excitement and began reaching out to contemporary art galleries months in advance, asking them, "What are you bringing to Miami?" Collectors even began sneaking into the fairs before the VIP openings (a highly controversial practice), which signifies both the competitiveness of the art market and the success of the fairs.

All of this worked to shift attention away from purchasing art in the galleries and onto the conspicuous art buying the party atmosphere made seem all the more thrilling. Galleries, therefore, began planning what they exhibited in their fair booths as carefully as what they exhibited in their spaces, with special projects designed to grab the headlines and the attention of the right collectors, who would later discuss what they bought at the exclusive dinners and parties throughout the city each night, generating even more buzz. As a result, many an art star has been born in Miami. How long it will continue is anybody's guess. As of this writing, the art market in New York is following the general economy, which has slowed a bit, but the new global nature of the art market seems to be prolonging the strength of it longer than anticipated. I'll discuss the art market and collectors a bit more in chapter 15.

Many of the galleries that participate in the main section of Art Basel also participate in ABMB. As in Switzerland, though, the fair has ample opportunities for younger galleries to be involved, including a few Miami-style variations such as (as of this writing); Art Positions (which used to house twenty young galleries creating projects in shipping containers on the beach, and will be incorporated into the main fair in 2009) and Open Air Cinema (which features outdoor presentations of collaborations between musicians and visual artists).

Despite all these opportunities, Art Basel and ABMB still turn down far more galleries than they can accept every year, which gives bragging rights to any gallery that even makes it onto the waiting list. The organizers of both fairs have gone on record as saying the best satellite fairs to participate in if you wish to eventually be accepted into an Art Basel fair are Liste in Switzerland and NADA in Miami (these are the younger fairs they see as farm-league). We'll look at these fairs in these next sections.

Although they don't generate quite the same level of unbridled excitement one finds in Miami, several major art fairs take place in New York City every year, including the members-only event The Art Show (*www.artdealers.org/artshow.html*), organized by the Art Dealers Association of America (ADAA) each winter, either in February or early March. To participate in The Art Show, a gallery must first be invited to become an ADAA member. (I'll outline that process in chapter 16.) This is a prestigious and very elegant fair with a range of work as broad as the ADAA's membership, but lately, it has been seen as perhaps too "safe" compared to its younger and edgier competitor, The Armory Show (*www.thearmoryshow.com*), which grew

out of the Gramercy International Art Fairs presented in New York, Los Angeles, and Miami between 1994 and 1998. Originally organized by four New York art dealers, The Armory Show was recently partially purchased by Merchandise Mart Properties, Inc. (MMPI), which is actively buying and running several fairs throughout the U.S. and Canada (including Art Chicago, Volta, and the Toronto International Art Fair, all of which I discuss below). Despite its Web site's statement that "The Armory Show, The International Fair of New Art, is the world's leading art fair devoted exclusively to contemporary art," in 2008, MMPI announced the addition of a concurrent fair, The Armory Show—Modern. This move has been interpreted by many in the New York art world as a challenge to the ADAA's format of mixing predominantly contemporary and Modern art galleries in The Art Show. Like many major fairs, The Armory Show's application process states that all submissions are reviewed by that year's selection committee—a "peer group of internationally recognized gallerists"—and that The Armory Show staff itself does not participate in the process. Every year, hundreds more galleries apply than are accepted into The Armory Show.

New York, like many other cities, also hosts several major media- or genre-specific art fairs each year, including the International Fine Print Dealer Association's (IFPDA) annual Print Fair (*www.ifpda2008printfair.com/site*); the privately organized Works on Paper (*www.sanfordsmith.com/wop.html*); the Outsider Art Fairs (*www.sanfordsmith.com/outsider.html*); and The Association of International Photography Art Dealer's (AIPAD) Photography Show New York (*www.aipad.com/photoshow/new-york*), which had also taken place yearly in Miami, but seems now to have been canceled. As noted above, depending on a gallery's focus and client base, any one of these fairs may be the most important fair of the year for it.

London's Frieze Art Fair (*www.friezeartfair.com*), which takes place in mid-October, is the newest contemporary art fair to rise to "major" status. Almost overnight, it joined the ranks of Art Basel and The Armory Show in prestige. Organized by the publishers of the art magazine by the same name, Frieze recruited a very impressive list of galleries for its debut in 2003, and the rest, as they say, is history. The fair, held in Regent's Park, includes a program of projects, talks, music, and film, a lineup that has become rather expected from major fairs these days.

Among the most important (predominantly) contemporary art fairs in Europe are la Foire internationale d'art contemporain (FIAC) [*www.fiac.com*], held each October in the Grand Palais and Cour Carrée du Louvre in Paris; Feria Internacional de Arte Contemporáneo (ARCO) [*www.ifema.es/ferias/arco/default.html*], which takes place in Madrid each February and focuses on the contemporary scene of a different guest country each year (in 2009, it was India); Art Cologne (*www.artcologne.com*), which

hosted its forty-third international fair of Modern and contemporary art in the German city in April 2009; and Art Forum Berlin (*www.art-forum-berlin.de*), which focuses on contemporary art, starts the last weekend of October and is widely viewed as the edgier cousin of Art Cologne. As noted above, my point of view in classifying the fairs is undoubtedly colored by the fact that my gallery specializes in contemporary art. If you intend to represent other types of art, or even if you don't, you should definitely get a second opinion about these fairs before applying.

Second-Tier Fairs

I certainly do not mean to insult any of the fairs discussed in this section by classifying them as "second-tier." (Fairs that I personally do not feel are worth your time, I'm not even mentioning, although I can't discuss all the fairs available, so an omission should not necessarily be seen as a dismissal.) Nor should their inclusion in this section suggest that they are necessarily easier to get into. My criteria for grouping fairs into this category are admittedly highly subjective and include how often I see the fairs advertise, how many of my peers participate in them, and what dealers who have participated in them report back in terms of attendance and sales. Any one of these professionally organized events, however, may prove to be the most profitable fair of the year (in terms of both sales and connections) for any given gallery, and as such are very much worth consideration. Besides, the major fairs often make determinations about younger galleries based on the total art fair experience they have, so participating in any fair serves to beef up your history and chances.

Not too long ago, Art Chicago (*www.artchicago.com*) was seen as the preeminent art fair in the United States. Virtually the entire art world made a pilgrimage to the Windy City each May, and competition for the booths there was fierce. The advent of The Armory Show in New York and Art Basel Miami Beach, however, changed all that, leading Art Chicago's appeal to wane and its organization to eventually all but implode with nearly disastrous results in 2006. Reports of galleries arriving to find an empty venue with no walls (because of union trouble in getting set up) seemed to be the death knell for the venture, but at the last minute, a deal with MMPI (who ended up buying the fair outright) provided a new location, and the fair did take place in the Merchandise Mart building. Of course, the damage to its reputation had been done, and when MMPI tried recruiting galleries for the 2007 version, it was met with very skeptical resistance. Still, the new team put in place by MMPI was very enthusiastic and convincing, and the rebirth of Art Chicago in 2007 got relatively rave reviews from all involved. By the following year, the number of galleries wanting to attend Art Chicago had reportedly risen dramatically.

The Palm Beach Fine Art and Antique Fair (*www.palmbeachfair.com*) has a much less rocky history and the added benefit of being located in a place to which many collectors are only too happy to travel at the end of January. From ancient art to porcelain and ceramics, from furniture to tribal, oceanic, and pre-Columbian art, this elegant event has a similar vetting process to that used for TEFAF and attracts a similarly genteel type of gallery. Also in Palm Beach, the contemporary art fair palmbeach3 (*www.palmbeach3.com*) takes place a few weeks earlier. Celebrating its twelfth anniversary in 2009, palmbeach3 is a little less expensive than the average satellite fair in Miami in December, but doesn't benefit from having ABMB as a draw. Also, unlike most fairs that ask for a nonrefundable application fee of between $200 and $450, palmbeach3 is one of the fairs that requires a $2,000 deposit with your application, which is refunded in full if you're not accepted, but the process takes months.

The Toronto International Art Fair (*www.tiafair.com*) is very much dominated by Canadian galleries, but does attract galleries from the U.S., the U.K., and beyond. In addition to its regular gallery section, which, with the 2008 fall of the U.S. dollar, costs just about as much as a booth in any U.S. art fair, TIAF offers a "Fresh Avant-Garde" booth for significantly less money. Works exhibited in the Fresh Avant-Garde booths must be by emerging artists, and at least 75 percent of them must cost less than $5,000. Another fair that offers opportunities for dealers selling low-priced work is the Affordable Art Fair (AAF) network of events that take place in New York, London, Sydney, Melbourne, Amsterdam, and elsewhere (the New York version's Web site is *www.aafnyc.com*). Artwork must cost less than $10,000 to be exhibited in the New York fair. With lecture series that include talks on how to start your own collection, as well as organizing its own collectors group (something usually the purview of museums), the AAF caters to both collectors and galleries just getting started.

With its economy roaring into dominance and its art scene bursting at the scenes, a number of art fairs based in China are gaining in stature. Art Beijing (*www.artbeijing.net*), which celebrated its third year in 2008, and ShContemporary (*www.shcontemporary.info*), which is based in Shanghai and is starting its third year in 2009, both focus on contemporary art and are actively reaching out to and gaining the participation of a growing number of international galleries. Reports from both fairs suggest American galleries will need to be patient to build a strong client base there, unless they're already dealing with Asian, and, in particular, Chinese, artworks. Chinese collectors of Western contemporary art were relatively few in 2007.[4]

Art fairs have also sprung up in Turkey and Dubai in recent years. Contemporary Istanbul (*www.contemporaryistanbul.com*) debuted in 2006 with

forty-nine galleries, most of them Turkish and German. By the next year, its participants had increased to seventy-nine galleries, but the mix of nations did not change much. One thing to keep in mind about Contemporary Istanbul's one-page application form (which may seem merciful compared to the applications with multiple pages of small type terms and conditions) is that this is not their final contract. You get the rest of the terms for participation upon acceptance of your application. Art Dubai (*www.artdubai.ae*) held its inaugural event in 2007. Called DIFC Gulf Art Fair initially, it changed its name in 2008. Even with an emphasis on galleries from the Middle East and the rest of Asia, dealers from Europe, Africa, and the Americas still make up half of the galleries participating. In its application, Art Dubai notes that "galleries are kindly asked to avoid art-work containing direct religious imagery (all religions), nudity, or overtly sexual references."

Mexico City's Feria México Arte Contemporáneo (*www.femaco.com*) has been generating a great deal of excitement in recent years. Launched in 2004, MACO has been steadily attracting more U.S. galleries with tales of high energy, amazing parties, and solid sales. Somewhat unusual but highly appreciated is their payment schedule, which is broken up into three installments rather than the more typical two. One unpopular practice among many galleries that the fair has, though, is the requirement that participants pay extra for obligatory inclusion in the fair's catalogue. Many dealers I speak with say they would rather that fairs simply add that expense to the cost of the booth as opposed to breaking it out separately.

The directors of two fairs in the Netherlands and Belgium have been actively promoting their venues to U.S. galleries the past few years. In its twenty-sixth year in 2008 and with about three times the attendance, Art Brussels (*www.artexis.com/artbrussels/ home.htm*) is the more international of these two fairs. Indeed, its main gallery category stipulates that an applying gallery should "actively promote its artists on an international level." Art Rotterdam (*www.artrot-terdam.nl*), which takes place in February, is celebrating its tenth anniversary in 2009. As many younger fairs do, it offers an artist prize each year that, in 2008, included €10,000 in prize money. The Art Rotterdam 2008 list was predominantly Dutch galleries (only three galleries from the U.S. participated), but it might end up being a perfect match for certain U.S. programs, so it is perhaps worth considering.

Finally, Italy's Artissima (*www.artissima.it*), held in early November, has quickly gained in international stature lately, as well. With a highly regarded cura-torial program running in conjunction with the fair, this Turin-based event has been attracting an impressive lineup of young European and American galleries. The selection committee board of directors is predominantly Italian, as one would expect, but the advisory board is fairly international. One of the features of

Artissima that has garnered it respect is its Constellations program, a special section reserved specifically for large-scale, museum-quality works.

Satellite Art Fairs

Many of the satellite art fairs (that is, fairs organized specifically to coincide with major fairs to take advantage of the visitors their promotional efforts and status attract) are actually more difficult to get into than many of the second-tier fairs, so strong are their own reputations and attendance. The organizers of the major fairs have expressed mixed feelings about the growing number of satellite fairs. Some admit that their explosion is frustrating and others acknowledge that they see the satellite fairs as essentially farm leagues from which they can recruit future clients. Satellite art fairs run the gamut in terms of how professionally they are run and in what kinds of locations they take place. Some of the best satellite fairs take place in hotels with very little in terms of high-profile promotions. Others are almost as high-end and are often more exciting than the major fairs they shadow. Most dealers agree that participating in the major fair in any city is preferable to the satellite fairs, but because they sometimes simply cannot afford to miss having a presence during the festivities, a satellite fair is better than no fair. Also, they may not yet qualify for participation in the major fairs, which do look at art fair experience in determining who to accept. Most of the best known satellite fairs focus on contemporary art, but that category is somewhat loosely defined by a few of them.

The most prolific of the satellite art fairs organizations—that is, the one with fairs in the most cities—is Scope Art Fair (*www.scope-art.com*). The Scope fairs' locations keep shifting, but in 2008, they advertised satellite events in New York, London, Basel, Miami, and Madrid, as well as one fair that didn't coincide with a major event: Scope Hamptons. Scope is renowned for its high energy and frequent surprises. It is often the first art fair on many galleries' résumés. The very first Scope fair was held in a New York hotel in 2002. It was followed by another hotel fair in Miami that same year. Since then, Scope has branched out to more traditional venues (in 2008, it was held in a 60,000-square-foot pavilion in Miami). Originally, Scope was a much less expensive alternative to the major fairs, but its prices have steadily increased, as have those of most satellite fairs. In 2008, a 200-square-foot Scope Miami booth cost $10,600, compared with the $2,500 hotel room it offered in 2002.

Another organization with fairs in both New York and Miami is the PULSE Contemporary Art Fair (*www.pulse-art.com*). Strategically positioning itself between the emerging gallery fairs and the dominant major fairs in those cities, PULSE has grown in stature since its 2005 debut in Miami and now attracts a strong list of international galleries. Originally, PULSE's main section was

comprised of galleries selected by invitation, but it accepted applications to its "Impulse" section for smaller booths and newer galleries. In 2008, PULSE switched to applications for all booths, as is a trend among satellite fairs that do well. In 2007, PULSE held one fair in London opposite Frieze, but its organizers decided not to repeat that effort in 2008. (Full disclosure: I am a member of the PULSE Art Fair selection committee.)

Two other organizations with satellite fairs in multiple locations are Bridge Art Fair (*www.bridgeartfair.com*) and Red Dot Fair (*www.reddotfair.com*). Each of these fairs is growing rapidly and garnering mixed reviews. Launched in Chicago, the Bridge Art Fair's 2008-2009 schedule included New York, Miami, London, and Berlin. The fairs' venues vary: an apartment building in Berlin, a hotel in London, a warehouse-style space in New York, and three locations in Miami (two South Beach hotels and a new space in the Winwood district). Depending on the location, participation is either by invitation only (though interested galleries are encouraged to inquire) or by application. The Bridge hotel fairs in Miami cost $8,000 per room in 2008. Red Dot organized fairs in 2008 and 2009 in New York (in a midtown hotel), Miami (in the Winwood District, having moved from a South Beach hotel in 2007), and London (a hotel in Tottenham Court Road, within walking distance of Frieze). Rooms in Red Dot London 2008 ranged from $5,500 to $14,000. Neither of these fairs has a reputation for being difficult to get into.

Most of the other satellite fairs occur in only one or two cities at most, so perhaps it's better to organize them by location. As noted above, no city approaches Miami in terms of the sheer number of satellite fairs that its anchor fair—Art Basel Miami Beach (ABMB)—attracts, so we'll begin with the December migration of the art world to sunny Florida. New fairs are being organized for Miami even as I write this, though, so I'll apologize in advance to any events I leave out of this description.

Among the most influential satellite fairs in Miami is the New Art Dealers Alliance, or NADA Art Fair (*www.newartdealers.org*). Launched in 2003 by members of the young art dealers association in a ground-floor building a few blocks from ABMB, it was an overnight sensation. Moving to a large warehouse space in the Winwood District of Miami, across the bridge from South Beach, in 2004, NADA was already a power player by its second year. Like other fairs, NADA switched from invitation only to applications in 2005, and remains perhaps the most competitive of the Miami satellite fairs. Even membership in NADA is not a guarantee of acceptance into the fair.

Along Collins Avenue in Miami Beach, a growing number of boutique hotels are playing host to satellite art fairs each December. Among them, the Aqua Art Fair (*www.aquaartmiami.com*) is perhaps the most popular. Founded by an artist and

former dealer from Seattle, Aqua focuses on West Coast galleries, which is refreshing enough for East Coast art lovers, but its open-court, breezy location is a tropical pleasure to navigate. To capitalize on its success, Aqua launched a second fair in the Winwood District in 2007.

Other hotel fairs in Miami include Art Now Fair (*www.artnowfair.com*), which also held a New York version in 2008; Ink Miami (*www.inkartfair.com*), which showcases publishers and galleries featuring works on paper and is sponsored by the International Fine Print Dealers Association (IFPDA); and a new effort for 2008 called The Artist Fair (*www.theartistfair.com*), which is predominantly catering to artists without gallery representation but is also open to galleries wishing to present a solo artist installation. And finally, among the other opportunities for galleries in Miami are Photo Miami (*www.artfairsinc.com/photomiami/2008*), Design Miami (*www.designmiami.com*), and the highly respected Art Miami (*www.art-miami.com*), which in its eighteenth year switched its location and dates (from early January) to coincide with ABMB and in doing so became an instant player among the satellite fairs catering to well-established galleries.

As noted above, opposite London's Frieze art fair are some of the same fairs that run events in Miami (Bridge, Red Dot, and Scope), but the most prestigious of the satellites is the Zoo Art Fair (*www.zooartfair.com*), which moved from the London Zoo (hence the name) to the Royal Academy of Arts in 2007. Originally an invitation-only event, with participation restricted to galleries located in specific cities and countries (the United Kingdom, mostly), Zoo also opened up an application procedure in 2007. Although its application process seems to suggest that galleries must be under six years old to participate, several of the galleries invited for 2008 were a bit older than that.

Until the art fair mania that ABMB initiated spawned dozens of new efforts, for years, there was only one notable satellite opposite the Swiss-based grandfather of Modern and Contemporary fairs, Art Basel, and that satellite was Liste (*www.liste.ch*). Understood to be the venue at which young galleries wishing to graduate into Art Basel should participate, Liste (also known as "The Young Art Fair") presents galleries no more than five years old and artists who are under forty years of age "in general." As with Zoo, however, this seems to be a guideline and not a hard-and-fast rule. Liste started in 1996 and prides itself on presenting only the strongest of the world's young galleries. Recently, Art Basel has attracted a variety of other satellites, including the Volta Show (*www.voltashow.com*), which began in 2005 and expanded to include Volta NY (*http://ny.voltashow.com*) in 2008. The New York version was an instant hit with its solo artist booth requirements. In addition to Scope Basel (discussed above), the Balelatina Art Fair (which changed its name to the Hot Art Fair [*www.hot-art-fair.com*]) opened

within a niche as the only fair orbiting Art Basel to focus on Latin Art. With galleries from mostly Spanish- or Portuguese-speaking countries, Balelatina lived up to its reputation for its first three years, but all the press for the 2009 version indicates that it's expanding to become another international fair with its re-branding. Finally, a new Art Basel satellite launched in 2008 may be a harbinger in response to the "fair fatigue" the art world seems to be feeling lately. The Solo Project (*www.the-solo-project.com*) positions itself specifically as an event organized in response to the growing corporatization of international fairs. Indeed, the fair's organizer, Antwerp dealer Paul Kusseneers, notes that he started the event "in order to address a number of qualities we consider to be missing from the international art agenda." Other anti-art-fair art fairs are likely to follow suit.

THE APPLICATION PROCESS

The deadline to apply for most art fairs is generally about nine months before the event is held. You'll be notified whether or not you are accepted about six months before the fair takes place, giving you plenty of time to plan. If your application requires a description of what you plan to present, it is expected that you do indeed present said booth concept at the fair. In some cases, you may be wait-listed, meaning that if one of the other galleries accepted outright cancels for some reason, you'll have the opportunity to take its place. This notification can come with much shorter notice, though, so being wait-listed can make galleries a bit anxious. Also, being wait-listed presents a dilemma with regard to applying to a concurrent fair. The costs of applying or paying the down payment (many of which are not refundable) make it expensive to apply to a number of fairs and then pick the best of the ones that accept your application, but galleries will do so because they feel they need to be in a fair in a certain city when their clients will all be there.

Most fairs will usually ask for 50 percent of the total booth costs shortly after notification of acceptance, with the other 50 percent due a few months later. If you apply to an art fair once, even if you're not accepted, the organizers will generally alert you to when applications for the next fair are available. As noted above, though, not all art fairs require galleries to apply for participation. Some are produced as "invitation only." If you're lucky enough to be invited to participate in a high-level art fair, do what you can to stay in the panel's good graces. The application process for most fairs is a significant amount of work. Below, for example, is what applicants were asked to supply to be considered for the 2006 version of Liste, a fair for cutting-edge younger galleries that coincides each summer with one of the most important fairs in the world, Art Basel in

Switzerland. Liste generally accepts applications only from galleries that are not older than five years presenting work by artists no older than forty. To apply, galleries submitted the following:

- At least four images of "all artists." And they mean all artists in your gallery, not just those you intend to exhibit at the fair. The application also specifies that the committee prefers slides (which are more expensive than and not as common as JPEGs are these days). Images cannot be submitted on CD, and the application is clear that you cannot simply point the committee to your gallery Web site.

- A biography for each of your artists, including when they were born.

- A "clearly defined and documented project for presentation at the fair."

- A completed application form.

- A registration fee in cash or money order. (No checks!) In 2006, the fee was $80.

The instructions are very clear that if your application is incomplete (and by that, they mean you don't supply everything above as instructed), the committee reserves the right to not even review it, even if you've sent the nonrefundable fee.

Liste's fee is actually very reasonable compared to many others, which can charge as much as $450 just to apply. Also, when you understand that the committees for the more popular fairs must go through hundreds upon hundreds of applications, you begin to empathize with the firmness of the submissions guidelines. (Imagine having to be prepared to view thousands of images in every conceivably different format.) Still, the amount of work a gallery must do to prepare an application (and each one will have some variation on how or what they need to review), added to the amount each fair charges as a nonrefundable application fee, means you should carefully consider which fairs you decide to expend that much energy and money on.

It should also be noted that very few fairs offer any sort of feedback to unsuccessful applicants. They generally send a polite form letter explaining that they had received an overwhelming number of submissions and, of course, encouraging you to try again next year (do the math on the number of applications times their application fee, and this becomes a bit less flattering), and noting that the selection committee cannot be available to discuss their decisions. A few of the rejection letters will indicate broadly what their criteria for selection were, which can help you better tailor your subsequent applications. But overall, you're simply left to wonder why your presumably brilliant proposal was turned down.

POLITICS AND OTHER CONSIDERATIONS

There's no dealer I've ever met who wouldn't admit—confidentially, at least— that art fair selection processes involve politics. Some dealers may opt not to apply to a fair simply because they don't know anyone on the selection committee or because someone on the committee is certain to lobby against them for whatever reason. Galleries that have excelled at certain fairs for years may find themselves uninvited without clear cause when selection committees change over. In a nutshell, such maneuvers are part and parcel of the same kind of personal preferences, alliances, and vendettas you'll find in any profession. In the art fair world, it pays to make friends.

Beyond just getting accepted, however, there are political considerations to staying on the good side of any fair's organizers once you are invited. With so much competition at the more lucrative fairs, those in decision-making positions don't need much of an excuse to pass on your next application, so it behooves dealers to keep in mind that the fair staff and management are not their personal employees. I have seen dealers arrive horribly late to install their booths, only to then complain forcefully about any number of relatively minor issues. These same dealers then wondered why they were not invited back the following year.

How well you install and run your booth does not go unnoticed, either. The overall look and feel of a fair is important to its organizers. Dealers who don't take seriously their part in making the fair a rewarding experience for the visitors (many of whom paid fees to enter) are not only seen as unprofessional but actually are sometimes in breach of contract. Most fair contracts stipulate explicitly what is expected in terms of quality of artwork exhibited and the standards with which a booth is installed and manned. Most fairs conduct an official walk-through toward the end of the event, with organizers taking notes on whose booth looked good and whose didn't. These observations are later used in next year's selection process.

ART FAIR BOOTH AND INSTALLATION LOGISTICS

Most higher-end art fairs are very detailed in their exhibitor manuals about what you get for the booth price and what services or fixtures will cost you extra. Some, though, are less comprehensive. Considering only the booth itself (that is, not including promotional efforts such as advertising and events), the fee usually covers the basic walls, flooring, general cleaning, and a certain number of lights. You can pay to receive extra walls, closets (with locking doors, at some events), painted walls, additional lights, furniture, flowers, drinking water, pedestals, and other such amenities. All of this can add up considerably, though, so in budgeting for a fair, be sure you get prices before you commit to any particular installation idea.

Most mid- to large-sized fairs also have an installation manager who will work with you to ensure that any special installation needs are incorporated into your booth. If, for example, you need a darkened space to exhibit a video projection (necessitating a covering over the booth), or you're bringing a particularly heavy wall piece, or you need to secure a work to the floor with screws, you should touch base with the installation manager well in advance. Not only might such needs change the location the fair can offer you, but finding out only when you arrive that the floor can't be drilled into, for example, can seriously impact your entire installation. It never hurts to ask for special considerations, but some will most definitely incur extra costs.

Having to install work in the highly un-ideal setting of an art fair can be physically and emotionally exhausting. Dealers who can afford to often hire art handlers to set up their booths, but many newer dealers must do so themselves or with the help of their artists. Patience and diplomacy are essential throughout the process. Generosity to other dealers will often pay off for you as well. One thing I recommend, because of the chaos into which art installations can descend, is to label all your tools and fixtures. We've had folding tables and other such items in our booth wander off while we were elsewhere.

ART FAIR SURVIVAL KIT

Walking around a major art fair, you'll see a range of approaches to the mobile gallery. Some dealers bring a network of laptops, printers, and even custom furniture or flat files to ensure that nearly anything they can show or communicate in their office, they can do on the road. Other dealers limit their working resources to a notebook and pen. Shipping costs and the distraction of getting some less essential things to work (for example, your printer runs out of ink, and there's no easy place to get more) tend to make dealers whittle down what they bring over the years, but if being able to print out an image on the spot closes a big deal, it may just be worth the effort. Figuring out what office equipment you personally need to work an art fair successfully may require a bit of trial and error.

Installation hardware, on the other hand, is something every gallery will need, and you cannot always count on the fair organizers to have what you didn't bring or a hardware store to be conveniently located. Therefore, it's a good idea to err on the side of caution when bringing tools and supplies. The best laid plans for installing work can, for any number of reasons, become impossible once you arrive at a fair, so flexibility and creativity go hand in hand with having an array of possible installation solutions available. Most fair organizers will have some of the tools you need, but you may need to wait in a long queue of other dealers to get a hold of them, so bringing your own is often the best plan here.

The owners of our neighboring gallery, Lisa Schroeder and Sara Jo Romero, have over twenty years of experience between them working a wide range of art fairs (some for their own gallery and some for previous employers). Through that experience, they have developed a checklist of items they make sure they bring to each fair in which they participate. They were kind enough to share it with me. Here's what it includes.

Tool box:
- Screw gun
- Hammer
- Both kinds of screwdrivers, as well as a tiny one
- All kinds of nails
- Ook hooks
- All kinds of screws
- Measuring tape
- Stapler
- Calculator
- Electric couplers
- Levels (small and large)
- Pencils
- Packing tape
- Masking tape
- Blue tape
- Duct tape
- White tape to cover cords
- Knives
- Two extension cords
- Power strip
- Plexi cleaner
- White gloves
- Garbage bags

Book Box:
- Business cards
- Sign-in book
- Receipt and business card holders
- Artist slides and books
- Copies of bios, books, and CDs
- Pads of paper
- Pens

- Sharpie
- Red dots
- Artist catalogues
- Press book
- Cards from shows
- Wall labels
- Extra labels
- List of works taken
- Extra letterhead
- Videos and DVDs

Stuff to buy on location:
- Windex
- Paper towels
- Wine, seltzer, cups, and a corkscrew

You will likely refine your personal survival kit list over the course of several fairs. As noted above, though, generosity with fellow dealers can often pay off, as it makes your colleagues more willing to share supplies with you. One final thought on being prepared for an art fair is actually more of a cautionary tale. As stressful and chaotic as the set-up can be, the de-installation (with dealers being exhausted after days on their feet and rushing to catch flights out of town and fair workers trying to bring in crates or take down walls) is known to be a time when artwork can be damaged at almost any turn. Leave yourself plenty of time to de-install.

NOTES

1. *Steven Stern, "At War with Canada,"* TimeOut New York *595 (Feb 22–28, 2007).*

2. *TEFAF Maastricht, The World's Leading Art and Antiques Fair,*
 http://www.tefaf.com/DesktopDefault.aspx?tabid551.

3. *Judith H. Dobrzynsk, "In Olympics Of Art World, Anything For an Edge,"* New York Times,
 June 17, 1999.

4. *Georgina Adam, "Chinese Buyers Thin on the Ground at ShContemporary,"* Art Newspaper,
 January, 10 2007.

14

Artists: Where to Find Them; How to Keep Them

I t can be easy, when faced with the day-to-day challenges of keeping a small business afloat, to lose sight of the fact that the inescapable prerequisite to selling art is that artists create it. As noted throughout this book, there are much easier ways to make money than opening a commercial art gallery. Without a profound passion for art, you might be happier selling something else. If you work in the primary market, having a passion for working with artists helps, as well. Passion is only part of the equation, though. It is the dealer's duty to serve as his artists' advocate and agent, and perhaps wear a few other hats, as well. As Alan Jones puts it in the introduction to *The Art Dealers,* the métier of art dealing can include "publicist, father figure, banker, merchant, patron, [and] advisor to artist and collector alike."[1]

The relationship between artists and dealers can include a rewarding interpersonal component, but it has legal implications, as well. As stated in Tad Crawford and Susan Mellon's book, *The Artist Gallery Partnership: A Practical Guide to Consigning Art,* taking work on consignment (in some jurisdictions, without a written agreement) makes the gallery the artist's "agent" and thereby obligates the gallery to "act in good faith on the artist's behalf, trying to make advantageous transactions for the artist's benefit."[2] Beyond legal obligations, there are also ethical considerations. Indeed, the Art Dealers Association of America (ADAA) makes adhering to the "highest standards of ethical practice" one of the criteria for its membership.

In this chapter, I discuss the common practices and tools used to manage the artist-dealer relationship. I'll begin by explaining how dealers typically find the artists they represent, including arguments for and against representation, from both points of view, as well as ways to work with artists before you offer them representation as a test of how well you work together. In addition, I'll look at the general services galleries provide their artists and some of the more "premium" services that can figure into negotiations on how to split sales.

Because it's the main tool for managing the sales part of the artist-dealer partnership, I'll examine the consignment agreement in detail and discuss the laws that govern it. Moreover, because emotion and ego can be involved in the presentation and pricing of artwork, I'll also look at the best practices for diplomatically discussing pricing, resolving differences of opinion, or getting through highly charged conflicts. Regardless of your diplomatic aptitude, though, as an art dealer you may find that some conflicts cannot be satisfactorily resolved, or your artists may find reasons they wish to end the relationship. Therefore, I'll discuss the range of considerations that need to be made when representation comes to an end.

FINDING ARTISTS

The first solo exhibition we presented in our gallery came about through perhaps the least probable scenario imaginable. The artist, a fabulous painter and sculptor named Joe Fig, lived two floors above our first ground-floor space. One of his former professors later used Joe's experience in lectures to graduate students about what to expect when they set out to find a gallery. He reportedly advised that they should not expect galleries that like their work and want to give them solo exhibitions to set up shop one day right below their apartments.

It did happen that way for us with Joe, though, and this demonstrates that you can find the right artists just about anywhere. That is, so long as you have a clear understanding of what kind of artists are right for your gallery. As discussed in chapter 2, your best means of ensuring that you do this is to take the time to write a carefully considered mission statement. Having a well-defined sense of your vision for the gallery will better enable you to assess whether an artist you find (or who finds you) might be one with whom you should pursue a partnership.

Personally, I only lucked out like we did with Joe that one time. All our other artists came to us through one of the following, more common, ways: recommendations (including from other dealers), institutional exhibitions, open studios, or cold-call submissions. I have specifically ordered these according to frequency in my current experience, but dealers just getting started may find the frequency is nearly the exact opposite. How you find your artists is not important, as long as they

are good matches for your mission, but in looking for artists, you may want to keep in mind the following considerations.

Recommendations

Another noteworthy advantage of having a clearly defined and well-publicized mission is how it can help other people realize when an artist is right for your gallery. Most of the artists we have added to our roster in the past few years were brought to our attention by curators, other dealers, and other artists (both those we currently work with and those from other galleries). Even when meeting a curator, collector, or artist for the first time, if you communicate succinctly what your gallery's mission is, you encourage them to limit any recommendations they might wish to make to artists more likely to be of true interest to you. This also gives you an easy and very polite way to explain why a recommendation may not be one you'll pursue.

Of the art world insiders from whom you will receive recommendations, few are likely to be as insightful as artists you already represent. This makes sense when you consider how much time you will have spent discussing why their art engages you. Indeed, your artists will become very familiar with your mission and personal tastes through your conversations about their art. More than that, no one is better qualified to understand what an artist is doing than other artists, in my experience. Having been curated together into group exhibitions or simply having followed another artist's work out of personal interest, your current artists can provide you with some of the most perceptive feedback on trends, quality, and even failings of other artwork being created.

Contemporary art curators, too, can be excellent sources for recommendations. Because curators often specialize in certain areas or curate thematically, few other art world professionals will be as well versed in the considerations of building specific programs or of objectively recognizing where your roster may be lacking. Like nearly everyone in the art world, curators can have agendas that cloud their judgment at times, and some will be instinctively more in tune with your mission than others, but developing a dialogue with those who share your interests can be an invaluable source of information about artists looking for galleries of whom you've not yet heard.

You may also receive recommendations from your collectors. Because many collectors are not only incredibly well-informed about the art in which they have interests but may be particularly astute judges of why your gallery is not quite living up to its mission (especially as compared with more established galleries they buy work from), heeding their advice can lead to great discoveries and can help you better understand the type of art they're interested in themselves. Like some curators, certain collectors may try to promote (or even push) artists they like, regardless of how poorly suited they may be for your gallery. Again, nothing will better assist

you in diplomatically explaining why their enthusiasm for an artist didn't result in an exhibition at your space than a clearly communicated mission statement.

Other Dealers

The final source for good recommendations that we'll discuss here—colleagues in other cities or even those in your area who, for reasons that don't reflect on the quality of art or personality of their artists, will no longer be working with them—is worth discussing separately because the issues involved get a bit more complicated. As explained in chapter 3 on business models, there can be many benefits to having artists you represent work with galleries in other parts of the country and other parts of the world. Just as you may want another dealer you respect to consider taking on one of your artists, other dealers may approach you singing the praises of artists on their roster. Indeed, sometimes, two galleries' programs will be so in sync that they may share multiple artists. Working with kindred spirits or "sister galleries" like this can be a highly effective business strategy, as joint promotions and other synchronicities work to increase awareness about your shared artists.

Moreover, taking on artists who already have galleries can have three distinct advantages: 1) you already know that someone else considers this artist's work marketable, 2) this artist already has experience working within the gallery system, and 3) you will likely benefit from the confidence collectors will gain from knowing that more than one dealer supports this artist's work. I should note that I'm not talking about poaching artists from other galleries (i.e., asking them to work with you but to stop working with the gallery already representing them). There may be circumstances in which that, too, makes sense for you, and I'll discuss that below, but here, I am referring specifically to sharing an artist with another dealer.

There are two ways to approach artists already working with other galleries: contact the artists directly or contact their galleries first. There is nothing set in stone as to which is more appropriate, but contacting the other gallery first is appreciated by most other dealers and is my first recommendation if you're unsure. Circumstances may not always make that the approach most likely to work for you, though. Some dealers may be overprotective (especially when approached by a gallery they don't know) or may wish to assert primary gallery rights, even when that may not seem warranted to you. Furthermore, you may meet an artist in some context outside the gallery world and really like her work. You may conclude that it makes sense to work with her even knowing that her current dealer may not wish to collaborate with you (even though the artist is interested in pursuing the idea). This preference on the other dealer's part may reflect nothing more than the fact that he already has a sister gallery in your area, but it may be an indication that the dealer feels your gallery is not yet prestigious enough to benefit this artist's career. Still, if you

are certain that this artist is right for your gallery, you may decide that it makes sense to develop a strong dialogue with her first and then approach her gallery with her as an advocate for the new partnership.

There's no getting around the fact that such negotiations can be tricky. So long as you are up front and honest with the other dealer when you finally do call him, your reputation should remain intact, regardless of what the outcome of your discussion is. Keep in mind that unless a signed representation contract says otherwise, choosing to work with you is the artist's choice, not his dealer's. How you manage such arrangements, though, can impact how other dealers will work with you throughout your career.

The practice most likely to bring antagonism your way from other dealers in your search for artists is poaching them. Convincing an artist to leave her current gallery and work with you instead will stir up strong emotion among many other dealers, so there's no point in sugar coating our discussion here. Some galleries build their entire stables by courting artists for whom other dealers already did the hard work of building a market and promising them more exposure, more money, more prestige, etc. While there is nothing necessarily unethical, per se, about limiting your roster to artists with proven markets, the ill will that going about it in an inconsiderate way can generate may come back to haunt you. The dealer whose artist you poached may end up on the selection committee of the art fair you really want to get into or influence the deciding vote on whether your application to the regional gallery association is accepted.

Then again, for some dealers, the risks are offset by the benefits of poaching. The art business is a business, after all. My personal advice if you feel this method is good for your business is to be confident first that each artist is a good match. There's no point in generating bad karma if it's not going to pay off.

You may find an artist who wants to leave his current gallery and work with you but is uncomfortable telling his current dealer why he is unhappy. No matter how you approach that other dealer, she may conclude that you poached the artist and resent you for it. Having a reputation for not poaching may go a long way toward convincing her otherwise, but you may just have to find some other way to regain her respect. In the end, an artist should work with the gallery with which he is enthusiastic about working. You wouldn't want your artists to feel any other way about your space.

Institutional Exhibitions

Not-for-profit galleries and contemporary art museums are often great sources for learning about very talented artists who are not yet represented by commercial galleries. The curatorial programs at many not-for-profit spaces in particular focus on under-recognized artists with extraordinary vision. Of course, you may encounter

artists in such spaces who are not particularly interested in working with a commercial art gallery. Further, should an artist you meet this way express interest in working with you, if the nonprofit sector has been his only exhibition experience, you may want to set aside additional time to discuss your expectations and the artist's before agreeing to a show. Many artists with exclusively institutional experience may automatically expect that travel expenses, production costs, and even a per diem are part of what the gallery provides when offering a solo exhibition. Also, museums or not-for-profit spaces may not willingly forward you the contact information for the artists with whom they are working if they don't know you. Therefore, going to their openings, supporting their benefits, and otherwise demonstrating your interest in their mission can help facilitate introductions and, of course, help you keep up to date with developments in contemporary art.

Studio Visits and Open Studio Tours

A studio visit is a business meeting for an art dealer. After you get to know an artist better, visits might become more casual, but in finding artists, I recommend keeping in mind that your reputation is built here, as well. Even if you decide a particular artist is not right for your program, all the courtesies of professionalism are appropriate throughout. Despite the outcome of your visit, the artist may be very good friends with another artist with whom you wish to work or other people in the art world you may want to think highly of you. I harp on this point because I have heard of a dealer who enters a studio, looks less than a minute, and then leaves without so much as a single question. For an artist hoping a visit might at least lead to a bit of feedback, this is insulting. The dealer in this instance is someone with whom I would not want to work because of this lack of respect. Again, your reputation is built here, as well.

Likewise, you can discern a great deal about an artist based on how prepared he is for your visit. In addition to what is clearly the most important thing—deciding how much you like the artist's work—gauging how well you might work with an artist or how soon it makes sense to consider starting a partnership is time well spent during a studio visit. Questions you may wish to ask include how much time she gets to spend in her studio, how long it takes her to make any given piece, what her work sells for, whether she has any other commitments with other dealers or non-gallery exhibitions, and what her career goals are. You can also tell a great deal from how well prepared she seems to be for your visit and how interested she is in your opinions. Even the most talented artist in the world may be a bad match for your personality or your gallery's specific goals.

Usually, a dealer is invited by an individual artist for a visit, but open studio tours can also be opportunities to find artists. Organized by foundations or artists

with studios in a particular area or building, open studio tours range from a single evening to a weekend and are generally promoted to local art dealers and other arts professionals. Universities host open studios for their students as well (and typically, you'll see plenty of dealers moving about at such events).

In the beginning of your career as a primary-market dealer, you may find yourself spending almost as much time in artists' studios as in your gallery. Although studio visits can be one of the most gratifying parts of running a gallery and will become a regular part of your working relationship with artists you represent, in the context of finding artists, it makes sense to focus briefly on what you should expect and hope to learn during initial studio visits. Because I've been asking this question of artists for years, I would guesstimate that the average first studio visit lasts between thirty and forty-five minutes (though personally, I have, in some cases, been so enthralled by the work and conversation that I stay, as long as three hours). When finalizing the appointment arrangements, it is a good idea to ask how much time the artist has for the visit and to let her know how long you have. On more than one occasion, I have had an artist wish to show me work that would require more time than I had available, and my departure came across as disinterest. Establishing how much time you have in advance (at least during scheduled visits) can help the artist tailor her presentation to your schedule.

It is common to request images, a CV, and more information about pricing, materials, availability of work, or artistic process during a studio visit—things that artists will ask more and more about whether it's acceptable to just e-mail to you rather than provide in print format. Artists will appreciate in return a preliminary assessment of your interest in their work. Some may come right out and ask whether you wish to work with them or take some work for your inventory. I feel it's fair to say that you want to think about what you've learned during a visit before making any such decisions, but it's also actually more polite to indicate truthfully if you know the work is not right for your gallery than to let them continue to wonder. It may take a good deal of courage to invite a stranger into the private sanctuary that a studio is for many artists. Respecting the privilege they're extending you is the least you can do in return.

Cold-Call Submissions

Whether you solicit them or not, as soon as you open a commercial art gallery, you are likely to receive submissions from artists who want to find galleries. Usually they'll come in the mail or via e-mail, but sometimes, an artist will bring a package or even actual work into your gallery and request that you look at it then. Some artists may not seem very choosy, either; any gallery will ostensibly do. As in so many other instances, having your mission statement on the tip of your tongue will help you save artists from wasting their time if the work they make is clearly not what you show.

Because cold-call submissions are often the least productive means of finding suitable artists, they tend to be most dealers' least preferred means of searching. No matter how explicit your submission guidelines may be about the type of art you're interested in, you are likely to receive packages or e-mails with images of work that seems plainly wrong for your program. On the other hand, every now and then, an unsolicited submission will make your day. Either the artist has done his research and knows his work is a good match for your mission, or fate basically smiles on you. Despite the odds, it does happen.

Usually, new galleries (that is, the ones still building their rosters) will be more open to receiving submissions than more established galleries. Lately, most commercial galleries that encourage submissions outline their preferred method for receiving materials on the "Contact" sections of their Web sites. If you have employees who will interact with gallery visitors, many of whom may be artists wondering if you're looking at new work, make sure your staff can communicate your submission guidelines clearly. Moreover, take the time to consider how you most effectively review submissions (i.e., do e-mailed JPEGs or printouts seem to tell you more, do you want an artist statement, or are images all you need?) and add that to your guidelines. Most galleries request self-addressed stamped envelopes for materials that artists wish to have returned to them. As more and more people turn to e-mail communications, though, this seems to be less of an issue.

Responding to cold-call submissions (especially those sent via mail or e-mail), depending on how you approach it, can either consume a great deal of time or be an excellent way to give back to the artist community. A few legendary dealers have written thoughtful reviews to every artist who sent them a package. Others use form rejection letters, and still others don't respond at all if the work is not of interest. If you reach the point where you are sure that cold-call submissions are no longer a good means of finding new artists for you (either because your roster is full, you don't have the time to respond as you would like to, or they were never part of your plan), I recommend posting that fact on your Web site. It probably won't stop all future submissions, but at least it will prevent the artists who check first from wasting their time and money.

THE ARGUMENTS FOR AND AGAINST REPRESENTATION

Not every gallery that works in the primary market offers representation to any of the artists it exhibits. As noted in chapter 3, in this context, representation has evolved to mean a long-term commitment to the artist-dealer relationship somewhat independent of any particular body of work for sale or active consignment agreement. Artists who are represented form the stable or roster of artists in a gallery (and therefore

collectively form its identity) and can expect regularly scheduled solo exhibitions, higher-profile promotion, and other such services. Art dealers may have a wide range of reasons for working with artists they don't consider part of their official stables, though (and perhaps never offer them a solo exhibition or long-term career support, but include them in group exhibitions or take their work to art fairs). Although they may manage the work of the artists they sell via consignment forms, they don't use representation contracts to establish the other terms of such arrangements. Indeed, with representation comes the expectation that the artist will agree to and live up to certain terms for access to future work and sales, such as not selling future work out of their studios to collectors who learn about their work through the gallery. There are generally no such expectations where there is no representation. Whether that business model is right for you or not will depend on your goals. Because your representation strategy may be a big part of the first conversations you have with artists you start working with, it's a good idea to consider the advantages and disadvantages of representation from both the artist's and the dealer's points of view.

Advantages for Artists

One of the most discouraging parts of being an artist, I've been told, is how difficult it can be even to locate a gallery that's a good match and is looking for new artists. The rejection letters, the studio visits that go nowhere, and the critiques of one's artwork that seem to make no sense can all be rather demoralizing and a terribly unproductive use of time better spent in the studio. Therefore, one advantage of representation for artists who wish to exhibit their work in galleries is the continuity it provides and the ability to stop looking for a gallery and focus on their work.

Furthermore, a gallery represents a credible context for exhibiting work, and representation generally goes hand in hand with regularly scheduled solo exhibitions. The reputation and prestige of the dealer and other gallery artists can lend themselves to all the work shown in the space, and as a program grows in prestige, all of the artists who are known to contribute to that stature benefit. Press is generally easier to get in galleries than in other contexts (with the obvious exception being institutions), but because some critics wait until an artist's second or third exhibition to offer a critique of their work, even when it intrigues them, having regularly scheduled shows can facilitate getting reviews.

Then there are sales. Commercial galleries exist specifically to develop markets for their artists' work. Here, again, represented artists can often benefit from association with a popular program, as collectors who come in to see or who view the work of other artists on the gallery Web site will assume that the same vetting process went into each of the artists on the roster. In addition to sales, galleries offer career management services. I'll discuss the services galleries generally provide their artist-clients below, but

in initially discussing representation, it's important to carefully review each of the services the gallery does or does not provide to avoid misunderstandings later.

Finally, perhaps the biggest advantage of representation for an artist is how it permits her to take a long-term view with regard to exhibitions and her career in general. If, for example, an artist has two bodies of work she wants to exhibit but only one guaranteed exhibition from a gallery not offering representation (and, therefore, no additional exhibitions down the road), her choice of which work to show now is influenced by the knowledge that the next opportunity for an exhibition is an unknown. On the other hand, the continual promotion offered by representation (as opposed to a one-time, limited consignment of work) means the other body of work might be presented in the gallery office or on the gallery Web site. The freedom of a long-term view on presenting work to the public that representation affords an artist enables her to take bigger risks with exhibitions, as well.

Disadvantages for Artists

Many artists without gallery representation experience might feel that the biggest disadvantage to working with a gallery is splitting the proceeds from sales, but in my experience, most of those who have been around a while generally agree that the arrangement is a good one. (Of course, that might just be what they say to my face.) If an artist questions why the split is 50/50 (or however you structure your consignment arrangements), it might help to explain what your expenses are and to discuss what other arrangements you can offer after it becomes clear that the gallery is making more money from the artist's work than it costs to promote it.

Another disadvantage to representation that artists might perceive is pressure to create artwork specifically for the market, as opposed to what they wish to create. Even when a dealer does not consciously exert such pressure, an artist may feel it. Here, again, I recommend discussing your expenses openly with the artist and explaining that you do have bills to pay, but also outlining how to ensure this topic is part of your ongoing dialogue so that you are aware if the artist becomes anxious about it.

When discussing this issue on my blog, artists also often bring up their frustration that their dealers simply aren't working hard enough to promote them. This is not a disadvantage of representation, per se, but not being sure whether a dealer will be a good partner in their career can make agreeing to representation more anxiety-provoking. Discussing in detail what your resources and contacts are, how you will use them to promote the artist, and how the artist can review his satisfaction (or lack thereof) with you about such matters can go a long way toward alleviating their concerns here.

The final disadvantage of representation that artists often mention is how difficult or uncomfortable it can be for them to end a bad relationship. This concern is easily addressed by pointing out early how you personally prefer such discussions

to take place. Indeed, discussing all the reasons it might make sense for an artist to end representation, how you intend to avoid them, and why sometimes they might be unavoidable can help you build a productive degree of trust with any artist with whom you begin working.

Advantages for Dealers

Perhaps the biggest advantage to representing artists from the dealer's point of view is the latitude it gives you to think more long-term in your marketing strategies. From carefully planning how a solo exhibition might benefit from an upcoming institutional exhibition to thinking years ahead on how an art fair installation might lead to other sales opportunities, to being able to wait until your collectors realize that you were right about a particular artist, representation frees you from the all-or-nothing decision-making that comes with the short-term consignment model. This, in turn, can give you the confidence to take bigger risks in your choices and help you realize a more vital program. Exhibitions predominantly designed to get press (rather than sales), for example, only make sense if you are still working with that artist when the press comes out.

Representing artists also helps to underscore your faith in your mission. The art world will interpret your commitment to your artists as evidence that you believe in the importance of their work. So will your artists. That commitment will help build the kind of loyalty that enables you, your artists, and your collectors to grow together. Collectors in particular like to see that a gallery believes in its artists, just as they expect that the commitment they show to a program by buying work will one day pay off in access to information about new work. Indeed, continuity in your programming strengthens overall brand and name recognition just as it does in any other business.

Finally, as it can take years of promotional efforts to build a significant market for an artist, representation ensures that when that market does take off, you are there to reap the benefits. Waiting to see a return on your investment in the art gallery business often requires being particularly patient. It helps when you believe in the artist's work, of course, but unless you've laid the groundwork to build loyalty and a sense of partnership, once an artist begins to sell well, he may feel the credit for that market is all his. Supporting an artist, through representation, when no one is buying his work will help ensure that he stays with you when everyone eventually wants it.

Disadvantages for Dealers

The most compelling reason not to represent an artist lies in the fact that unless a market exists already, there is never any guarantee of being about to create one. Even the world's most talented dealers have had to admit, from time to time, that

they were wrong about a particular artist. They simply could not sell her work. The blame for this inability to sell the work rightfully falls to the dealer. Indeed, if you convince the artist to let you represent her and then fail to develop a market, ethically, you must then explain why you were mistaken without implying that the artwork was in any way lacking or admit that your "eye" isn't quite what you claimed it to be.

Representation has also been known to take on all the characteristics of a bad marriage. Learning years into a partnership that you simply cannot stand one an other can be its own special kind of hell. Carefully considered consignment agreement or representation contract terms can alleviate much of the bickering that might ensue, but with added pressure caused by expectations from collectors and other players in the art world that you owe them the effort it takes to work things out, personality conflicts can really make you rue the day you ever agreed to a partnership.

On that same note, ending a partnership often isn't any easier from a dealer's point of view than it is from an artist's. An uncomfortable or highly emotional parting of ways can take on many of the dynamics of a messy divorce and distract you from the other business you must attend to, create fissures in your mutual circles, and perhaps make your other artists insecure about their positions within the gallery. Knowing that an artist may be particularly difficult, regardless of how much you believe in the work or its potential market, should be weighed against the possible disruptions representation could mean in your daily work and personal life. Choosing the right artists for your gallery also means choosing the ones you'll be happy to see or hear on the other end of the phone. It is your business, after all.

WORKING WITH ARTISTS BEFORE REPRESENTATION

There are several common ways to work with an artist before you discuss representation in order to avoid jumping into that complex relationship before you are both sure the match is a good one. Group exhibitions are one method, although the interaction you will have with any given artist in a large show may be limited. Solo exhibitions in a project space usually let you and the artist experience most of the same circumstances that a main gallery solo exhibition will include and, as such, are even better tests of compatibility. Some dealers will bring work by an artist they're considering for representation to an art fair as a test. That can sometimes present entirely new difficulties, though, as collectors will assume you represent the artist already and not appreciate if they later discover you don't and that this practice can imply you're only interested in the artist for their sales potential (which can impact your reputation with other artists). In general, a project space exhibition or group exhibition are the best means of providing you both with a significant trial of how well representation will work.

CONSIGNMENT AGREEMENTS

As noted in chapter 3 on business models, I don't personally advocate representation contracts, but I do recommend using consignment agreements. Many primary-market dealers I know who represent artists don't use them, but depending on what state you're conducting business in, certain legal obligations may be your responsibility in taking work on consignment, whether you have written and signed contracts or not. Therefore, in order to ensure that you are helping your artists and protecting yourself, I highly recommend that you have your attorney review at least a template for a consignment agreement that you use with every artist whose work you bring into your gallery.

In their book *The Artist Gallery Partnership: A Practical Guide to Consigning Art*, Tad Crawford and Susan Mellon present a sample standard art consignment agreement (see appendix A). Based on a model developed by the Artist/Craftsmen's Information Service (A/CIS) of Washington, D.C., with input from artists, dealers, and arts lawyers, the agreement is designed to be flexible enough to work in any U.S. state (sometimes with a bit of tweaking), and includes the following sections:

- **Paragraph 1: Agency and Purposes** (outlines who the parties are and sets the general purpose of the agreement)

- **Paragraph 2: Consignment** (clarifies that the gallery is not buying the artist's work and does not own it)

- **Paragraph 3: Warranty** (states that the artist indeed created the work and is free to sell it, and verifies the facts about the materials used)

- **Paragraph 4: Duration of Consignment** (names what date, if any, the agreement ends)

- **Paragraph 5: Transportation Responsibilities** (states which party shoulders the costs for packing, shipping, and insuring artwork to and from the gallery)

- **Paragraph 6: Responsibility for Loss or Damage; Insurance Coverage** (clarifies that the gallery has insurance and what the liability terms are should any artwork covered by the agreement be damaged while in the gallery's possession, including what defines that status [i.e., during shipping, while on re-consignment, etc.])

- **Paragraph 7: Fiduciary Responsibilities** (clarifies that the gallery never owns the artwork and that until the artist has been paid in full for any work sold, the title remains with him; also, clarifies that proceeds from

any sale are due the artist before they can be made available to the gallery's creditors)

- **Paragraph 8: Notice of Consignment** (states that the gallery must make clear to the public that it does not own the artwork, necessitating in some jurisdictions that notice be posted to that effect)

- **Paragraph 9: Removal from Gallery** (requires permission from the artist before any work covered by the agreement can be loaned or otherwise removed from the gallery)

- **Paragraph 10: Pricing; Gallery's Commission; Terms of Payment** (specifies the retail price of each work covered by the agreement, what percentage of any sales the gallery will retain, and when the artist will receive payment after a sale)

- **Paragraph 11: Promotion** (outlines what efforts the gallery will make to sell the work and defines the division of artistic control and who pays for what in promoting the work)

- **Paragraph 12: Reproduction** (defines the conditions under which the gallery can reproduce the work in promoting its sale, including what the copyright credit needs to be for any piece, and that a bill of sale must clarify that the artist retains the copyright)

- **Paragraph 13: Accounting** (specifies the terms for which the artist will receive a statement of accounts from the gallery and have access to both the work in inventory and records pertaining to its sale)

- **Paragraph 14: Additional Provisions** (left blank in the standard agreement to permit the artist and gallery to add anything specific to this agreement, such as degree of exclusivity, advanced agreement on any arbitration terms, etc.)

- **Paragraph 15: Termination of Agreement** (clarifies the terms by which the gallery, the artist, or the artist's estate may terminate the agreement, including how much time the gallery has to wrap up any pending sales and return any unsold work)

- **Paragraph 16: Procedures for Modification** (explains what written authorization is required for additions or deletions to the agreement by both parties)

- **Paragraph 17: Miscellany** (legal disclaimers and such that are best read and signed off on, or changed, by your lawyer)

- **Paragraph 18: Choice of Law** (generally, the state the gallery is located in, but in instances where advantages may be had by one or both parties, this clarifies which state's laws will govern the agreement)
- **Signatures of both parties or their authorized representatives**

The consignment agreement I use in my gallery is a bit shorter than this template, and this template is indeed designed to be tailored to the needs of you and your artists. Knowing what issues new artists may expect to be covered by an agreement, though (because other galleries they have worked with specified such terms), and being willing to add such provisions to your agreement, will go a long way toward building artists' trust in leaving their artwork with you. For artists we don't represent but are showing in a group exhibition or other context, our consignment agreement also doubles as an inventory sheet/receipt. More typical in some galleries is to create a separate document for that purpose. If you use consignment agreements to traffic the work of artists you represent, a separate inventory sheet will work better for you. Items that are important to capture in your inventory sheet include the following:

- Artist's full contact information (we also record here the artist's Social Security number or Tax ID)
- Description of each artwork (including title, year, media, dimensions, and edition size, and the total number of artist proofs)
- Retail price for each work (including details if editioned work increases in price as the edition sells out)
- Gallery commission
- Terms of payment (agreements usually stipulate that the gallery will pay within thirty days of receiving full payment, or sixty or ninety days in some galleries)
- Clarification of terms defining how or when the artist will share in any discounts offered
- Date and signature

Both parties should keep a copy of each consignment agreement or update to the inventory sheet. If unsold artwork is later returned, the artist should sign the agreement to verify its safe return. If you choose not to use a consignment agreement but an artist you want to work with insists on one, I strongly recommend that you provide it. If you opt not to, though, at least be willing to sign a document that they provide (after you have your lawyer review it). Again, regardless of all the

reasons dealers offer for not using them, consignment agreements remain an effective tool for building trust with the artists you wish to work with. Moreover, whether you sign one or not, depending on the state in which you conduct business, you may still be legally responsible for many of the terms outlined in the standard agreement discussed here by taking work on consignment.

Laws Governing Consignment Agreements

As noted in chapter 3, the Uniform Commerce Code (UCC) forms the basis for most state business laws and governs in the absence of specific state statutes covering consignment agreements between artists and galleries. As noted by Laura Stevens in Crawford and Mellon's book (*The Artist Gallery Partnership*), thirty-two states and the District of Columbia have enacted independent consignment laws.[3] (For a state-by-state discussion of the statutes and what to make sure you know about conducting business as a primary-market dealer in your state, I highly recommend this book.) The state statutes offering the most detailed protections for artists are those in New York and Oregon. Of the states that require written consignment agreements, most require that at least the following four items be covered:

1. How the proceeds from sales are delivered to the artist.

2. That the gallery is liable for damage to the artwork in its possession.

3. That a minimum price for the artwork is specified.

4. What commission the gallery will receive from sales.

Much state law governing consignment agreements focuses on protecting artists (who legally own the work) from their galleries' creditors. Provisions indicating that works of fine art are "held in trust" for the artist occur in all of the thirty-three existing statutes. Indeed, protecting artists from a dealer's creditors is generally the impetus for such legislation. As Stevens notes, "in all thirty-three consignment statutes, the gallery has a responsibility to hold the art, as well as the proceeds from the sale of the art, in trust and a statutory obligation to pay the artist." Details for how the proceeds must be held in trust vary from state to state, but there are three general approaches to such matters.

1. A general provision that proceeds from sales are not subject to a gallery's creditors until the artist has been paid.

2. The same provision plus stipulation that an artist must be paid within a specific time-frame (possibly also giving the artist the option to waive a specific time-frame).

3. One provision specifying that all proceeds be held in trust, and another specifying that no waiver of the first provision is lawful.

At the risk of being redundant, I will note once more that you should always have your attorney review your consignment agreement to ensure that you are in compliance with state law.

CAREER MANAGEMENT AND OTHER SERVICES GALLERIES PROVIDE

What services a gallery offers its artists often depends on whether it represents the artists, whether it represents the artists exclusively, and whether it serves as the artists' primary gallery. Many of the services listed below are presumed to be offered with general representation, but a primary gallery is generally expected to take the lead on many of these services for the commission they take from sales at other galleries. Whether you can afford to provide some of the services I call "premium" (for lack of a better word) may depend on whether or not an artist has strong enough sales, but you may also consider offering such benefits as a means of attracting those artists you wish to add to your roster.

Services (Almost) Always Offered with Representation

In addition to regularly scheduled exhibitions, continual promotional efforts, a presence on the gallery Web site, regular art fair representation, and other such benefits of representation, galleries (almost) always provide the following services:

- **Artist's archive**: a complete paper and (more lately) digital archive of press releases, digital images, slides, reviews, invitations, catalogues, up-to-date CV (including exhibition history and bibliography), installation images, etc.

- **Loan agreements**: completing or writing the agreements for loans of artwork, as well as, if needed, having the gallery attorney review the terms to ensure that the artist's concerns are addressed and their best interests are protected.

- **Consignment agreements to other galleries:** completing or writing consignment agreements for artwork consigned to other galleries (always with the artist's permission). How much you ask as commission from re-consignments is your call, but typically, a gallery in the same local market as the representing gallery will receive less than one in some distant location, the logic of which is that you've done most of the work to build up the local market for the artist's work, but you probably have fewer clients in the distant market than the other gallery does. We request a 10 percent commission from sales in galleries outside New York City and between 20 and 25 percent for sales by New York City dealers. As with loan agreements, your re-consignment agreements should ensure that your artists' best interests are protected.

- **Communications with other galleries and institutions:** Another common career management service, beyond just fulfilling the terms set forth in loan agreements or consignments, is handling all the details involved in getting your artists' work to and from another location and supplying that other location with the images or other materials they need. The main goal of this service is to ensure that your artist can focus on their artwork, rather than such logistical matters. Some institutions may prefer to work directly with an artist to avoid too close a relationship with the commercial gallery or other potential conflicts of interest, but as an artist's agent and advocate, it is the gallery's responsibility to be as helpful in such an arrangement as possible.

- **Feedback:** Through regular studio visits, most primary-market dealers offer their artists constructive and supportive feedback on their work. Not every artist-dealer relationship includes this highly subjective "service," but many of the artists I know say that having a trusted sounding board for their ideas is one of the things they value most about their dealers.

- **Buffer:** This is not as official a "service" as the previous ones, but an artist will frequently receive requests for donations or to participate in group exhibitions or any number of other things in which they may not wish to get involved, and being able to tell the requestor "You'll have to ask my gallery" can indeed be a valuable advantage to representation.

Services Frequently Offered with Representation

Depending on how much capital a dealer starts off with, in the very beginning, it may not be possible to offer each of the following services, but for established commercial galleries, they are considered fairly standard.

- **Photographing artwork:** In addition to hiring a photographer to document each work as it comes into the gallery inventory (or all of an artist's work when serving as a primary gallery), a gallery will typically pay for installation shots of each exhibition.

- **Framing:** This is perhaps one of the most frustrating expenses for a young art dealer (because, among other reasons, it's expensive and piece-specific, and if the work doesn't sell, you still own the frame but not the art), but it's no less expensive or frustrating for an artist, which is why it's a service usually offered by established galleries. If an artist frames her own work, she is reimbursed off the top of any sale before the

commission is calculated. The same is true in reverse (if the gallery pays for framing).

- **Crating/Shipping/Storage:** This is the mid-level service most quickly offered by young galleries once they can afford it, but it can remain a negotiating point and often depends on how easy or expensive the work is to ship. When just getting started, a dealer will generally beg, borrow, and cash in favors to ship art around. After it's clear that the gallery is making money (or before then, if funds are available), this becomes a widely expected service among artists.

"Premium" Services Sometimes Offered with Representation
Most of the services in this category remain the privilege of galleries with deep pockets. Being able to offer them can give a dealer a significant advantage in signing artists, but setting precedents that may have to be trimmed during downturns in the market makes these worth serious consideration before offering.

- **Stipends.** The history of art dealing is rich with tales of dealers who paid their artists monthly stipends so they could afford to work in their studios rather than having to get day jobs. What that history often doesn't reveal is that the dealers able to do so were generally quite rich themselves. Most new primary-market dealers will reinvest the money they might have previously reserved for stipends back into promotional efforts or expansion projects, but the practice of paying is not entirely unheard of today. If competition to sign a particular artist is tough, a stipend can be a very convincing service to offer.

- **Production Costs.** More typical among galleries with the resources to do so is helping artists with production costs. How that money is accounted for after sales remains a negotiating point, but some dealers prefer to cover production costs rather than alter the 50/50 split. For very expensive projects, a dealer may also serve as producer, finding other investors in addition to financing the work from the gallery's resources.

- **Loans.** In addition to advances against work the gallery believes it can sell, some dealers will offer their artists personal loans. Given how irregular income from sales can be at times, banks may not always be as willing to help artists buy homes or studios. The faith that a personal loan demonstrates in the partnership between dealer and artist is one advantage of such gestures, but by the time a dealer reaches this point in the relationship, it's usually driven by genuine friendship.

- **Others.** Just about any service that an agent offers a client can become part of the artist-gallery partnership. Paying for studio assistants, per diems during travel, clothing allowances—dealers have offered them all. What makes sense for you will depend on what you can afford, as much as what you cannot afford, not to offer, in order to keep you artists happy.

DIPLOMACY IN RESOLVING DISPUTES OR CONFLICTS

There are, of course, those among us with natural born talents when it comes to the art of diplomacy, and if you're going to take a stab at selling art, you should probably be a fairly adept mediator. In my experience, resolving disputes diplomatically depends mostly on having a good grasp of what's at stake and what motivates the players (including yourself), and always being willing to listen, even as you calmly and confidently express your side of things. Most of the issues below should, of course, be discussed at length before you agree to representation and should be addressed in your standard consignment agreement. But even when they are, differences of opinion will arise. With that in mind, the following section looks at some of the typical disputes that emerge in the artist-dealer relationship and how you might consider handling them if they come up.

Artistic Control

Unless a dealer is interfering with what's being produced in the studio (something I personally feel is inappropriate), this issue generally comes down to installation decisions in the gallery or at art fairs. Some artists are perfectly happy to let the gallery handle all installation decisions (and some dealers insist on this whether the artist is happy about it or not), but some artists may have very specific ideas about how their work must be presented. Even if the gallery has a highly experienced installation manager, some artists will not be comfortable with an exhibition until they've had some input or rearranged things themselves.

If you prefer that an artist not be present during installation, this should be discussed well in advance of an exhibition. Most artists will get used to the idea with enough time, even if it's not in their nature to let go of that, but surprising them with that requirement at the last minute can create friction that lasts throughout the show. If you prefer to have the artist present during the installation, make that clear well in advance, too.

Working to find common ground and agreeing on what the most important message is to communicate to the public can often resolve differences of opinion during an installation. Most artists agree, for example, that making sure the exhibition works as a whole and looks good as a whole is job one. Unless the concept requires

another take on the matter, most would also agree that the white cube virtually commands a "less is more" approach. Ensuring that you have enough time during an installation to try each other's suggestions, if only to then rule them out (framing the discussion that way really helps: "We can move it back, but let me at least try placing it over here just so we're confident that that's not better."), can also smooth the road to agreement.

Discussing Pricing

There are two key points to keep in mind when trying to resolve a disagreement with an artist about pricing work that is on consignment. First is that the artist owns the artwork and therefore rightfully gets to set the price. Second, though, is that your reputation as a dealer is built upon your guarantee that a work's price is an honest reflection of its current market value. In that regard, overpricing any work can be as bad for your business as underpricing is for your bottom line. Working with an artist to ensure that you are pricing the work appropriately is not just a matter of appeasing an ego or moving inventory; there are long-term considerations for both of you, the most important of which is building a stable, steady market of verifiable value.

To establish common ground here, begin by asking about the artist's sales history. Conventional wisdom says you cannot go back on prices without upsetting collectors who paid higher prices for comparable work, but learning more about any such collectors and what they know about the art market is also important. Young artists in particular may have only previously sold work to relatives or friends of the family who may have simply wanted to support their careers and didn't care whether they were overpaying. It may not be prudent to ask about this outright, but keep it in mind if an artist's sales history strikes you as high. If it strikes you as low, use examples of comparable work to underscore why you feel it's time to raise the prices.

You may find that some artists with limited sales experience will have calculated what they feel their prices should be based mostly on the price of work in other galleries, without having any real sense of the strength of those other artists' markets. Explaining that the laws of supply and demand apply as much in the art market as in any other market may only get you so far here. I find that most artists appreciate hearing that your goal in pricing their work "competitively" (i.e., lower than they might feel it should be priced) is not to make some quick sales, but rather to get the work out there into homes of important collectors who will in turn start promoting their work, as well. Moreover, tell them that the ultimate strategy is not to generate the highest possible proceeds from selling the current body of work, but rather to place all of the work and, in doing so, help create more demand. With a significant waiting list of collectors, an artist's prices will rise much more authentically and more quickly.

Scheduling Exhibitions

In my experience, only a few artists who don't have obvious and understandable insurmountable conflicts will insist that you reschedule their exhibitions, but it can happen. The rationales I have heard for strong disagreements over scheduling include fear that not as many people attend gallery openings or exhibitions during that time, that there are too many holiday conflicts, that it's not well timed with when taxes are due or when collectors expect their bonuses, that an artist's friend is also having an exhibition during the other time slot and they were hoping their shows could coincide, or that an artist whose work is too similar to your artist's work is scheduled before your show. In other words, the reasons can run the gamut, and sometimes, the reasons are well worth considering.

There is no question, though, that you will be in a better position to decide what is best for the gallery overall, but explaining that to an artist may not be as productive as other strategies. First, I recommend explaining the upside to the time slot you've chosen and the downsides to the other time slots. Because of all of the variables at play, no single period is ever perfect. If that fails, I would explain that other artists are already planning for the other time slots, and so are their collectors. If that fails, offer the time slot your artists prefers but in the following year, if possible. I have yet to have an artist opt for the next year.

Selling Work out of the Studio

So much of the relationship between an artist and a dealer is based on trust. Nothing tests that trust more than the questions surrounding an artist selling his work directly out of his studio. Even with contracts or lengthy discussions about what you expect in return for representation, it is impossible to anticipate all the scenarios under which this issue may come up. What if an artist wishes to sell a piece to a relative? Would you still expect the same commission? Would you agree to a "family discount" before the split? What if an artist has a dedicated collector long before you begin working together? What if that collector is used to buying from the studio and now resents the new "middleman" interfering with the relationship? Each of these possibilities should be discussed in advance. Some artists feel that the only time it's appropriate to split sales outside of the gallery with a dealer is if the dealer accompanies the collector there. Others direct any visitor who wishes to buy their work, even friends and family, to do so through their gallery.

If you find yourself disagreeing about what your arrangement is after a sale from the studio, the same rules of diplomacy apply in resolving it. Find common ground first. Expect the artist to be defensive (after all, you are objecting to something he did), and make clear that common understanding is your goal here—not indictment. Explain how other artists in the gallery handle studio sales. Explain

what you feel your representation and promotional efforts contribute to the market value of the artist's work. Also, explain that even if the work is never exhibited in the gallery, there may still be work involved for the gallery in updating the archive, keeping track of its provenance, or offering appraisals for insurance purposes and such down the line. If none of that makes the desired impact, ask what the artist feels is fair compensation for the work you do.

ENDING REPRESENTATION

Sometimes, common ground is not strong enough to warrant continuing a partnership. Knowing that the decision to part ways may come from either party and that ending representation can spur strong emotions and deep resentment for dealer and artist alike, it is a good idea to discuss the possibility at the beginning of a partnership. In particular, you should use this conversation to open the door to the type of continual dialogue that can hopefully help prevent irreconcilable differences from coming up and also establish clear expectations with regard to responsibilities once a decision is final. This is easier said than done, though, especially when you are working to build excitement about the collaboration.

Still, questions that need answers (which can depend on who initiates the end of representation) include who pays to ship back any inventory and when that should happen, how long the gallery has to complete any pending sales, when the artist's archive will be delivered, when any presence of the artist's work will be removed from the gallery Web site or other promotional channels, and when final financial loose ends will be tied up. Clearly, the gallery should pay any outstanding money owed to the artist within the time-frame specified in the consignment agreement, but what if the gallery had paid production costs or for framing of work that's unsold? Such matters will need to be resolved professionally by both parties. Commissions in progress may also require the kind of considerate collaboration that is difficult if resentments exist.

Indeed, keeping a long-term view on your goals and reputation after representation ends should help guide how professionally you wrap things up. The art world is small, and rumors will fly with any changes in your roster. Your other artists will also be watching how you respond, and so it is best to be as responsible and true to your word about how you prefer such endings to take place as possible. Throughout the process, regardless of whose decision it is, encouraging mutual respect will pay off in the long run. Should you decide to end representation, I would (having asked many other dealers about this and having adopted these guidelines myself) recommend that you consider the following and express your preference for such with your artists.

- Give your artist the opportunity to address your concerns, if possible. Outline why you are considering ending the partnership and explain what might make you change your mind.

- Have this, or the final, conversation on neutral territory. Invite the artist out for lunch or coffee. Don't announce your decision in the gallery or the artist's studio. Both of you are more likely to keep your emotions in check in a public space and avoid statements that make the rest of the process less pleasant.

- Discuss how best to make the transition less difficult. Offer to keep the artist on your Web site until he can find other representation (it's often easier to get another gallery if the artist is viewed as initiating the change) or some length of time into the future. Offer to suggest other galleries you feel might be a good match for the artist, and reassure the artist that you will offer as positive a reference as possible.

- If your decision is final, be very clear about that up front. Don't let the conversation becoming a bargaining session. Move on to the logistical steps of wrapping things up.

- Discuss your decision honestly with other gallery artists or collectors who ask. It may not make sense to offer an explanation if none is requested, but it may be better to explain your rationale than to let the rumor mill impact what others think about it.

Again, nothing will help you avoid the sort of misunderstanding that can lead you to this point as much as thinking through and communicating your goals and expectations early on in working with an artist. Listening carefully to their goals as well is simply part of the job. Many artist-dealer relationships develop into mutually beneficial business partnerships that neither party would trade for anything. Others evolve into genuinely dear friendships. Personally, I find working with artists the best part of the entire enterprise and can't recommend it highly enough.

NOTES

1. Laura de Coppet and Alan Jones, The Art Dealers: The Powers Behind the Scene Talk about the Business of Art (New York: Potter, 1984), 16.

2. Tad Crawford and Susan Mellon, The Artist-Gallery Partnership: A Practical Guide to Consigning Art, 3rd ed. (New York: Allworth Press, 2008), 16.

3. Laura Stevens, "State Consignment Acts," The Artist-Gallery Partnership: A Practical Guide to Consigning Art, 3rd ed., authors Tad Crawford and Susan Mellon. (New York: Allworth Press, 2008), 55–87.

15

Collectors: Where to Find Them; How to Keep Them

The history of major art patrons is fully intertwined with the history of art itself. High-profile collectors greatly influence what art is viewed as valuable or important. Moreover, the harsh reality is that the art that gets purchased is more likely to be well taken care of, and the art that is not bought (or at least given away as gifts) can end up being recycled, either in the artist's studio or via the local landfill. An even more relevant reality to our present purpose is that without collectors, there is no need for commercial art galleries. As it is, artists can sell their work directly to collectors, cutting out the gallery system entirely. This, of course, requires artists to spend more time on the business side and less time on the creative side of things, though, and as I mentioned in chapter 14, the context and credibility a gallery lends an artist might, in the long run, prove to be worth sharing the proceeds from sales. Still, primary-market dealers are very conscious of the fact that once a certain breed of collectors knows how to contact an artist, the value of their services as an agent becomes debatable. (This does not include all collectors, mind you, but a few have earned that reputation.)

Because of this, many dealers will be highly protective of their collectors' contact information, going so far as to not tell artists who is buying their work. There is a big difference of opinion throughout the industry on the importance of guarding your collectors' information. I fall on the side of advocating transparency but understand how having been betrayed can make some dealers more

cautious. Trust and credibility on both sides remain as important a part of the dealer-collector relationship as they are of the dealer-artist relationship.

In this chapter, we will discuss how to find collectors for your business and how to keep them coming back once you do. We'll also look at the experiences of two dealers, one on the East Coast and one on the West Coast, including how they built their collector lists and where they feel a dealer's energy is best spent in maintaining those relationships. Then, I'll examine what information dealers typically record in their bills of sale (and why), as well as the issues involved in establishing discounts. Finally, we'll look at the business from the collector's point of view. Four New York City collectors were very generous with their advice to new dealers on a range of issues involved in buying art and working with galleries. Of all of the sections in this book, you do not want to skip this one.

FINDING COLLECTORS

As noted in chapter 6 on writing your business plan, the total feasible market for the art you will sell is much more finite than, say, the market for necessities like bread or gasoline and, as such, requires a more targeted marketing strategy than other products may. Unlike dry cleaners or car salesmen, art dealers do not cater mostly to the residents within a certain radius. A small percentage of people worldwide collect art, and the sort of blanket advertising used to push burgers will be a huge waste of money in reaching them. More than that, simply finding the people who buy art offers no guarantee that they'll be even remotely interested in the art you sell, or if they are, that they'll decide to buy any art from you before they've taken time to become very comfortable with both you and your program. This is a long-winded way of saying that selling art is about building credibility and trust within a small circle of people predisposed to spend their money on the objects Oscar Wilde once infamously called "quite useless."

But don't despair. There are people out there who buy art, and many of them are very interested in learning about new galleries. Targeted advertising is essential to letting them know how to find you, and I discussed how galleries typically go about that in chapter 11, but because the essence of selling art is developing strong relationships with the select few who buy it, nothing is more important to your success in building a client base than your reputation for providing what collectors want. First among the things they want, of course, is excellent art. Second is good service. Many collectors know many other collectors. They frequently meet and compare notes on both the art and the service in the galleries they've visited. Getting good word of mouth about how easy it is to work with you is essential. In the next four sections, I'll look at common ways that dealers and collectors connect, and discuss each in terms of working toward a solid relationship built on credibility, good service, and keeping them informed about the art that will keep them coming back. I'll also look at how you can encourage such connections to take place.

Walk-Ins

Collectors who are interested in learning more about new galleries often visit a space without an appointment or even announcing that they collect unless they like what they find. Rude, inattentive, or poorly informed gallery staff can be as big a deterrent to coming back again as work on the walls that doesn't appeal to them. In New York City in particular, it is often impossible to tell a major art collector from any other visitor based on the way they're dressed. Therefore, it is important to treat every walk-in as if she might soon be your best client.

Perhaps the number one reason people who are just starting to collect say they don't like going into certain galleries is the attitude or lack of courtesy they encounter from the staff when they ask questions. A welcoming atmosphere combined with easy access to information about the work on exhibit is essential. Another turn-off collectors report is inappropriately intense pressure to buy something just because they expressed interest. Like any other visitor to a public gallery, collectors often just want to see your current exhibition. Moreover, collectors who have been buying for a long time have heard all of the sales pitches and resent not being able to contemplate the work, its importance, and whether they want it more than other available work they've seen in other galleries recently. It is your job as a dealer to make the sale, of course, but that often requires striking a balance between sharing your passion for the work with a collector and scaring her away with an overload of information or pressure.

Experienced collectors often wish to get a broad sense of the vision of a new dealer they meet before they buy. They enjoy learning about new art and discussing the art world in general. Developing a relationship like this with a dealer often requires several repeat visits. Dealers who cannot share in that part of the process are not as likely to see collectors return to their galleries. As I've noted throughout this book, unless you, too, enjoy that dialogue (and in this context, specifically, I mean enjoy it enough to see it as one of the rewards of running a gallery), you might be happier selling something else. Approaching each collector who walks into your gallery as a long-term project, so to speak, with an emphasis on getting to know them, letting them get to know you and your program, and then working up toward sales, is undoubtedly the method preferred by most collectors I've spoken with.

Encouraging walk-ins is obviously one of the main goals of your targeted advertising or promotional events, but there are other approaches you can try, as well. One is to hold your opening receptions on the same night as other galleries in your area. Gallery hoppers will often pop into a new space as part of a night out seeing art. Another approach is standard across all retail businesses: put something compelling in your windows. For a fine art gallery with installation and decorum concerns, this can be trickier than for a clothing store, but ways galleries have approached it include creating a project space in the entranceway, placing large

posters of exhibition work in high-traffic areas, or going the high-tech route with a video in the window (either a work of art or an informational advertisement).

Such efforts will, of course, also bring in visitors who do not collect art. Many collectors I meet tell me that their very first art purchase happened almost accidentally, because they were compelled to enter a gallery, for whatever reason, and then found a piece they simply had to have. Potential collectors who walk in will generally have the same response that experienced collectors do when it comes to accessibility, credibility, and providing good information and quality follow-up service, as well as to undue pressure to make a purchase. Here, again, taking a long-term view on your relationships with walk-in visitors is the best approach.

Referrals

Collectors will also visit a new gallery because of a strong referral. Artists, art consultants, curators, and other collectors who have visited your space or bought work from you will often share their experience with their collector friends. Just because someone informs you that they don't buy art doesn't mean they don't have the ear of many other people who do. Making a good impression with each visitor, then, is simply part of building your collector base. How you receive someone referred to your gallery will likely be reported back to the initial source of the recommendation, making each new contact an opportunity to strengthen a series of relationships.

Encouraging the people who know and like your gallery to share that fact with their friends and colleagues is perhaps best achieved by ensuring that they enjoy each visit. Hosting enjoyable opening receptions is another proactive way, as many people prefer to take someone along with them to such events. When it comes to professionals like art consultants and curators, providing them with quality information when they request it and keeping them well informed of upcoming events and exhibitions that may interest them will encourage referrals, as well. Simple courtesies, such as handwritten notes to thank them for bringing someone by, can go a long way toward making your gallery one to which they bring or send colleagues and clients on a regular basis.

Art Fairs

Depending on the intensity of traffic at an art fair, you may not have time to develop much of a dialogue with new collectors who stop into your booth. The relatively expensive rent and intense competition at a fair require that you make the most of the high concentration of potential clients. Still, as always, first impressions are critical. Being prepared to offer succinct explanations or take away information on the artwork you have on display and make quick decisions about how best to close a deal, or end a conversation in order to welcome the collector right behind the one you're talking to, can help you speed up the process considerably (and considerately).

Experienced collectors will expect the faster pace at a busy art fair and usually need to keep moving, themselves, but some who are new to buying art are perhaps best encouraged to visit you at your space, where you can both take your time getting to know each other.

Nothing will help you attract new clients to your booth at an art fair like quality artwork. That is why they come. As art fairs increasingly become a major source of income for newer galleries, many have taken to presenting large-scale or solo exhibitions to help them stand out in the sea of competition. Some fairs accept applications for special projects—usually large-scale public art style installations. Presenting a crowd-pleasing special project is another way to gain attention and encourage collectors to seek you out. Finally, some galleries have great success with small take away items, either in the form of free items (we've given away tote bags with gallery literature in them, for example) or inexpensive work for sale that visitors will show their friends over lunch or in the aisles of the fair and that drive more visitors their way. Such efforts shouldn't undermine the message of your booth or the reputation of your gallery, obviously, but a well-conceived, inexpensive multiple by one of your artists can turn into the must-have item of the fair.

Cold Calls

In any business, cold calls are likely the least productive way of meeting new clients. In a business built on personal relationships like the art business, letters and e-mails from unknown players often go straight into the trash. Cold calls taking advantage of an offered referral (i.e., "So-and-so said you might be interested in . . .") can be more successful, but it's always good to remember the admonishing that Dame Judi Dench's character Elizabeth I gave a magistrate overstating his authorization on behalf of the queen in the film *Shakespeare in Love*: "Have a care with my name or you will wear it out."

If you do approach potential clients via cold calls, targeting your audience takes on even greater importance. Sending information on a great new photographer you're working with to a collector who buys only Old Master paintings is tantamount to throwing your money away. Indeed, the best beginning to a cold call introduction is to demonstrate you understand what art the recipient collects. The next message would perhaps be to connect their collection to your inventory (i.e., "Knowing that your collection is renowned for its strength in abstract paintings by contemporary mid Atlantic painters, I wanted to let you know about the work of . . . "). If you receive no response to your introduction, I recommend that you follow up once but then let some time pass before you make any additional communications to avoid being seen as a pest. Calling a collector you do not already know, either at home or at work, is generally not smiled upon.

ADVICE FROM DEALERS IN DIFFERENT MARKETS

To provide a broader sense of how dealers find collectors and maintain those relationships, I asked the owners of two comparable galleries, one on the East Coast and one on the West Coast, to discuss what has worked best for them. Each of the two galleries is located on the second floor of their respective buildings; the owners of each gallery had worked for a larger, more established gallery before deciding to open their own spaces with a very different vision; and both galleries sell contemporary art. The differences in their thoughts on the topic reflect differences in their locations and programs, as well as what they view as their personal strengths.

Valerie McKenzie is owner of New York's McKenzie Fine Arts (*www. mckenziefineart.com*). When asked to rank which means of finding collectors seemed to work best for her, McKenzie listed them in this order: 1) walk-ins, 2) referrals, 3) a comprehensive and high-quality Web site with lots of images, 4) art fairs, and 5) cold calls. Because walk-ins are listed first, it is no surprise that she highlights being accessible among the most important approaches to encouraging collectors to buy from you. "Don't hide in your office," she says. "Get out of your chair and say, 'Hello.'" McKenzie has placed her desk squarely in the middle of her gallery to ensure that this philosophy is clear to first-time visitors.

As for how new dealers can go about encouraging new walk-in visitors, McKenzie recommends doing the research and work to make sure your exhibitions and openings are listed in each possible publication. Further, she says to make sure that opening receptions are fun parties, so that word of mouth will help promote your space. To ensure a high-energy reception in the beginning, she recommends developing your mailing list way ahead of time, creating an impressive invitation, and then personally inviting everyone you know—even your family, whether they buy art or not.

The San Francisco gallery Marx & Zavaterro (*www.marxzav.com*) is owned by the wife and husband team of Heather Marx and Steve Zavaterro. They rank the means of meeting new collectors differently: 1) art fairs, 2) referrals, 3) walk-ins, 4) cold-call introductions. "In part because we opened less than two months after 9/11, and also because we operate in San Francisco, we do not know if we could have survived the first few years in business without participating in art fairs," they say. Indeed, the difference in first-time foot traffic for galleries in New York versus San Francisco might explain this difference in ranking.

When asked what a new dealer can do to encourage new clients in between art fairs, Marx puts it succinctly: "Get your artists' and your name out there." Among the ways Marx and Zavaterro work to do that are signing on for benefit art auctions, joining museum collector groups, and offering to host lectures or private receptions at their gallery. "Go to as many events as possible and talk to people about your upcoming shows and projects. Talk to both artists and collectors; artists have a lot of influence and word travels swiftly through both circles about a great artist or exhibit."

Regardless of location, another essential component to attracting new clients is courting the press. Zavaterro recommends that you "introduce yourself to freelance writers or bloggers; if you see someone in the gallery skulking around with a note pad, be friendly and ask if they are writing a review, and then offer to provide good, high-resolution images to accompany their story. Provide them with what they need in an extremely timely manner, as they are often under tight, last-minute deadlines." McKenzie recommends thinking of the press, especially the online press, as a source for information, as well. Gossip columns or blogs about the art world are often full of useful information about which collectors are focusing on certain types of art. They often publish photographs of collectors, as well, so through browsing them, you can often recognize those potential customers at receptions or art fairs.

Once you have established someone as a client, which doesn't necessarily mean you have sold him anything yet, the quality of services you provide becomes the biggest factor in keeping him as a client. Among the types of services an art dealer should be prepared to offer, McKenzie lists education, information about or referrals to other galleries, appraisals for insurance purposes, if you can, and developing a real friendship based on your shared passion for art. Indeed, the nature of the relationship between dealer and collector can be as personally rewarding as that between dealer and artist. Marx adds to that list of services guidance, availability, and payment plans.

Both galleries manage their collectors' lists and communications with their clients via databases they have separately developed in Filemaker Pro. As noted before, such homegrown databases are common among younger galleries because of the high costs of the ArtSystems offerings. McKenzie notes that she also uses a running list of notes in a notebook to stay on top of things on which she needs to remember to follow up and collectors she wants to reach out to. As noted in chapter 11 on promotions, Zavaterro goes a more high-tech route by producing a podcast every few months that collectors can download from the Marx & Zavaterro Web site. "It's basically news and banter mainly focused on what is going on in the gallery, but also covers things here and there about the SF Bay Area art scene," Zavaterro explains.

Regardless of how well organized you may be in communicating with your collectors or how much you and your clients like each other, when it comes to the business end of things, it pays to be more formal about the terms and responsibilities of each transaction. This is a very important part of keeping your clients happy with your service. Even the best relationship can be damaged if there are misunderstandings about your arrangements. Likewise, even the most unfortunate of circumstances can be worked through to everyone's satisfaction if expectations are carefully set and resolutions to problems are understood as simply following through on the agreed-upon terms. In the next section, I'll discuss how to ensure that such expectations are indeed clear.

INVOICE AND TERMS OF SALE DETAILS

The invoice (or bill) with which you provide collectors is a statement of the artwork being sold, the price, any additional charges, and the terms of the sale. Some dealers use their invoices to record other information, as well, such as the provenance of the work or shipping details. Adding a "notes" section where you can describe any unusual terms or instructions you wish to record is helpful, as well. You should have your attorney review the terms of sale you list on your invoice template to ensure that your interests are covered and the invoice is in compliance with state law.

The original invoice we used in our gallery was very concise and, we thought, user-friendly, reflecting our accessible and approachable identity. Over the years, though, as incidents have arisen that have revealed how confusion and problems can be avoided by adding more detail in the terms of sale, our invoices have become a bit longer. I have asked around, and it seems that every dealer takes a slightly different approach to what terms of sale they incorporate or what style of invoice they use. Below are the components of our gallery's current invoices, which we print on gallery letterhead.

- Invoice number

- Date

- Collector information (name, billing address, shipping address [if different], phone, e-mail)

- Full details of artwork (inventory number, artist name, title of work, date, media, dimensions, number in edition, number of artist proofs, if editioned, and thumbnail image of work)

- Price

- Discount details, if any

- Subtotal

- State sales tax, if applicable (footnote as to why not, if that's the case)

- Shipping/handling charges, if applicable

- Total to be paid (specified in U.S. dollars)

- Terms of sale (exactly as we have them):
 - Payable upon receipt of invoice (net thirty days).
 - Title does not pass until payment has been received in full.
 - Standard packaging to be provided by the gallery.
 - Shipping, insurance, and custom crating (if necessary) are the responsibility of the purchaser.

○ Copyright of the artwork is nontransferable and remains the property of the artist.

- Notes section

- Wire transfer information (including name of bank, address, phone number, swift code, account number, routing number, and a notice that states, "Please be sure that all wire transfer fees and conversion rates are deducted from the account of the sender such that sum total of invoice is amount received via wire.")

- "Make check payable to" instructions

- Thank-you

DISCOUNTS

At an art fair once, a charming woman interested in a piece we had in our booth asked me, "What is your New Collector's Discount?" I stifled a chuckle. I was unaware that I was supposed to establish a "New Collector's Discount." Indeed, I was unsure just how sincere her question was, but that exchange stuck with me and helped me to realize that for some collectors, negotiating the price of artwork is widely viewed as part of the process, if not one of the main pleasures of purchasing art.

In your career as an art dealer, you will encounter all kinds of negotiating approaches among collectors. Some seem to be unable to accept that the price you list is the price they should pay. Others will ask for a discount merely out of curiosity about what you'll say. You may not have much latitude with the listed price of some works if you priced them competitively in the first place. Other times, you may know there is considerable interest in a piece and as such have no real motivation to accept anything less than full price. Offering discounts to your most important clients, of course, is one way of keeping them among your most important clients, but each sale will be different, so it's hard to pinpoint what is considered standard.

Still, there are certain circumstances in which discounts may be more expected than others. Museums, for example, may only purchase a piece if you can offer them a significant price break. The prestige that comes with having work in a museum collection is often well worth it, though, especially for emerging artists. Major collectors may also insist on a considerable discount for lesser-known artists. (For a list of the top collectors in the world, as ranked by *ArtNews* magazine, see their annual summer issues or visit their Web site, *www.artnews.com*.) As with museums, sometimes the prestige of a private collection makes such reductions nonetheless a good deal. Art consultants also negotiate the best price they can on behalf of their clients. In all such cases, of course, you will need to weigh the potential

benefits of having the work sell against those of insisting on the list price and possibly not selling.

In your artist consignment agreements (as discussed in chapter 14), you should specify what portion of any discounts the artist would share with the gallery. Our standard consignment agreement permits us to offer up to 10 percent off and have that discount split between the artist and the gallery. The artist must be notified of and agree to any discount greater than 10 percent. This can actually serve as an effective negotiating tactic for you—telling a potential collector that you will consider offering them more than 10 percent, but that you will have to call and ask the artist first. Sometimes the delay that causes, or the idea that the artist would know they insisted on a larger discount, can lead them to settle on the lesser amount.

COLLECTORS' POINTS OF VIEW

Four New York City collectors, including Michael Hoeh, Joel and Zoë Dictrow, and a major collector of contemporary art who asked to remain anonymous, but whose insights are well worth sharing (he is consistently listed among the world's top collectors; for the sake of clarity below, let's call him "Collector X"), were kind enough to share their thoughts about the art dealing business for this book. Each of them has been collecting art for many years, as evidenced by the fact that although their homes are nearly as full of art as museums, what is installed at any given point in time represents only a fraction of their total collections. I am sure that each of them would agree that they are passionate about collecting art and understand very well what they need most from the art dealers with whom they do business.

Indeed, as we discussed in chapter 2, the essence of running a successful business is to identify your clients' needs and effectively meet them. With that in mind, I asked our New York collectors what they needed most from an art dealer. Zoë Dictrow put it as succinctly as anyone, answering without hesitation, "A good program." Joel Dictrow added, "Which is somewhat different than having art that sells. If the dealer has a point of view and can convey that to people coming into the gallery, inevitably there will be a certain number of people who will buy into that dealer's vision." Michael Hoeh and Collector X both listed "access" among the top things they need from a dealer.

"The good dealers identify their 'most important' client for each artist and make sure that client gets the first look at all new material," says Collector X. "Nothing is more frustrating than coming to see new work only to be told something desirable is already sold or on hold. While this isn't possible to do with more than one or two collectors for each artist, it is critical if you want to build loyalty and a long-term relationship with top collectors."

Hoeh adds that knowledge is an important offering. "Good dealers help collectors identify and find works of art that 'fit' their collections," he says. "[These] can be new works by young artists or secondary pieces from established artists that may

become available, either through the public auctions or private sales. This helps a collector 'complete' and 'focus' the quality of his collection."

The Dictrows also single out knowledge as something that identifies the "good" dealers. "They tend to know not just their own artists," they say. "They know and love art. You have to be a source of information and not just about your gallery. The idea for us is to gain information about where else to go and what to see. That is an important function of a dealer and helps people feel he is on top of things."

All four collectors essentially agreed on what they need least from an art dealer: pressure. Collector X singles out relentless follow-up e-mails, asking if a first e-mail sent was received. "I promise, if I or any collector is interested," he says, "we will call or e-mail back." Ambiguous information was also high on the list of non-beneficial efforts. "Blast e-mails and mass mailing cards about their new show openings with no helpful information about the artist or show," clarifies Hoeh. "These frequently assume the collector knows the artist and their work. It would be more useful to send at least the press release, or better yet, send an e-mail (or small package) with the artist bio, some images of the new work, prices, maybe a link to reviews the artist has received from previous shows, and some context for the new work."

Next, I asked which of the many services a dealer can provide for collectors are seen as most helpful, including acting on their behalf at auctions, helping with installations, and facilitating shipping or framing. Although they agree that purchasing work at auction is helpful, it is not something that these collectors expect from new dealers (which is simply a nice way of saying that they prefer to have a more experienced dealer do this for them). Collector X also recommends not charging for this service. "Do it to show your support of your artists and to build relationships with your best clients."

Each of the collectors say they appreciate when a gallery helps with installation, especially if it is a tricky one, but that, having large collections, they are generally pretty set with assistance in that department. Newer collectors, they suggest, tend to need more help with installing work in their homes. Assistance with framing and shipping, on the other hand, is always appreciated.

One service that we offer automatically (so much so that I had not thought to ask about it) was mentioned by both Collector X and Hoeh. "After every sale," says Collector X, "send a JPEG and full documentation of each purchase." Hoeh agrees that "always sending electronic invoices, along with JPEG files of any artwork purchased, helps collectors keep track of their collection[s]." Indeed, the larger a collection your clients have, the more likely it is that they too will use a computer application to manage it. Just as you will find digital versions of data and images helpful for managing your inventory, collectors appreciate the help such materials provide them in managing their collections.

After an art dealer becomes more familiar with the communication style her clients prefer, certain things unquestionably become less of an issue, but in the initial stage of building trust and credibility with a collector, it tends to be better to err on the side of not being viewed as a pest. When asked how often it is appropriate for a new dealer to contact a collector she has just met, Collector X offers the most solid advice imaginable: "Just have the conversation. 'How often should I contact you? What is the best way to do it?'" The Dictrows note that it often depends on the method used. E-mails are generally okay, they say, but phone calls are less okay. All four collectors expressed dismay about new dealers they had just met calling them at inappropriate times, especially at work, and before they had a truly established relationship. "Don't call out of the blue," recommends Zoë Dictrow. "There should be a reason. Call to say, 'I've started working with somebody. I think she's very special, and I think you would like the work.' This is how it works, but it has got to be an established special relationship with a collector."

One of the hallmarks of collectors who have established good relationships with art dealers is that they recognize the value a gallery brings to the table. Asked if they had an opinion about represented artists cutting out their dealers and selling from their studios, all four collectors note that they do not approve of that practice. Michael Hoeh says, "I generally never buy art direct from an artist. Art dealers provide a valuable service, and if they introduced me to an artist's work, they deserve to be compensated for their efforts." Collector X concurs: "No real artist should ever sell out of his studio unless he has no gallery. No real collector should ever encourage an artist to do it, either. Galleries do a lot for their artists and artists should respect their relationship."

Finally, I asked each collector what advice they would offer a new dealer hoping to make a good impression on a collector he has just met. Collector X suggests what I have always felt is a really good approach: "Go see their collection. Get a sense of their interests. Decide how good a fit they are to you and your artists, and then just respect their time and show them things as much as they would like and go from there." Hoeh echoes that idea, saying, "Know your customer. If the person collects photographic landscapes, don't try to sell him a contemporary conceptual installation work of their art for their collection. Learn what the collector is looking for and is excited about." The Dictrows note also that when someone expresses interest in something, you should follow up on it. "I know you'll think you are too busy or you don't know who this person [is] . . . but I think that is a mistake," warns Joel. "You have to get to that. You have to make sure you take care of someone who expresses interest in something." But he rounds that advice out with what every collector will tell you and what every experienced dealer comes to recognize: "Never press too hard, because you should never let them see you sweat, and I think that's an important thing. No one wants to deal with someone who seems desperate."

16

Peerage: The Art Gallery Community

A s competitive as the art business can be, most dealers genuinely admire the vast majority of their colleagues. Who else but another dealer can they talk to about an industry as idiosyncratic and, in many ways, uncharted as the art world? Who else knows what they're going through? Having friends in the art dealing business can be important to your success. With our next-door neighbor gallery and good friends, Schroeder Romero, we regularly host Tuesday night cocktails in our spaces, inviting other friends with galleries to come over and share strategies, "war stories," and advice. It is immensely encouraging to hear that you're not the only one feeling anxious about a certain situation or that someone else has a simple way of doing something that ends up saving you time or money.

More formal art dealer organizations exist throughout the country and are resources you should consider as part of your professional growth as a dealer. Membership in some organizations is by invitation only. Most have some form of membership dues. A few notable associations also organize renowned art fairs, and membership may be a prerequisite to participating.

In this chapter, I'll discuss the business and personal rewards of networking with other art dealers and what you can do to earn the attention and trust of your colleagues. I'll also list the professional courtesies that other dealers tend to extend to each other, whether they are well acquainted or not. Briefly, I'll also look at some notable national and international associations for art dealers, including their

membership processes, and how to contact the multiple regional organizations, as well. Finally, I'll explain what is involved in starting your own art dealers association. I was a founding member and the first president of the Williamsburg Gallery Association (WGA). There were a few hurdles in getting our nascent association up and running, including finding common ground among businesses infamous for their individuality. The benefits of working together, though, proved well worth the effort it took to get over the initial obstacles.

ADVANTAGES OF NETWORKING WITH OTHER DEALERS

Implicit in the idea of networking with other dealers is the notion that you're doing so with your best foot forward and sensibly building your reputation among your colleagues through generosity and ethical business practices. Many art dealers associations and almost all of the important art fairs invite participants after review by a selection committee comprised of at least a few other dealers. Having the selection committee think well of your gallery can help you get a leg up on the competition for such opportunities. Indeed, as noted in chapter 15, what players in the art world prize more than anything is access. Whether that means access to an art fair, access to another gallery's artists for group exhibitions, or simply access to information, being well known and liked throughout the industry increases your chances of securing what you want. The personal rewards of having a strong support network throughout the art world can include having friends to help take the edge off the often grueling ordeal of working an out-of-town art fair, having sympathetic pairs of eyes and ears in other locations, and having a shoulder to cry on or having the art community rally around you when tragedy intercedes. There have been truly heart-warming benefits organized by the gallery world to help beloved dealers who have been stricken with life-threatening ailments. In many cities, the art world is a community that looks out for its own.

Similar professional support comes through networking. Dealers are well known for speaking out against efforts to censor the artwork in other galleries, for example, or for joining forces to fight for legislation that protects artists. Sharing information among dealer friends about available spaces or qualified personnel is important given how specific the requirements can often be for both. Likewise, being able to pick up the phone and get honest assessments of framers, shippers, or other professionals who might solicit your business can save you from learning the hard way that a vendor is notoriously slow or unreliable.

What can you do to reach that level of access when you're just starting out in the business? How can you get to that place where other dealers will recognize your name on your art fair application or think of you when considering new members for a dealers association? Nothing will gain you the respect and admiration of other

dealers more quickly than a reputation for presenting quality exhibitions. Dealers pay close attention to what their colleagues are doing and will be pleased to meet you if it's known that you take the job of promoting important art seriously. In fact, it's generally a good idea to have your reputation precede you when meeting other art dealers; getting good press for your exhibitions is important, and therefore, strong promotional efforts are key in this, as well.

Once you have established that you contribute something interesting to the overall dialogue, the settings in which networking is often easiest include art fairs (whether you are participating in them or not), museum or other institutional opening receptions, art-themed charity benefits (particularly volunteering for benefit committees), and, during quieter times in the week, visits to other dealers' galleries. As in all walks of life, a generous gesture is often your best introduction. Being able to offer gracious and well-informed comments about another dealer's gallery will often make him much more interested in your other opinions.

PROFESSIONAL COURTESIES

Regardless of how well you know another dealer, there are some standard professional courtesies that gallery owners tend to extend to one another. Because these practices will contribute to your growing reputation, I recommend simply asking the other art dealer how he handles such matters when you are in doubt about what is standard. Although opinions vary as to what is a customary percentage, for example, price discounts on artwork for another dealer's private collection generally range from 15 percent to 20 percent. A discount of 10 percent or less, while better than no discount at all, is widely viewed as ungenerous. Every dealer will understand if you say you're holding a piece in which he has expressed interest for one of your most important clients, so you are never under any obligation to sell work you would rather not discount, but when you do sell to a colleague, he will be surprised if you don't include at least some price break. Keep in mind that the discount you offer your fellow dealer is likely to be the same he offers you in return.

Information is the most valuable asset any dealer has, but within limits, most dealers share what they know about collectors, curators, critics, artists, and vendors with other dealers who ask. Karma is king here. How generous you are when someone asks you for a critic's e-mail address, or insights into what a cryptic response they receive from a collector might mean, directly impact how munificent he feels when the questions are yours. Obviously, when possible, it is best to approach another dealer for whom your inquiry cannot be seen as a potential threat to their income, but when someone asks you, keep in mind that this is rarely a valid concern. Not only will the person seeking the information eventually get it somewhere (making you seem irrational and overprotective if you refuse to help), but unless the

other dealer sells work by the same artists that you do, the odds that any sale they make will cancel out a potential sale for you are extremely slim. Sharing what information you can without breaking any confidences can also increase your knowledge base, as any such inquiry generally comes with some additional tidbits you didn't know before.

Spreading about certain forms of information is generally seen as bad form, though. In particular, suspicions about the value or, especially, the authenticity of a piece another dealer is offering should not be grist for the rumor mill. Letting the dealer know through a third party that you feel they may want to look more carefully at it is seen as the polite way to share your sense that something may be "not quite right" with how they've priced it or what they claim it is. There have been widely publicized cases of dealers being sued for publicly questioning the authenticity of a piece, with a few of them proving the doubtful dealer wrong. Quietly getting word to the dealer with the piece, preferably without your name attached to the uncertainty, can prevent any unpleasant fallout and will be appreciated by all involved.

NATIONAL AND INTERNATIONAL ART DEALERS ASSOCIATIONS

Most art dealers associations are non profit entities founded and run by active art dealers. The mission of most national and international art dealers associations generally includes some, if not all, of these activities.

- Promoting professionalism, scholarship, and high ethical standards
- Increasing public awareness about what its members do, as well as sponsoring education events focused on how to build and maintain a collection
- Promoting the exhibitions their members are presenting
- Identifying their members as dealers of outstanding expertise and integrity
- Lobbying for legislation that affects the arts community
- Sponsoring community efforts focused on building support for the arts
- Providing their members with education on legal or technical matters that impact their business
- Sponsoring advertising campaigns or promotional events, such as panel discussions, seminars, or art fairs
- Assisting law enforcement agencies in investigating fraud or stolen artwork

The more influential an association is, the more stringent its membership criteria tend to be. In the following descriptions of several of the most prominent international—and, in particular, American—dealers associations, I'll list what it takes to become a member and what specific benefits each association offers.

Art Dealers Association of America (ADAA)

With 170 member galleries in twenty-five U.S. cities, the ADAA is the country's most prestigious dealers association. Founded in 1962 and representing both primary-market and secondary-market galleries, it categorizes its members as specializing in Old Master, nineteenth-century European, Modern (1900-1950), postwar, contemporary, American, German Expressionist, Latin American, vintage photography, contemporary photography, prints, and Asian art. Membership is by invitation of the board of directors only. On its Web site (*www.artdealers.org*), the ADAA notes: "In order to qualify for membership, a dealer must have an established reputation for honesty, integrity, and professionalism among their peers and must make a substantial contribution to the cultural life of the community by offering works of high aesthetic quality, presenting worthwhile exhibitions, and publishing scholarly catalogues." Major benefits of ADAA membership include the confidence that a dealer's membership in it inspires in collectors, the high-profile advertising it does to promote members' exhibitions (including in the very expensive *New York Times*), and increased potential for members to participate in its annual art fair, The Art Show.

Fine Art Dealers Association (FADA)

Founded in 1990, the FADA (*www.fada.com*) is an American association with more than fifty members. Membership is by invitation only, and the requirements for consideration include owning a full-time public art gallery for at least five years; a reputation for honesty and integrity; established expertise in the works, artists, and periods in which one specializes; an inventory of works of high aesthetic quality; and a history of "meaningful" exhibitions, catalogues, and resource materials. The FADA does not enjoy the same level of prestige that the ADAA does, but its membership benefits include an annual art fair (the Los Angeles Art Show) and similar promotional efforts in arts publications.

The International Fine Print Dealers Association (IFPDA)

The IFPDA (*www.printdealers.com*) is a good example of an association with a very specific *raison d'être*. In addition to promoting the interests of its members, the IFPDA was founded to promote "greater appreciation of fine prints among art collectors and the general public." Founded in 1987, the association elects members based on their "high level of expertise, ethics, and professional integrity, and takes

into account years in business, the quality of art offered for sale, exhibitions, and published catalogues as well as community service." Although it does have international members, the vast majority of its nearly 170 members operate in the United States. IFPDA also sponsors an eponymous art fair each year in New York, supports lectures and demonstrations at its member galleries and print workshops, and gives an annual book award honoring excellence in recent books or catalogues in the field of fine prints.

The Association of International Photography Art Dealers (AIPAD)

AIPAD is another international association organized to encourage public appreciation of art created in a specific medium and to promote dealers who specialize in it. Started in 1979, AIPAD is one of the only associations to post its code of ethics and bylaws on its Web site (*www.aipad.com*), noting that members are expected to "provide accurate descriptions of photographs in all disclosures, including, but not limited to, invoices, wall labels, and price lists." Also available on its Web site is a downloadable membership application form. AIPAD had sponsored both a New York and Miami art fair, but cancelled the Florida version this past year.

New Art Dealers Alliance (NADA)

The most recently formed international dealers association, NADA (*www.newartdealers.org*), was founded in 2002 and works to connect and promote dealers and other professionals specializing in contemporary art. Unlike many other association-sponsored art fairs, the NADA version held each year in Miami is not limited to member galleries. Membership is by invitation, following nomination by a current NADA member. In addition to seminars and panel discussions dedicated to helping its predominantly young members learn about the business from their more experienced peers and other professionals, in the business, NADA offers its members a range of community-building events. (Full disclosure: I am a member of NADA.)

REGIONAL DEALERS ASSOCIATIONS

In addition to the national and international art dealers associations, dozens of regional organizations provide networking and promotional opportunities for their members. Most serve the galleries of a major city, including those in Atlanta, Boston, Charleston, Chicago, Dallas, Denver, Fort Worth, Houston, Milwaukee, Portland, San Francisco, Santa Fe, and Seattle, but others spread a wider net, as do the Art Dealers Association of California and the North Dakota Art Gallery Association. Still others, such as the Japanese Art Dealers Association of New York or the Antique Tribal Art Dealers Association, serve members that specialize in a particular type

of art. It would be impossible to discuss each of these associations individually (for a partial list, see appendix B), but what they often share are maps of their members' locations (sometimes distributed in print form, but often downloadable from their Web site), promotional events, and joint advertising efforts. Whether joining an association makes business sense for you depends, of course, on whether their mission and services offer good value in return for your membership dues.

FOUNDING A REGIONAL ART DEALERS ASSOCIATION

Most art dealers associations are founded when a gallery community grows enough to benefit from one or because an existing association cannot meet the needs of all the galleries that might wish to join. Two of the associations of which I have been a member represent the two main methods by which an association is organized: 1) a small group of dealers form the nucleus, define the mission and identity, create the bylaws, and begin inviting other galleries to join the association as created; or 2) a small group of dealers form a committee that presents a plan to the gallery community at large, debates and votes on the plan, and then moves forward from there. Both models have their advantages. The second model is how a group of galleries in Williamsburg, including ours, started the Williamsburg Gallery Association (*www.williamsburggalleryassociation.com*). It will also form the basis for the advice that follows on founding a dealers association in your area.

Mission

Just as it does in starting your gallery, carefully writing a mission statement early on in the foundation of a dealers association helps clarify the decisions you need to make. The list of common association activities above might be a good place to start, but we learned early on in founding the WGA to keep it simple, especially in the beginning. The more complex our mission became, the more we disagreed about how to move forward. Our breakthrough in writing the mission statement came when we decided to focus on only the goals that bound us together (i.e., advertising, hosting events, increasing traffic to our galleries, supporting the arts community, etc.). Enthusiastic ideas about co-curatorial projects or political activities only served to derail any progress.

Legal Business Form and Executive Structure

Most art dealers associations are nonprofit organizations. Obtaining nonprofit status can take time, though, so the WGA, anxious as we were to get things going, began as a corporation and then eventually switched. Some administrative work will accompany the set-up and operations of the association, so planning for at least one part-time employee is practical. As with any organization funded by membership

dues, you should also regularly arrange to share with the entire membership an account of how the association's funds are being spent.

Bylaws

In writing the bylaws for the WGA, each dealer had strong ideas about how the organization should be structured, who should be eligible for membership, what criteria should qualify someone to be an officer or board member, and what means members would be given to provide input and feedback. Especially problematic for us was trying to create a two-tiered membership in which fewer benefits corresponded with lower dues. I don't recommend that. It brought out some disagreements that nearly derailed the entire effort.

Another potentially stressful topic is membership qualifications. Aside from trying to minimize the politics or business agendas likely to play themselves out in that discussion, I recommend limiting the frequency with which new members are accepted (to avoid letting a year-round drain on board members' time) and remembering that keeping the cost of dues in check will require either opening up the membership as widely as possible or having less to spend on advertising or other promotions. Then again, the prestige of membership and the credibility of the association will require that certain business and ethical standards be met, so the criteria cannot be too lax. Voting rights for members should obviously be as democratic as possible, but I recommend making the types of decisions the board is authorized to make on its own as broad as possible so that the association's work can get done with as little distraction from every member's business as possible. Finally, spelling out in detail what is cause for terminating a dealer's membership, actions the association will take if dues are not paid on time, the responsibilities with which a member who is terminated must still comply, and what rights specifically (including participation in upcoming events that were paid for) a termination suspends are important to get right the first time around. Members *will* drop out or not pay dues and then challenge the repercussions of their actions—believe me.

Promotions and Value for Members

Apathy is perhaps the single biggest threat to the longevity of an art dealers association, as evidenced clearly by members' willingness to let their memberships lapse. Ensuring that there are incentives to pay dues (and on time) falls to the officers, board members, and promotional events committee members. The most successful promotional efforts, of course, are the ones through which members make money or otherwise directly see a benefit for their businesses. This is why many associations make membership a requirement for the art fairs they sponsor. Few regional associations can pull off a flourishing art fair or other sure-bet money making event,

however, so increased traffic or press are often the measures of an effort's success. Each event your association sponsors should include a follow-up assessment, either by the board or through some survey of the entire membership, to gauge whether it provided true value. If the consensus is no, then the focus should be on whether to work to improve it or abandon it altogether. If the answer is yes, then the focus should be on how to replicate or even increase that success the next time around.

My experience in the WGA leads me to believe that any association can pull off, at most, two to three large-scale events a year. Some simpler events, like monthly late-night receptions, panel discussions, or seminars, are easy enough to repeat frequently, but even they will zap enthusiasm for the association in general if they are not well produced or well attended. The ultimate goal of any association is to increase the stature, relevance, collective power, and business for its members. Any promotional event not guided by that goal will fail under the weight of eventual lack of interest.

Appendix A

The Standard Art Consignment Agreement

Reprinted with permission from *The Artist-Gallery Partnership: A Practical Guide to Consigning Art* by Tad Crawford and Susan Mellon (Allworth Press, 2008, pages 179-182).

The Artist (name, address, and telephone number): _____

_____ and the

Gallery (name, address, and telephone number): _____

hereby enter into the following Agreement:

1. *Agency Purposes.* The Artist appoints the Gallery as agent for the works of art ("the Artwork") consigned under this Agreement, for the purposes of exhibition and sale. The Gallery shall not permit the Artworks to be used for any other purposes without the written consent of the Artist.

2. *Consignment.* The Artist hereby consigns to the Gallery, and the Gallery accepts on consignment, those Artworks listed on the attached Inventory Sheet which is a part of this Agreement. Additional Inventory Sheets may be incorporated into this Agreement at such time as both parties agree to the consignment of other works of art. All Inventory Sheets shall be signed by Artist and Gallery.

3. *Warranty.* The Artist hereby warrants that he/she created and possesses unencumbered title to the Artworks, and that their descriptions are true and accurate.

4. *Duration of Consignment.* The Artist and the Gallery agree that the initial term of consignment for the Artworks is to be _____ (months), and that the Artist does not intend to request their return before the end of this term. Thereafter, consignment shall continue until the Artist requests the return of any or all of the Artworks or the Gallery requests that the Artist take back any or all of the Artworks with which request the other party shall comply promptly.

5. *Transportation Responsibilities.* Packing and shipping charges, insurance costs, other handling expenses, and risk of loss or damage incurred in the delivery of Artworks from the Artist to the Gallery, and in their return to the Artist, shall be the responsibility of the _____ (specify Gallery or Artist).

6. *Responsibility for Loss or Damage, Insurance Coverage.* The Gallery shall be responsible for the safekeeping of all consigned Artworks while they are in its custody. The Gallery shall be strictly liable to the Artist for their loss or damage (except for damage resulting from flaws inherent in the Artworks), to the full amount the Artist would have received from the Gallery if the Artworks had been sold. The Gallery shall provide the Artist with all relevant information.

7. *Fiduciary Responsibilities.* Title to each of the Artworks remains in the Artist until the Artist has been paid the full amount owed him or her for the Artworks; title then passes directly to the purchaser. All proceeds from the sale of the Artworks shall be held in trust for the Artist. The Gallery shall pay all amounts due the Artist before any proceeds of sales can be made available to creditors of the Gallery.

8. *Notice of Consignment.* The Gallery shall give notice, by means of a clear and conspicuous sign in full public view, that certain works of art are being sold subject to a contract of consignment.

9. *Removal from Gallery.* The Gallery shall not tend out, remove from the premises, or sell on approval any of the Artworks, without first obtaining written permission from the Artist.

10. *Pricing; Gallery's Commission; Terms of Payment.* The Gallery shall sell the Artworks only at the Retail Price specified on the Inventory Sheet. The Gallery and the Artist agree that the Gallery's commission is to be _____ percent of the Retail Price of the Artwork. Any change in the Retail Price, or in the Gallery's commission, must be agreed to in advance by the Artist and the Gallery. Payment to the Artist shall be made by the Gallery within _____ days after the date of the sale of any of the Artworks. The Gallery assumes full risk for the failure to pay on the part of any purchaser to whom it has sold an Artwork.

11. *Promotion.* The Gallery shall use its best efforts to promote the sale of the Artworks. The Gallery agrees to provide adequate display of the Artworks, and to undertake other promotional activities on the Artist's

behalf, as follows: _____
_____. The Gallery and
the Artist shall agree in advance on the division of artistic control and
of financial responsibility for expenses incurred in the Gallery's exhibi-
tions and other promotional activities undertaken on the Artist's
behalf. The Gallery shall identify clearly all Artworks with the Artist's
name, and the Artist's name shall be included on the bill of sale of each
of the Artworks.

12. *Reproduction.* The Artist reserves all rights to the reproduction of the
 Artworks except as noted in writing to the contrary. The Gallery may
 arrange to have the Artworks photographed to publicize and promote
 the Artworks through means to be agreed to by both parties. In every
 instance of such use, the Artist shall be acknowledged as the creator and
 copyright owner of the Artwork. The Gallery shall include on each bill
 of sale of any Artwork the following legend: "All rights to reproduction
 of the work(s) of art identified herein are retained by the Artist."

13. *Accounting.* A statement of accounts for all sales of the Artworks shall be
 furnished by the Gallery to the Artist on a regular basis, in a form agreed
 to by both parties, as follows: _____

 (specify frequency and manner of accounting). The Artist shall have the
 right to inventory his or her Artworks in the Gallery and to inspect any
 books and records pertaining to sales of the Artworks.

14. *Additional Provisions.* _____

15. *Termination of Agreement.* Notwithstanding any other provision of this
 Agreement, this Agreement may be terminated at any time by either the
 Gallery or the Artist, by means of written notification of termination
 from either party to the other. In the event of the Artist's death, the estate
 of the Artist shall have the right to terminate the Agreement. Within
 thirty days of the notification of termination, all accounts shall be settled
 and all unsold Artworks shall be returned by the Gallery.

16. *Procedures for Modification.* Amendments to this Agreement must be
 signed by both Artist and Gallery and attached to this Agreement. Both
 parties must initial any deletions made on this form and any additional
 provisions written onto it.

17. *Miscellany.* This Agreement represents the entire agreement between the Artist and the Gallery. If any part of this Agreement is held to be illegal, void, or unenforceable for any reason, such holding shall not affect the validity and enforceability of any other part. A waiver of any breach of any of the provisions of this Agreement shall not be construed as a continuing waiver of other breaches of the same provision or other provisions hereof. This Agreement shall not be assigned, nor shall it inure to the benefit of the successors of the Gallery, whether by operation of law or otherwise, without the prior written consent of the Artist.

18. *Choice of Law.* This Agreement shall be governed by the law of the State of _____.

_____ _____
SIGNATURE OF ARTIST SIGNATURE OF AUTHORIZED
 REPRESENTATIVE OF THE GALLERY

_____ _____
DATE DATE

Appendix B

Regional Art Dealers Associations

The following list is by no means to be construed as exhaustive. The activities, as well as online presences, of many regional art dealers associations come and go at times. As of this writing, these are the ones I was able to find with active programs and Web sites you can visit for more information.

ARIZONA
Scottsdale Gallery Association
www.scottsdalegalleries.com
Sedona Gallery Association
www.sedonagalleryassociation.com
Central Tucson Gallery Association
www.ctgatucson.org

ARKANSAS
Eureka Springs Gallery Association
www.artofeureka.com

CALIFORNIA
Art Dealers Association of California
www.artdealersassociation.org
Buenaventura Art Association
www.buenaventuragallery.org
San Francisco Art Dealers Association
www.sfada.com
Santa Barbara Art Dealers Association
www.sbada.org/index.html

COLORADO
Denver Art Dealers Association, DADA art galleries
www.denverart.org

DISTRICT OF COLUMBIA
Art Dealers Association of Greater Washington
www.washingtonartdealers.org

FLORIDA
Naples Fine Art Dealers Association
www.naplesfineartdealers.com

GEORGIA
Atlanta Gallery Association
www.atlart.com/pages/about.php

IDAHO
Sun Valley Gallery Association
www.svgalleries.org

ILLINOIS
Art Dealers Association of Chicago
www.chicagoartdealers.org
Wicker Park/Bucktown Gallery Association
www.wpbga.com

INDIANA
Indianapolis Downtown Artists and Dealers Association
www.idada.org

LOUISIANA
Lafayette Gallery Association
www.pyrocajun.com

MAINE
Gallery Association of Portland Maine
www.galleriesportlandmaine.com

MARYLAND
Annapolis Gallery Association
www.artinannapolis.com

MASSACHUSETTS
The Boston Art Dealers Association
www.bostonart.com

MICHIGAN
Grand Rapids Gallery Association
www.grga.org

MINNESOTA
Duluth Art Gallery Association
www.duluthartgalleryassociation.com

MONTANA
Livingston Gallery Association
www.livingstongalleries.com
Montana Art Gallery Directors' Association
www.mt-magda.org/magorg.htm

NEW MEXICO
Santa Fe Gallery Association
www.santafegalleries.net/index.php
Taos Gallery Association
www.taosgalleryassoc.com

NEW YORK
Williamsburg Gallery Association
www.williamsburggalleryassociation.com

NORTH CAROLINA
Asheville Downtown Gallery Association
www.ashevilledowntowngalleries.org/index.html

NORTH DAKOTA
The Bismarck Art & Galleries Association
www.bismarck-art.org
The North Dakota Art Gallery Association
www.ndaga.org

OKLAHOMA
Norman Gallery Association
www.normangalleryassociation.com

OREGON
Ashland Gallery Association
www.ashlandgalleries.com
Bend Art Gallery Association
www.bendgalleries.com/BG
Portland Art Dealers Association
www.padaoregon.org

SOUTH CAROLINA
Charleston Fine Art Dealers Association
www.robertlangestudios.com/cfada
French Quarter Gallery Association
www.frenchquarterarts.com

TENNESSEE
Nashville Association of Art Dealers
www.nashvilleartdealers.net

TEXAS
Dallas Art Dealers Association
www.dallasartdealers.org/about.php
Fort Worth Art Dealers Association
www.fwada.com
Houston Art Dealers Association
www.hada.net

UTAH
Salt Lake Gallery Association
www.slga.info

WASHINGTON
Seattle Art Dealers Association
www.seattleartdealers.com

WISCONSIN
Milwaukee Art Dealers Association
www.rotisseriestyle.com/MADA/index.htm

WYOMING
Jackson Hole Gallery Association
www.jacksonholegalleries.com

Bibliography

Abbott, Susan. *Fine Art Publicity; The Complete Guide for Galleries and Artists.* New York: Allworth Press, 2005.

Behrman, S.N. *Duveen: The Story of the Most Spectacular Art Dealer of All Time.* New York: The Little Bookroom, 2003.

Crawford, Tad, and Susan Mellon. *The Artist-Gallery Partnership: A Practical Guide to Consigning Art,* 3rd ed. New York: Allworth Press, 2008.

Crawford, Tad. *Business and Legal Forms for Fine Artists.* New York: Allworth Press, 2005.

—. *Legal Guide for the Visual Artist.* New York: Allworth Press, 1999.

De Coppet, Laura, and Alan Jones. *The Art Dealers: The Powers Behind the Scene Tell How the Art World Really Works.* New York: Cooper Square Press, 1984.

DuBoff, Leonard. *The Law (in Plain English) for Galleries.* New York: Allworth Press, 1999.

Goldstein, Malcolm. *Landscape with Figures: A History of Art Dealing in the United States.* Oxford, U.K.: Oxford University Press, 2000.

Guggenheim, Peggy. *Out of This Century: Confessions of an Art Addict.* New York: Universe Books, 1979.

Jacobs, Lisa, and Ingrid Schaffner, eds. *Julien Levy: Portrait of an Art Gallery.* Cambridge, Mass.: The MIT Press, 1998.

Pollock, Lindsay. *The Girl with the Gallery: Edith Gregor Halpert and the Making of the Modern Art Market.* New York: PublicAffairs, 2006.

Secrest, Meryle. *Duveen: A Life in Art.* Chicago: University of Chicago Press, 2005.

Vasari, Giorgio. *The Lives of the Artists.* 2 vols. Gloucester, Mass.: Peter Smith Publisher, Inc., 1993.

Index

Books from Allworth Press

Allworth Press is an imprint of Allworth Communications, Inc. Selected titles are listed below.

Learning by Heart: Teachings to Free the Creative Spirit
by Corita Kent and Jan Steward (6 7/8 × 9, 232 pages, paperback, $24.95)

The Quotable Artist
by Peggy Hadden (7 1/2 × 7 1/2, 224 pages, paperback, $16.95)

The Artist's Guide to Public Art: How to Find and Win Commissions
by Lynn Basa (6 × 9, 256 pages, paperback, $19.95)

Selling Art without Galleries: Toward Making a Living from Your Art
by Daniel Grant (6 × 9, 256 pages, paperback, $19.95)

The Business of Being an Artist, Third Edition
by Daniel Grant (6 × 9, 352 pages, paperback, $19.95)

The Artist-Gallery Partnership: A Practical Guide to Consigning Art, Third Edition
by Tad Crawford and Susan Melton (6 × 9, 216 pages, paperback, $19.95)

Fine Art Publicity: The Complete Guide for Galleries and Artists, Second Edition
by Susan Abbott (6 × 9, 192 pages, paperback, $19.95)

Legal Guide for the Visual Artist, Fourth Edition
by Tad Crawford (8 1/2 × 11, 272 pages, paperback, $19.95)

Business and Legal Forms for Fine Artists, Revised Edition
by Tad Crawford (8 1/2 × 11, 144 pages, paperback, includes CD-ROM, $19.95)

The Artist's Complete Health and Safety Guide, Third Edition
by Monona Rossol (6 × 9, 416 pages, paperback, $24.95)

Artists Communities: A Directory of Residences that Offer Time and Space for Creativity
by the Alliance of Artists Communities (6 × 9, 336 pages, paperback, $24.95)

Creative Careers in Museums
by Jan E. Burdick (paperback, 6 × 9, 224 pages, paperback, $19.95)

Caring for Your Art: A Guide for Artists, Collectors, Galleries and Art Institutions, Third Edition
by Jill Snyder (6 × 9, 256 pages, paperback, $19.95)

To request a free catalog or order books by credit card, call 1-800-491-2808. To see our complete catalog on the World Wide Web, or to order online for a 20 percent discount, you can find us at ***www.allworth.com.***